Studies in Impressionism

John Rewald

Studies
in Impressionism

Edited by Irene Gordon
and Frances Weitzenhoffer

Harry N. Abrams, Inc., Publishers, New York

Library of Congress Catalog Card Number 85-71021
ISBN 0-8109-1617-7

© 1985 John Rewald

Published in 1986 by Harry N. Abrams, Incorporated, New York.
All rights reserved. No part of the contents of this book may be
reproduced without the written permission of the publishers.

Printed and bound in Japan

Contents

Foreword

Every scholar, in the course of research, comes across documents or sources of information that have not previously been utilized. Yet these do not always relate directly to the research project at hand. The choice, therefore, is either to ignore them, or to explore them in an independent study of greater or lesser length. Articles, thus, are frequently by-products of larger or differently oriented investigations. This, in any case, has been the origin of many of the papers assembled here.

A chance meeting in Paris with Edmond Renoir shortly before World War II resulted in interviews concerning his brother and even in an essay in which he eagerly jotted down his recollections of the painter. A trip to New Orleans led to a meeting with Degas's nephew, who made me aware of the existence of court papers dealing with the divorce proceedings against his father, René de Gas, the painter's brother, papers that the nephew himself had never seen but that bore out everything he had told me about his family. Through Professor Lee Johnson I learned of the whereabouts of the Goupil records, which turned out to belong to Jean Diéterle, an old acquaintance of mine, who, with incredible generosity, gave me unrestricted access to them. As a result, I was able to throw new light on the activities of Theo van Gogh, of which even his son, my longtime friend Ing. V. W. van Gogh, had no knowledge. And it was another friend, Arï Redon, who provided me with the documents that served for a study of his father, of which every line was checked with him. My long friendship with Charles Durand-Ruel made it not only possible, but actually easy for me to work with the invaluable Durand-Ruel Archives and to obtain countless documents and photographs.

Sometimes research can be inspired by the desire to correct errors. Douglas Cooper's statement that the sale catalogue of the Chocquet collection provided a 'first hand source for reliable dating' of Cézanne's works prompted me first to re-examine the catalogue, which corroborated my recollection that it does not contain any dates, and then led me to search for information that would enlarge our knowledge of Victor Chocquet, his collection, and its ultimate dispersal. In the course of this investigation I was able to confirm certain highly perceptive stylistic conclusions drawn by

Lawrence Gowing which Cooper had tried to discredit with his references to the Chocquet catalogue.

In a few cases articles reprinted here were not intended to offer new material, but represent an endeavor to assemble carefully all the known facts on a given subject and, in so doing, draw them together in a more logical structure than had been fashioned before. This, for example, is how the essay on Cézanne and his father came to be written.

None of these pieces ever seemed to fit into any of the projects on which I was working when I found the material on which they are based. As a result, they appeared in various, more or less widely scattered places where it is not always easy to locate them. Thus the idea developed that these pages, which refused to fit into my various books, might form a volume by themselves. In the process of selecting and assembling these papers, some of which go back several decades, I have limited myself—instead of rewriting passages that sorely needed it—merely to correcting occasional errors, as well as to including more recent findings by myself and others where they related to the subject.

I am deeply grateful to the editors of the various periodicals and publications in which these articles first appeared for permission to include them in this volume. My special thanks are due the late Georges Wildenstein, director of the *Gazette des Beaux-Arts*, and to his son, Daniel, who succeeded him, as well as to Jean Adhémar, for many years editor in chief of the *Gazette* where, since February 1936, many of my studies, and especially the rather long ones, have always received a generous hospitality. I am no less grateful to the two editors of this volume, Irene Gordon and Frances Weitzenhoffer, who were jointly responsible for the choice of the pieces to be admitted (or rejected). While Frances Weitzenhoffer translated the articles that had been written in French, as well as many of the quotes that had appeared in French in English texts, and also prepared the exceedingly involved bibliography, Irene Gordon modernized much that had become outmoded and prepared a miraculously presentable manuscript.

JOHN REWALD

Auguste Renoir and his brother

In memory of Kurt Wolff

Auguste Renoir *Initial 'L': Young Girl Seated under a Tree Knitting* 1879, pen and ink

IFE accorded greater clemency to Edmond Renoir than to his famous brother. Not only was he permitted to live much longer, but he was spared the sorrows and impotencies which made the advanced years of the painter a succession of uninterrupted sufferings. Past his ninetieth year, Edmond Renoir was alert and active, a dried up little *bonhomme* whose features acknowledged an undeniable resemblance to his brother Auguste, no doubt accentuated by the years that had wrinkled his skin and lined his cheeks, permitting the bony structure of his skull to show beneath a thin yellowish membrane. A narrow, pointed nose separated two eyes that regarded life with an amused and curious air, revealing a spirit as spontaneous as it must have been seventy years earlier. The painter also had been endowed with this same impulsive spirit, but whereas his Parisian humor served as a façade for profound sensibility and even humility, his brother seemed to cultivate his by love and joy of living. To hear Edmond Renoir, one could believe oneself to be in the presence of Victor Hugo's famous *gavroche*, a street urchin miraculously grown old, so much did he burst forth with preposterous observations, bold ideas, innocent humbug, and unexpected repartee. Completely conscious of the contrast between his appearance and his attitude, the strange little old fellow took a wicked delight in further accentuating it by affecting petty airs which only his good humor and nonchalance saved from ridicule.

Eight years younger than the painter, Edmond Renoir had lived the obscure life of a journalist and editor; it was only due to the fame of his brother and to his own great age that he knew, a bit late, a little notoriety which he enjoyed innocently enough and without any ostentation. He was

First published in the *Gazette des Beaux-Arts*, March 1945

proud to be dean of Parisian journalists and did not resist the pleasure of presenting himself to the dumbfounded guards of the Bibliothèque Nationale of Paris with a reader's card issued before 1870 and bearing the heading Bibliothèque Impériale. His conversation was seasoned with little histories witnessed and experienced, presented with a skill that revealed the journalist, but when one questioned him about the painter his memory had to delve way into the past, because from about 1885 contacts between the two brothers were apparently more and more infrequent. However, what he related of the youth of Auguste Renoir, concerning years of which he was the only witness, deserves recording, even though he did not always avoid the tendency to place himself, and not the painter, in the center of the tale.[1] This begins shortly before 1856, when the painter was about fifteen years of age and his brother only seven.

'We lived,' remembered Edmond Renoir

'on the rue d'Argenteuil, in a flat scarcely large enough to hold all seven of us. Most happily, an additional room of sloping ceilings on the sixth floor of the house devolved upon my brother and me. In our little garret we were masters and we profited by it, arguing until late into the night without our father interfering as before to make us be quiet and to put out our little lamp.

'We were dying with desire to instruct ourselves; evening courses on all subjects, including drawing, did not satisfy us, and endless reading was added in our little attic. Lying in bed we devoured old volumes part of the night, questioning each other, book in hand, without stop.[2]

'The flair of Auguste for drawing manifested itself at an early age. As a child, he stole colored crayons from our father who was then established as a tailor, rue de la Bibliothèque, near the Palais Royal. Later, at school, he enlivened his copybooks with marginal sketches. The teacher, instead of reprimanding him, begged our parents not to oppose the lad and added, "All that I ask is that you give me the copybook when it is filled."

'In 1856 when Auguste reached the age of fifteen, it was necessary for him to learn some profitable trade because we were very poor. Realizing he would have a taste for an artistic profession, our parents placed him in a shop of china painting, the firm of Levy, rue vieille du Temple. Auguste liked the place immensely and worked with great application. He progressed rapidly and after several months they already entrusted to the young apprentice some pieces ordinarily reserved for experienced workmen, which gave rise to some teasing; they called him in jest "Monsieur Rubens" and he wept because they made fun of him.

'It must be understood that porcelain of that period was not at all what it is today when the same subject is repeated on every piece of a service. The work was done entirely by hand and, piece by piece, was ornamented with different subjects, often most complicated. When Auguste finished his first dessert service decorated with reproductions of paintings in the Louvre, the patron was so enchanted that he permitted him to take a plate.[3]

'After work, armed with an enormous portfolio, Auguste went to follow a free drawing course. During the two or three years that he stayed in this shop, Auguste

attached himself to one of the workmen in particular, a nice old man whose passion was to paint in oils at home. Happy, perhaps, to have a pupil, he invited his young colleague to share his provision of canvases and colors; after some time he persuaded him to paint a picture alone. Auguste applied himself to the task and one Sunday the visit of his "master" was announced.

'I recall it as though it were yesterday. I was still a small boy but I understood perfectly that something serious was happening. The easel with the famous picture had been placed in the very center of the largest room of our modest home. Everyone was feverish and impatient. I had been dressed up and had been told to be well behaved. It was absolutely solemn. The master arrived; I assure you that we were not feeling overconfident in the Renoir family. At a signal, I placed a chair before the easel. He sat down and proceeded to examine "the work." It was, I can see it still, an Eve: behind her the serpent curled about the branches of an oak; it stretched its gaping mouth as though to fascinate her.

'The examination lasted a good quarter of an hour; after this, without other comment, the kind man moved toward our parents and spoke these simple words: "You should permit your son to become an artist, a painter. In our trade he will succeed, at most, to earn twelve or fifteen francs a day. I predict a brilliant destiny for him in the arts: see what you can do."

'That evening we dined sadly at rue d'Argenteuil; the joy occasioned by Auguste's success disappeared before the terrible prospect of having him forsake a trade that would secure him a living, for an art that could only lead him straight away to misery. Finally we resigned ourselves, and the Ecole des Beaux-Arts had one more student.'[4]

In fact, Renoir did not enter the Ecole des Beaux-Arts until about two years later, employing these years to secure a little cash to provide himself with the necessaries of a student, because he could not count upon any financial assistance from his parents. It was for this reason that he entered a shop on rue du Bac where calico blinds were decorated, which were sold to missionaries who placed them, instead of stained-glass windows, in their portable churches in Paraguay. According to Meier-Graefe, who doubtless had the information from Renoir himself, the young apprentice received thirty francs a blind.[5] By the end of the week he was already earning one hundred francs a day, painting the blinds ten times faster than his colleagues. At the end of two years he had saved enough to enable him to enter the Ecole des Beaux-Arts, in the section of painting, to which he was admitted on April 1, 1862.

'Auguste,' says his brother

'entered the studio of Gleyre, studied anatomy, passed the concours of perspective, sketching, etc., like everybody. He won success upon success at the different examinations,[6] above all he formed lasting friendships at the Ecole des Beaux-Arts. From the first days, he fell in with Fantin-Latour whose studio was two steps away, rue Visconti. Fantin took him off to work with him when he came from the Ecole, lavishing the best advice upon him and repeating without end: "The Louvre! The Louvre! There is only the Louvre! You can never copy the masters enough!" And

Fantin carried him away to the Louvre where he continued his lesson, by insisting upon the choice among the masterpieces.'[7]

But Auguste Renoir was to attach himself still more to three disciples of Gleyre's studio: Monet, Sisley, and Bazille. It is Bazille who, in one of his letters to his parents, gives some information on the life of the studio: 'M. Gleyre comes twice a week,' he wrote, 'and passes every student in review, correcting each drawing or painting. Then from time to time he gives a little subject of composition on which each does his best.'[8]

Contrary to what is often said, it seems that the budding young Impressionists suffered but little under the 'yoke' of their master. In truth, Gleyre was a modest man who did not like to lecture; he was content to advise his students to draw a great deal and to prepare their tones on their palette in advance, so that they could devote themselves more to drawing, always fearing that the 'devilish color' might go to their heads. If he ever was irritated, it was with the studies of pupils who were too preoccupied with color, to the exclusion of drawing.[9]

There can be no doubt that in spite of all his diligence and his desire to follow the master's advice, Renoir was among those guilty of excess in colors. Much later he himself said to his friend Elie Faure: 'At the studio, while the others shouted, broke the windowpanes, martyrized the model, bothered the teacher, I was always quiet in my corner, very attentive, very docile, studying the model, listening to the teacher . . . and it is me that they called the revolutionary.'[10]

In 1864 Gleyre's studio had to close its doors. The contributions of the students did not cover the cost of the model; Gleyre himself had from the beginning generously renounced all remuneration. The good professor advised Renoir and Monet to work outside the studio in order to make serious progress.[11] Indeed, at Easter 1864, Monet, Renoir, Sisley, and Bazille set out for Fontainebleau to paint in the forest, as Monet had done the preceding year. The young Edmond Renoir was of the party.

'Auguste used to take me with him to Marlotte, to the inn of Mother Anthony,' he related.

'It was the meanest village on the edge of the forest, with its modest tavern where Claude Monet, Sisley, Pissarro, and others covered their canvases. I accompanied them everywhere, carrying my share of the equipment, drinking in their words, dumbfounded by their amazing remarks, their endless discussions; and more than astonished to see them take along with them enough painting material to make in a morning at least two or even three sketches reproducing the different effects of light. It was here that my brother met Courbet, who was the idol of young painters, and Diaz who said to him that "no self-respecting painter ever dares touch a brush if he has no model under his eyes." This axiom remained profoundly fixed in the memory of the beginner. The forest was there, ready for him to study at leisure. He stayed the

summer, he stayed the winter, and this he did for years. It was by living in the open that he became the painter of *plein air.*'

His funds eventually exhausted, Renoir knew very difficult moments. Bazille repeatedly invited him to share his studio, but when he no longer had enough money to pay for his canvases and paints, Renoir supported himself, according to his brother's recollection, by small jobs such as doing, for instance, some *Images d'Epinal.* Also because of financial straits, he tried to make his own colors with powder, but this endeavor proved fruitless. What misery he suffered—he who always seemed gay and carefree—was revealed to his brother when Edmond spoke to him of his own projects.

'Having tasted journalism,' Edmond Renoir reports in his recollections, 'I was on fire with the desire to go on. Auguste knew Arsène Houssaye[12] of the *Gazette de Paris* and I wished very much to be asked to join it. To my pressing entreaties Auguste finished by exclaiming, "Don't you think it is enough for one of us to be dying of hunger?"'

Despite the pessimism of his brother, Edmond Renoir was to launch himself upon a journalistic career, although the Franco-Prussian War interrupted its beginning. The two brothers served in the army and found each other again in Paris after the defeat and the Commune. It was then that Edmond Renoir became more intimately associated with his brother's work, either in posing for him, or helping him, as he did in the execution of the view of the Pont Neuf *(IV)* painted by Auguste Renoir in 1872. Here is his account on the subject of this work:

'We established our quarters at the entresol of a little café at a corner of the quai du Louvre, but much nearer the Seine than are the present buildings. For our two coffees, at ten centimes each, we could stay at that café for hours. From here Auguste overlooked the bridge and took pleasure, after having outlined the ground, the parapets, the houses in the distance, the place Dauphine, and the statue of Henri IV, in sketching the passers-by, vehicles, and groups. Meanwhile I scribbled, except when he asked me to go on the bridge and speak with the passers-by to make them stop for a minute.'

Edmond Renoir asked this gentleman the time and that lady where such and such a street was located. While he was given the unnecessary information, his brother had time to sketch the figure for his painting.

Among the numerous canvases for which Edmond Renoir posed, full face, profile, and often from the back, are *The Loge (1)* and *La Famille Henriot.* During the sittings he had the chance to observe his brother's methods. He says:

'He worked with such a prodigious virtuosity that a portrait required just one sitting. The model would leave his place and come look at the canvas and find the painted image very like him, very good; but he expected to return. Auguste accepted this of necessity, but he had a bad time pretending to retouch the picture, occasionally

satisfying himself with perfecting the background and certain details of the dress, without at all modifying the face. We argued about this and he said to me: "Understand well: nothing is so mobile as a face. If the features remain constant, the physiognomy changes for a yes, for a no. The eyes will be more or less tired. The forehead may be wrinkled with preoccupation, the hair will not be in the same place and the amiable smile, natural today, may become affected tomorrow. Can I follow these evolutions? No!"'

Renoir also made a full-length portrait of his brother for a panel on the staircase of the house of the publisher Charpentier whose acquaintance he seems to have made a short time before the war. After the collapse of the Second Empire, the salon of Madame Charpentier was bound to assume first place in the bourgeois republican world. Here Renoir met celebrities in the fields of letters, arts, and politics, since Daudet, Zola, Flaubert, Edmond de Goncourt, Maupassant, Turgenev, Manet, Gambetta, Jules Ferry, Théodore de Banville, Huysmans, and many others numbered among the group, not to mention the beautiful women by whom Renoir was attracted, Madame Charpentier herself and also the singer Jeanne Samary.[13] 'Although Renoir did not care for sophisticated gatherings,' his friend Georges Rivière reported, 'he went with pleasure to the parties of Madame Charpentier. Here he found himself in an intelligent milieu where, by the tact and grace of the hostess, haughtiness and boredom were banished. Here he felt himself understood, encouraged by the welcome of the friends he met.'[14] These encouragements were soon to take a particularly tangible form; not only the artist, but also his brother were to profit from them.

In 1879 Georges Charpentier founded, apparently upon the insistence of his wife, *La Vie Moderne*, a weekly devoted to the artistic, literary, and worldly life, with a marked tendency toward popularization and seeking a compromise between current taste and what was considered as advanced. Reproductions of drawings by Bonnat and Gérome appeared with studies by Degas and Mary Cassatt, accurately reflecting the tastes of Monsieur and Madame Charpentier, because while she was painted by Renoir, his portrait was done by Henner. Renoir numbered among the illustrators from the beginning; yet, aside from his occasional contributions and those of Forain, *La Vie Moderne* distinguished itself very little by the quality of its illustrations, which too completely corresponded with the taste of the boulevard. It is true, nevertheless, that occasionally one finds in *La Vie Moderne* reproductions of drawings by Monet, Degas, Redon, or Mary Cassatt. However, these did not figure as illustrations of articles, but were rather examples of their work published on the occasion of an exhibition or the appearance of a book. The literary section of *La Vie Moderne* was a little better cared for, thanks to the collaboration of all the authors published by the firm of Charpentier. Thus, contributions appeared by Camille Pelletan, Edmond de Goncourt, Alphonse Daudet, Ludovic Halévy, and Edmond

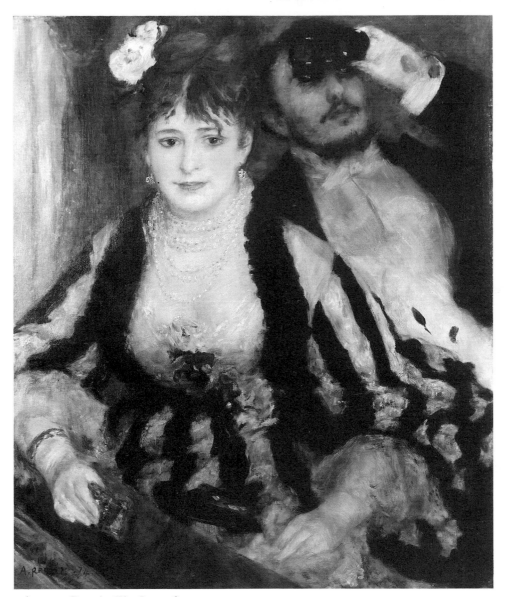

1 Auguste Renoir *The Loge* 1874

Duranty while the art criticism was entrusted to Armand Silvestre. Among the eminently successful authors of the publisher Charpentier, Emile Zola alone seems not to have collaborated with the weekly *(2)*.

The first issue of *La Vie Moderne* appeared on April 10, 1879. It contained a notice prepared by Edmond Renoir, in which he announced: 'Having at their disposal perfectly suitable quarters in a most Parisian atmosphere, the founders of "La Vie Moderne" have very naturally been prompted to organize an artistic exhibition which will serve as a kind of corollary to their publication.[15] This exhibition, or rather this series of exhibitions following

15

2 Auguste Renoir *L'Assommoir* 1877–78, pen and ink

Emile Zola's *L'Assommoir* was issued by Charpentier's publishing house in 1877. This drawing may have been made to illustrate an excerpt of the novel to be published in Charpentier's magazine *La Vie Moderne*, but it never appeared there

each other at close intervals, will have a special character in that each will assemble the works of a single artist, without distinction of importance or kind. . . . Our exhibition will be nothing else than the studio of the artist transported momentarily to the boulevard, in a gallery accessible to everyone.' Edmond Renoir, who was then editor in chief of *La Presse*,[16] a daily printed by Chaix, was placed in charge of the organization of these exhibitions and of their presentation to the readers of *La Vie Moderne*. The first exhibition was devoted to the works of a certain Ulysse Butin, the second to those of J. de Nittis (which, Edmond Renoir says with respect, bring their author 200,000 francs a year), the third to the paintings of Louise Abbema, in whom Edmond Renoir recognized 'un talent des plus virile,' and the fourth to those of Antoine Vollon. While Edmond Renoir thus dispensed innocent flattery to the 'masters' of the day and hour, Emile Bergerat, director of the weekly, devoted an interminable series of eulogistic articles to the art of Meissonier.

Simultaneously with these articles and the illustrations that accompanied them, *La Vie Moderne* also reproduced several drawings by Auguste Renoir. The second issue already carried on the title page his portrait of the painter Léon Riesener. This was soon followed by the portraits of the Austrian

16

3 Auguste Renoir
*Portrait of Théodore
de Banville*. Published
in *La Vie Moderne*,
July 10, 1879

statesman Comte de Beust and of Théodore de Banville *(3)*, and also by a study of a young girl. Anything but pedantic and always eager to help out, the painter does not seem to have been seriously opposed to the artistic compromises of the editors; he was especially anxious to render service to his benefactress, Madame Charpentier. A letter to her, written during the summer of 1879, testifies to his zeal:

> Dear Madame,
> I impart to you an idea of Madame Bérard which, in my opinion, is not entirely devoid of sense. It is to have in 'La Vie Moderne,' on the last page, the fashion of the week. I would take upon myself to make very exact drawings as soon as I return to Paris. In this manner you would attract the whole feminine audience who are not always interested in the sketches of Meissonier and others. An arrangement might be worked with milliners and dressmakers: a week of hats, another of gowns, etc. . . . I would go to their shops to make the drawings after the model from different angles. There is an idea. I transmit it to you for what it is worth.[17]

Since the project was not carried out, Madame Charpentier must not have thought that it was worth much.

The fifth exhibition organized in the galleries of *La Vie Moderne* was devoted to the works of Renoir, constituting his first one-man show. He presented mostly pastels. His brother, in charge, as in the past, of writing an article on the exhibition, did so in the form of a friendly letter to the editor, Emile Bergerat. He who up to now had abstained from any serious art criticism, could this time speak knowledgeably of the subject, and particularly so since Auguste Renoir himself must have revised his article.[18] Edmond Renoir first mentioned that he had lived for fifteen years in the close intimacy of the painter 'not only as a brother, but as a companion.' He insisted especially on the absence of *convenu* in the work of Renoir and specifically wrote:

'Does he make a portrait? He begs his model to maintain a customary attitude, to seat herself the way she naturally does, to dress as she dresses, so that nothing smacks of constraint and preparation. Thus his work has, aside from its artistic value, all the charm *sui generis* of a faithful picture of modern life. What he paints, we see every day; it is our very existence that he has registered in the studies which are certain to remain among the most living and most harmonious of the epoch. . . . This absence of *convenu* upon which I insist so much, gives me extreme pleasure; it gives me the impression of nature with all its unexpected and intense harmony; it is indeed this which speaks to me, without my being obliged to reckon with the "talent" of the artist, this "talent" which pursues us, interposing itself and destroying all sensation. It is in following my brother's work in its ensemble that one discovers that the manufacture, the routine, does not exist. In none of his works, perhaps, does one find the same method of procedure; however the work has unity, it has been entirely felt the first day, and pursued with the unique preoccupation of achieving not a perfection of rendering, but the most complete perception of the harmonies of nature.'[19]

While Edmond Renoir continued to collaborate more or less regularly with *La Vie Moderne*, his brother's drawings did not appear in it after the close of his exhibition. It is only several years later that he is found again among the illustrators of *La Vie Moderne*. The reasons for his abstention were doubtless many. In the Salon of 1879 Renoir had just exhibited the large portrait of Madame Charpentier *(4)*, for which the wife of the publisher had obtained a central place and the success of which was quite naturally due in part to the prestige of the sitter. For the first time Renoir could feel he had almost 'arrived.' It was the moment to 'strike a blow' and not waste time with work that did not pay. As he told Vollard: 'We were to be paid by future benefits— that is, we did not get a penny. But the most terrible of all is that they forced upon us, for our drawings, a paper . . . which requires the use of a scraper to render the whites: I have never been able to get used to it.'[20] This referred to a special technique, very popular at that period, of making drawings for reproduction *au gillotage*, on specially grained paper, on which white was obtained by scraping.[21]

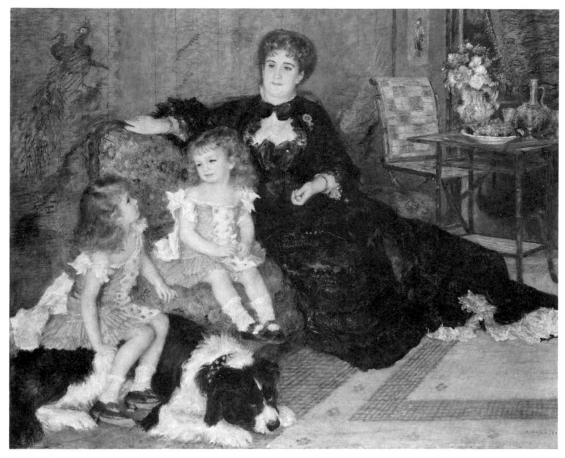

4 Auguste Renoir *Madame Charpentier and Her Children* 1878

But Renoir interrupted his collaboration with *La Vie Moderne* mainly because he undertook a series of travels, some of them in company with his brother. Edmond traveled a great deal for his journals. In 1881 he worked for a daily, *La France Méridionale*, a daily published in Nice, for which he went to Marseilles and Algiers.

'Auguste would not let go of me,' he related.

'He fell in love with the liveliness of the Vieux Port [of Marseilles], with the whole seashore, and was extremely taken with the Cote d'Azur as such. The Mediterranean proved irresistibly seductive to his astonished eyes, more accustomed to the pale lights of the capital and its surroundings. The play of light under the olive trees and the drooping pines made him burst forth with exclamations of admiration. The intense picturesqueness of the region so gripped him that he finally settled at Nice whence he could more easily get to the mountains and waters—incomparable frame of this city.

'I amused myself by writing for "La Vie Moderne" a little tale—"L'Etiquette."

19

5 Auguste Renoir *Edmond Renoir in Menton*. Published in *La Vie Moderne*, December 15, 1883, as illustration to Edmond Renoir's story 'L'Etiquette'

Auguste did the illustrations, naturally enough, making me pose in the garden of our hotel at Menton [*5*] and on the steep and rocky road which climbs to Castellas.'[22]

While the painter roamed over the Côte d'Azur and, during the winter of 1881/82, went to Naples and from there to meet Richard Wagner in Palermo and later to visit with Cézanne at l'Estaque, near Marseilles, and then on to Algiers, his brother was continuing to contribute articles to *La Vie Moderne*, accompanied by drawings of professional and more than mediocre illustrators. In the summer of 1882 he published a series of studies on angling *(6)*, his favorite subject,[23] and several months later another on the surroundings of Paris. It was not until 1883 that Auguste Renoir again contributed some drawings to *La Vie Moderne*, which, incidentally, were no longer done *au gillotage*. In February his *Portrait of Wagner* appeared; in April a drawing after the *Léda* by Riesener; in November *Dance in the*

6 Auguste Renoir *Anglers along the Seine* 1883. This reproduction was made after a galley proof owned by Edmond Renoir, according to whom it appeared in *Le Figaro* in 1883 as illustration to his article 'La Pêche à travers Paris'

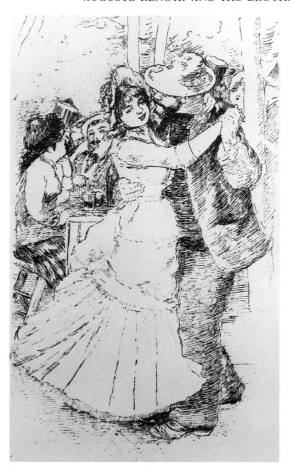
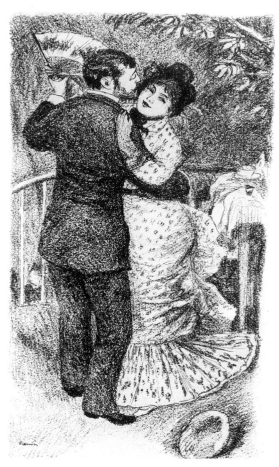

Country (7); and in December the *Couple in the Street*, two illustrations for his brother's story, and two sketches of the famous dancer Rosita Mauri.

In 1884 Renoir contributed only two drawings to *La Vie Moderne*: *Dance (8)* and a sketch after the *Fifer* by Manet *(9)*, even though during this year his brother was chief editor of the weekly, straining every effort to stabilize a tottering budget and writing most of the articles under different names. 'Renoir's brother edits *La Vie Moderne*,' wrote Camille Pissarro to his eldest son. 'Renoir does drawings for the paper. It is not very good. Someone told me that I was expected to collaborate, but I have not done so, for I have a horror of *gillotage*.—From a financial point of view it is hardly worth while. I even believe the paper pays only its well-known artists!'[24]

In the beginning of 1886 Renoir again did several sketches of no great importance and a drawing for *La Vie Moderne*. These were his last contributions to the weekly. Charpentier had lost interest in it, Edmond Renoir in turn had left, and from 1885 the journal was in the hands of a certain Gaston Lèbre whom the poet Gustave Kahn characterized as 'a spirit, if not

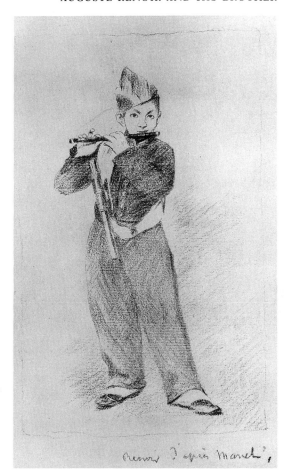

7 (far left) Auguste Renoir *Dance in the Country*. Published in *La Vie Moderne*, November 3, 1883

8 (left) Auguste Renoir *Dance*. Published in *La Vie Moderne*, January 26, 1884

9 (right) Auguste Renoir Drawing after Manet's *Fifer* 1883. Renoir made the drawing on the occasion of a memorial exhibition of Manet's work held less than a year after his death at the Ecole des Beaux-Arts, Paris. Published in *La Vie Moderne*, January 12, 1884

superior, at least very liberal and shrewd with respect to opinions submitted, metaphysically minded at times and usually a realist.'[25] His realism expressed itself, as with his predecessors, in the assumption that the publicity of being represented in his paper should be considered sufficient recompense for the illustrators (and doubtless authors as well). If, in spite of these scarcely advantageous conditions, he could attract a crew of brilliant young artists to his journal in 1887–88, it was because they were seeking precisely this call to public attention. Thus, for those two years there appeared in *La Vie Moderne* drawings by Seurat and his friends Signac, Cross, Luce, van Rysselberghe, Dubois-Pillet, Lucien Pissarro, and Hayet. But at the same time the literary section of the paper showed an unfortunate tendency to specialize in accounts of assassinations, resounding lawsuits, contestations of wills, and other sensational matters. In 1889 half-tone reproductions made from photographs appeared for the first time in *La Vie Moderne*.[26] Art criticism, on the other hand, was suppressed and the contributions of professional illustrators became ever more mediocre. In 1891 there was a sudden change. Although

23

La Vie Moderne continued to favor judiciary accounts, it also offered a warm welcome to the literary Symbolists; for two years the signatures of Laforgue, Moréas, Rimbaud, Verlaine, and Mauclair, Kahn, Morice, Saint-Pol Roux, Mme Rachilde, and others appeared on its pages. Albert Aurier published several art criticisms; so did an author who signed himself 'Francis.' Occasionally drawings by Gauguin and his more or less close associates—Sérusier, Filiger, Bernard, Denis, Ranson, van Gogh, Bonnard, Vuillard, Roussel, and Redon—were published, together with illustrations of no particular value or interest. In 1893 *La Vie Moderne* ceased to appear.

When their common collaboration on *La Vie Moderne* was terminated, the two Renoir brothers seem to have lost their point of contact. Edmond continued with his journalistic career, passing from one paper to another. Auguste slowly climbed toward glory and isolation, soon retiring to the Midi which he had discovered in company with his brother. They now spent long years without seeing each other. As the memories of youth fade into the shadows of the past, as each affirms his own convictions and achieves his own position in life, even family ties are often not strong enough to preserve the intimacy that formerly seemed invincible between old comrades. Henceforth nothing but recollections of days gone by could unite the two brothers. If Edmond did not fail in admiration for his brother, his good will alone could not give him an understanding of the art of Auguste Renoir. Had he not already insisted that Auguste adopt 'un genre defini' so that he would be more readily recognized by the public when his pictures were exhibited? The easy jokes, the abrupt ideas, and slightly superficial conceptions of Edmond Renoir could not suffice to maintain brotherly relations based upon mutual respect. If the painter also cultivated this jeering attitude, he nevertheless knew how to reconcile it with the rich experiences in artistic and human emotions of a life devoted entirely to the creation of beauty. What in one was an agreeably juggled void, in the other can be designated by only one word: genius.

NOTES

1. This account is based not only on what Edmond Renoir told me in Paris in 1939–40, but chiefly on his recollections that were written by him upon my request, which reached me in America in 1943 at a moment when it had become impossible to ask him for clarification of details in certain instances. In these written memoirs he often refers to an article on Auguste Renoir which he published in *La Vie Moderne* in 1879. Wherever the text of this article is more explicit than the more recently written memoirs, I have substituted passages of this text, which is reprinted in *Les Archives de l'Impressionnisme*, edited by Lionello Venturi (Paris, 1939), vol. 2, pp. 334–38.

2. Obviously Edmond was too young at this period to follow the evening courses; this episode relates then to a later date or, if to this time, applies only to his brother.

3. Edmond Renoir still owned this little plate, a saucer, decorated with a copy of the *Bain de Diane* by Boucher, done with all the conscientious application and skill characteristic of the type. It goes without saying that nothing about it betokened the future Renoir.

4. Ambroise Vollard, in his book on Renoir, relates that the painter told him he had to leave the firm because the first experiments in printing on faïence and porcelain had just been made and this new process caused the shop to close. According to Jervis's *Encyclopedia of Ceramics*, however, printing on pottery had been done in Paris at least since 1855, that is, even before Auguste Renoir started to work. Since his brother's version appears in the article of 1879, published doubtless with the painter's consent, it must be considered closer to the facts.

5. See J. Meier-Graefe, *Auguste Renoir* (Paris, 1912), p. 14.

6. Admitted sixty-eighth out of eighty, Renoir passed the Concours of 1863 twentieth out of eighty and that of 1864, tenth out of eighty. See Robert Rey, *La renaissance du sentiment classique dans la peinture française à la fin du XIXe siècle* (Paris, 1931), pp. 45–46.

7. Fantin-Latour himself at that time made numerous copies at the Louvre and frequently met Manet, Degas, and the Morisot sisters who were also copying there and whom Renoir may have met through him.

8. See Gaston Poulain, *Bazille et ses amis* (Paris, 1932), p. 23.

9. See Charles Clément, *Gleyre, étude biographique et critique* (Paris, 1878), p. 175.

10. Elie Faure, 'Renoir,' in *La Revue Hebdomadaire* (Paris), Apr. 17, 1920.

11. See Poulain, *Bazille*, p. 34.

12. At the 1866 Salon he had bought Monet's *Camille*.

13. Renoir's first portrait of Mme Charpentier (the head only), now in the Louvre, had been exhibited with the Impressionists in 1877. Renoir was also to paint several portraits of Mlle Samary.

14. Georges Rivière, *Renoir et ses amis* (Paris, 1921), p. 176.

15. Georges Rivière says about these 'perfectly suitable quarters': 'The editorial office was rather modestly housed in a wineshop on the boulevard des Italiens at the entrance of the passage des Princes; very small premises, poorly lighted but excellently located.' See Georges Rivière, 'Claude Monet aux expositions des Impressionnistes,' in *L'Art Vivant*, Jan. 1, 1927.

16. At this period, Auguste Renoir drew two initial *L*'s for an article by his brother, but they were not used, at least not in *La Vie Moderne*. One of them was drawn on a sheet with the heading of *La Presse* (p. 9).

17. Michel Florisoone, 'Renoir et la famille Charpentier,' *L'Amour de l'Art*, Feb. 1938.

18. There is little doubt that Renoir did the same for the articles of his friend Georges Rivière which appeared in 1877 in the journal *L'Impressionniste*.

19. This article appeared in *La Vie Moderne*, June 19, 1879. See above, note 1.

20. Ambroise Vollard, *En écoutant Cézanne, Degas, Renoir* (Paris, 1938), p. 194.

21. One of the portraits reproduced here was executed in this technique *(3)*.

22. This tale appeared in *La Vie Moderne*, Dec. 1883.

23. For another article on angling by Edmond Renoir, his brother composed an entire page of sketches of anglers. Edmond Renoir showed it to me in an old galley proof, but I have not been able to identify the publication in which this page appeared; it was not, in any case, *La Vie Moderne*. See J. Rewald, *Renoir Drawings* (New York, 1946), fig. 21.

24. Camille Pissarro, *Letters to His Son Lucien* (New York, 1943), p. 55.

25. Gustave Kahn, 'Au temps du pointillisme,' *Mercure de France*, May 1924.

26. The Sept. 14, 1890, issue of *La Vie Moderne* reproduced an article on *photographie instantanée* which Edmond Renoir had just published in *Liberté*.

Degas and his family in New Orleans

To Agnes Mongan

Coat of arms of the
de Gas family

When the Italian-born French banker Auguste-Hyacinthe de Gas[1] married Miss Marie-Célestine Musson of Louisiana in Paris on July 7, 1832, the fate of his descendants became intimately linked with the New World. His father had come from Orléans (whence he fled during the French Revolution to Italy); his wife came from New Orleans.[2] Auguste de Gas was twenty-five years old, his bride only sixteen. She had arrived in France with her father, Germain Musson, who, though of French origin, was born in Port-au-Prince, Haiti, and had settled in 1810 in New Orleans where he had married a Miss Rillieux, a member of one of the most prominent families of the town.[3] His wife had died in 1819 at the age of twenty-five, leaving him with five small children, all of whom he subsequently took to Paris. Although Germain Musson apparently returned to the United States shortly after the marriage of his daughter to M. de Gas, most of his children decided to remain in France. Another daughter, Eugénie, married the Duc de Rochefort; his son Henri settled in Paris; his son Eugène also remained in Europe. Only his eldest son, Michel, went back to New Orleans (see the family tree).

New Orleans was then one of the country's most active and optimistic cities—the fourth largest in the United States—and it was vying with New York for first place as a port. Ever since the first steamboat had come down from the Ohio region in 1812, the city's export of cotton and sugar had expanded without interruption. It was the center both for enterprising merchants and for adventurers and soldiers of fortune, whose interest was turned toward the West as well as toward Mexico and other Latin-American countries. Germain Musson must have combined the qualities of both merchant and adventurer. In 1811 he purchased a site on the city's main

First published in the *Gazette des Beaux-Arts*, August 1946

boulevard, at the corner of Canal and Royal streets. There he erected, in 1833, a large building, the first of its kind in New Orleans to be constructed entirely of Quincy granite. It had occured to him that it might be useful for his ships, carrying cotton to Boston, to bring back some New England granite as ballast. The severe structure built with this ballast was known for many years as 'Musson's Fort.'

Not content with dealing in cotton, Germain Musson also mined silver in Mexico. It was on one of his trips to Mexico to inspect mines that he was killed when his coach overturned.

Michel, Germain Musson's eldest son, inherited not so much his father's spirit of enterprise, as his great tenacity. After his return from France, he set up, in 1834, as a planter and exporter of cotton. Ruined during the great business depression of 1837, he was able within a few years to rise again to considerable wealth. In that most difficult year he must have married Odile Longer, for their first child was born in 1838 and was followed by six others, four of whom died in infancy or before reaching the age of ten. During the 1850s he built himself a large house at Colyseum and Third Street, in the fashionable quarter of the city, where he lived from 1859 to 1869.

Meanwhile, in Europe, his sister had borne five children to Auguste de Gas, with whom she lived in both Paris and Naples. The first, born in Paris in 1834, was named Edgar-Germain-Hilaire—the two latter names in honor of his two grandfathers: Germain after Mr Musson, and Hilaire after René-Hilaire de Gas, banker in Naples.[4] A second son, Achille, was born four years later in Paris *(10)*. A daughter, Thérèse, was born in Naples in 1840, followed in 1842 by a second daughter, Marguerite. The latter was born in Paris, as was a last son, René, in 1845 *(11)*. Two years later their mother died, leaving her children some property in New Orleans. Her eldest son, Edgar, was only thirteen years of age when he lost his mother.

The ties between the de Gas family and the Mussons of New Orleans were kept up through Henri Musson in Paris, who was named tutor to the children of his deceased sister. These ties became closer as a result of the American Civil War. When New Orleans, one of the most important cities of the Confederacy, was taken on May 1, 1862, by General Benjamin Franklin Butler in the name of the Union, most of the citizens of French descent began to think of sending their families to France. The feelings against the conquerors ran high.

'These people are treated with the greatest haughtiness by the upper classes and rudeness by the lower,' noted a New Orleans citizen in her diary. 'Shopkeepers refuse to sell to them. . . . We are compelled to laugh at the frequent amusing accounts we hear of the way in which they are treated by boys, Irish women, and the lower classes generally.'[5] Butler retaliated on May 15 by his famous and infamous decree that if any woman should 'insult or show contempt for any officer or soldier of the United States, she shall be

27

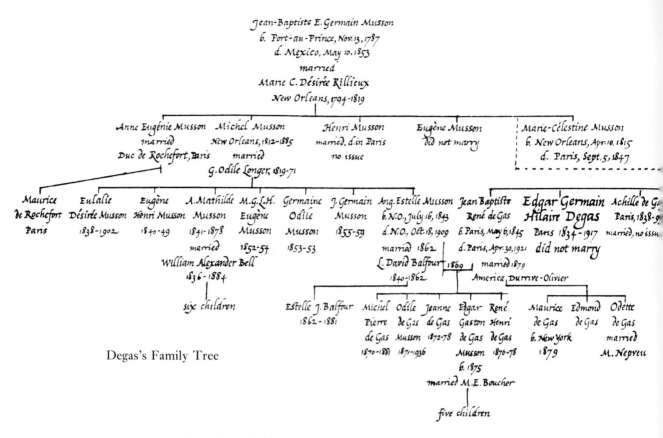

Degas's Family Tree

regarded and shall be liable to be treated as a woman of the town plying her avocation.' This threat produced the flight abroad of all those who could afford to go.

Michel Musson seems to have contemplated doing likewise and sending his wife and three daughters to France. But his daughter Mathilde, who had just married one William Bell, apparently decided to remain in New Orleans. In January of the same year, his daughter Estelle had married, at the age of eighteen, Lazare David Balfour, a captain in the Confederate Army and three years her senior. She, too, may have been reluctant to leave at a time when she could not even communicate with her young husband. In October 1862 Captain Balfour was killed at Corinth, in one of the bloodiest battles of the war. Three weeks after his death a daughter was born to his widow[6] and was christened Estelle Josephine; the family called her Joe. A few months later Estelle Balfour agreed to leave for Europe with her mother and sister Désirée, taking her infant daughter with her.

In Paris, where they arrived in 1863, Mrs Musson and her daughters probably stayed with the de Gas family. Later they accompanied Auguste de Gas and his children to Italy, where they were joined by the Duchesse de Rochefort. A family tradition has it that Edgar Degas, who was then already thirty and had devoted more than ten years to painting, although he had not yet exhibited at the Salon, either in Naples or Florence drew a portrait of his

28

Transcribed after John Rewald by Paul Standard, NewYork Aug.1946

aunt the Duchess, as well as of his cousin Désirée Musson.[7] But it was apparently the latter's sister Estelle, who more deeply impressed her cousins, especially Edgar's brother René, who was two years younger than the attractive widow. When, in the spring of 1865, after the defeat of the Confederacy, the time came for the Musson ladies to return to New Orleans, René decided to accompany them.

Michel Musson affectionately admitted his nephew into his family. 'René lived at my house,' he later said, 'and I had him employed in my firm [John Watt and Co.].' Officially, René came to New Orleans to look after the property left by his mother, which his father and brother Edgar had already tried in vain to liquidate from Paris. To facilitate these efforts, his uncle Michel was appointed his tutor in January 1866. A few months later René returned for a short visit to France.

'With a good education, intelligence, and ambition,' according to his uncle, 'he decided to try his fortune in 1866, to go to Europe to make some business connections. He returned in the autumn of that same year with his brother Achille and they established themselves here under the name of De Gas Brothers.'[8] It may be surprising that René chose to settle in New Orleans immediately after the Civil War, when the city was slow in recovering its former commercial advantages. The years between 1865 and 1877 were actually the bleakest in the history of the town. It was a period of violence,

29

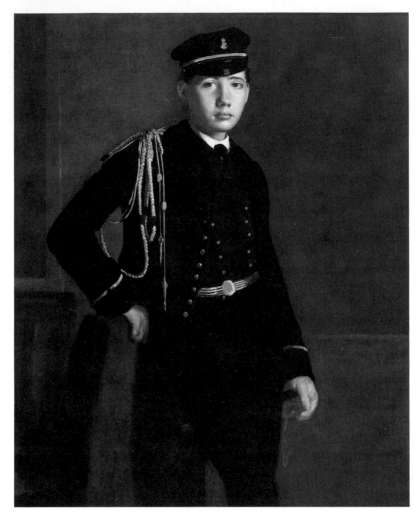

10 Edgar Degas *Portrait of the Artist's Brother Achille in the Uniform of a Cadet c.* 1856

lawlessness, political agitation, and corruption. New Orleans was the stronghold of the 'radical' or 'carpetbag' government of Louisiana and can have offered but few attractions to a young foreigner anxious to lay the foundation for a prosperous future. But then, René de Gas's decision was not dictated by reason alone.

Subsequent events allow the supposition that René, while in Paris, arranged a loan from his father's bank in order to start a business of his own in New Orleans. His desire to establish himself independently was doubtlessly spurred on by his intention to ask his uncle for the hand of Estelle. A dreadful shock awaited him upon his return. In August 1866 Estelle Balfour was stricken with ophthalmia, and in spite of desperate and expensive treatments, she became totally blind. This misfortune, however, did not impede the young lovers. On June 17, 1869, against the opposition of her father and after

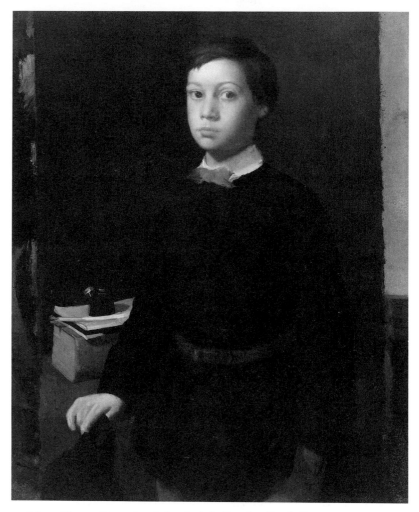

11 Edgar Degas *Portrait of the Artist's Brother René* 1855

obtaining special Episcopal dispensation to marry her first cousin, Estelle became Mme René de Gas. Yet the newlywed couple continued to live with Michel Musson, who, around 1869, rented a huge house at 372 Esplanade, one of the most elegant avenues of New Orleans. Michel Musson's wife died there in 1872. Achille de Gas also lived at the Musson home, as did Musson's daughters Désirée and Mathilde, as well as the latter's husband and children. Although this big family lived rather sumptuously in their large mansion, Michel Musson seems not to have been too well off. The disasters of the Civil War, a succession of crop failures, and the bankruptcy into which the city was driven by its corrupt administration severely affected his finances.

In April 1870 a son, Pierre, was born to René and Estelle de Gas, followed in August 1871 by a daughter. In 1872, when his wife was expecting their third child—her fourth—René sailed back to France, anxious to meet his

family after the terrible French defeat in the Franco-Prussian War and the bitter months of the Commune. In Paris he endeavored to persuade his brother Edgar, who had served in the army and was beginning to complain about eye trouble, to accompany him to Louisiana. Depressed by the situation in France, and possibly also by the proclamation of the Republic, Edgar Degas welcomed the opportunity for a change. In October 1872 the two brothers sailed to New York via Liverpool. The various letters which the painter wrote from New Orleans—and these are longer than his usual letters—show that he appreciated René's traveling experience which smoothed the trip.

The brothers spent ten quiet days at sea and thirty hours in New York. The painter was impressed by the city 'where steamers from Europe arrive like buses at a station,' and where the citizens are 'very familiar with the great expanse of water; they speak of the voyage to Europe as the crossing to the other side.'[9] But he was even more impressed by the American railroads. 'You must have heard about the sleeping cars,' he wrote his friend Désiré Dihau,

'but you haven't seen them; you haven't traveled in them and therefore cannot imagine this marvelous invention. You lie at night in a real bed; the carriage, which is as long as at least two in Europe, is transformed into a dormitory. You even place your boots at the foot of the bed and a nice Negro polishes them while you sleep.

32

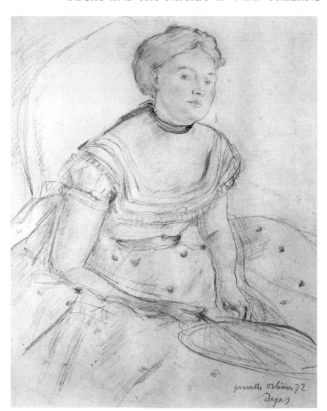

12 (left) Edgar Degas
*Woman Seated near a
Balcony* (Mathilde Bell?)
c. 1872, pastel

13 (right) Edgar Degas
Seated Woman with Fan
(Mathilde Bell?) 1872,
pencil and colored crayon

Sybaritism, you would say? No, it is simple necessity. Otherwise one could not make such trips in one stage. And then, the possibility of moving about in one's car and throughout the whole train, of standing on the platforms is extremely restful and diverting. Everything is practical and is done simply here. . . .'

The trip from New York to New Orleans took them four days.

Originally, the two travelers had had the intention of surprising the entire family with Edgar's arrival, but persistent rumors of a yellow fever epidemic in New Orleans led René to ask Achille by cable whether there might be any danger for a stranger not accustomed to the climate. This inquiry had given away their secret. Everybody came to the station and Edgar was deeply touched to find himself awaited by his brother, his cousins, their six children, and his uncle who 'looked at me from over his spectacles.' He went to live with them in their large mansion.

There were almost too many things for Degas to see, and the multitude of new impressions both stimulated and weighed upon him. 'How many things I have seen, and how many plans they have suggested to my mind!' he wrote to a friend about four weeks after his arrival in New Orleans, and added:

'But already I have cast them aside, I want to see nothing but my corner and dig away obediently. Art doesn't grow wider, it recapitulates. And, if you will have

33

comparisons, I shall tell you that in order to produce good fruit, one must grow espalier fashion. You remain there throughout life, arms outspread, mouth open to take in what passes, what is around you and to live from it. . . . So I am hoarding projects which would require ten lives to put into execution. I shall abandon them in six weeks, without regret, to return to and leave no more *my home*.'

And to another friend he wrote, 'It is better to concentrate oneself, and in order to do so one ought to see little.' It was difficult, however, for Degas, to 'see little' in these new surroundings, which offered so many unusual aspects. If, as he stated in one of his letters from New Orleans, it was true that 'one likes and one makes art only of that to which one is accustomed, the new captivates and bores in turn,' Degas did not spend enough time in the Crescent City to become bored. His letters only reflect his fascination.

'Everything attracts me here,' he wrote again.

'I observe everything. . . .[10] Nothing pleases me so much as the Negresses of every shade, holding little white babies—Oh! so white!—in their arms; Negresses either in white mansions with fluted columns[11] or in orange gardens; ladies in muslin in front of their little houses, steamboats with two funnels as high as factory chimneys; and the fruit dealers with their shops chock-full; and the contrast between the busy, so well-arranged offices and this immense black animal force, etc., etc.—And the pretty purebred women, the charming quadroons and the well-built Negresses!'

In another letter he speaks once more of the

'beautiful and elegant Indian [?] women drawing their green shutters slightly aside, and the old women in their ample Madras peignoirs going to market. . . . The orange gardens and painted houses also appeal to one, as do the children all in white, and so snow-white when cradled in black arms. . . . I observe and admire many things here; I classify their use and the way they can be expressed, mentally. And I shall leave them all without regret.'

Degas felt that it was impossible to paint in Louisiana as he had done in Paris and that a long sojourn would be necessary for him to grasp the true character of this new world. He thought of Manet who, better than he, might have painted beautiful things here. He also remembered Pissarro, who had known somewhat similar surroundings in his native Saint Thomas. Yet he did not remain idle in New Orleans. He even complained that the strong light prevented him from painting on the banks of the Mississippi. Instead, he worked in his uncle's house, surrounded by his cousins and their children. 'I spend my days in the midst of this affectionate world, painting and drawing, doing some family pictures. My poor Estelle, the wife of René, is blind. She endures this in an amazing way; she is seldom helped around the house. She remembers the rooms and the arrangement of the furniture and hardly ever hurts herself. There is no hope.'

Estelle de Gas's fourth child, Jeanne, was born on December 20, 1872, and the painter agreed to be the godfather. Shortly before the birth of the girl,

Degas painted a portrait of the young mother in a white muslin dress, her ample skirts hiding her condition *(1)*. She is seated on a sofa, her hands folded in her lap, her head turned to the left, her empty eyes wide open. But these eyes are by no means without expression, and those who do not know of her affliction may not even be aware that those eyes could not see. There is a happy expression on the face, a strange mixture of mildness and intensity. Since she was a very gifted musician, it seems almost certain that while posing she listened to someone playing, and her face appears to reflect her contentedness with the music and her serene feeling of expectation.

Degas's sister-in-law was extremely patient and he probably had little reason to be dissatisfied with her. But this did not apply to the other members of the family. The painter complained in one of his letters about those 'family portraits which must be done to the family taste, under impossible conditions of light, always disturbed, and with models who, though most affectionate, show little consideration and take you all the less seriously because you are their nephew or cousin.' And he adds, 'I have just failed with a large pastel and experience a certain sense of mortification.' Besides the portrait of Estelle, a few other family portraits done in New Orleans are known *(12, 16, 17)*, especially—though it can hardly be considered as such—the one in which so many of his relatives are represented, namely the painting of his uncle's cotton office *(14)*.

In this work Degas assembled his uncle Michel Musson and the latter's business associates, Prestidge and Livaudais, his own brothers, René and Achille, as well as Mr Musson's other son-in-law, William Bell. Michel Musson sits in the foreground of the painting,[12] testing a sample of cotton from a plantation. Standing at the extreme right, John Livaudais, the cashier, bends over some account books. In the center sits René de Gas, absorbed in the local newspaper, *The Times-Picayune*; behind him, sitting on a high stool, Musson's partner James Prestidge seems to converse with a customer who makes notes in a memorandum book. Seated on a table covered with cotton from various bales, William Bell hands a sample to a buyer across from him who examines the merchandise, both arms resting on the table. At the extreme left, leaning against the dividing wall of the outer office, stands Achille de Gas. The idleness of the latter as well as of his brother might be explained by the fact that they were not in their own office but in that of their uncle, where they seem to have dropped in for a visit.[13]

The working habits of Edgar Degas[14] make it highly improbable that this painting was actually executed in his uncle's office. This seems confirmed by a sketch he made of the cotton-laden table alone, in which the location of the table and the few indications of the room itself differ widely from those in the completed picture. It can be assumed that the artist carefully studied the premises and that he drew portraits of all the persons before he executed the painting in his studio, that is, in his uncle's house.[15] Although he felt free to

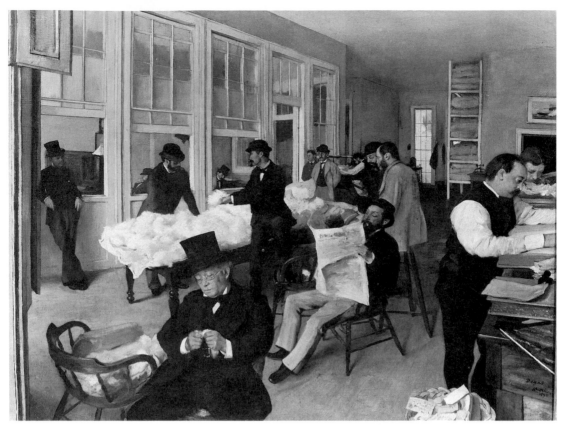

14 Edgar Degas *Portraits in an Office—The Cotton Exchange, New Orleans* 1873

change some features of the office according to his compositional needs, there can be no doubt of the utmost faithfulness in the portraits of the people. A photograph of his uncle *(15)*, taken a few years after the painting was completed, shows the degree of resemblance achieved by the artist. Degas was well pleased with his work and mentioned it in one of his letters, together with another canvas of a similar subject, which seems to have been lost. He even intended to place these two paintings with the dealer Agnew in London, in the hope that the latter might be able to interest some Manchester industrialists in them.[16]

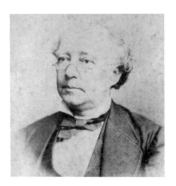

15 Photograph of
Michel Musson *c.* 1876

Degas's complaint about his models may refer to those who sat for this painting, but their lack of consideration did not prevent him from doing still another portrait, of a Mme Challaire,[17] a friend of the family, dated 1872. The same lady seems to have posed for another painting, of a woman arranging flowers, presumably done at the same period *(16)*.

Yet another painting probably executed in New Orleans, or at least begun there and for which the artist drew on his immediate surroundings, was *The Pedicure*, dated 1873 *(17)*. It shows a dark-haired young girl wrapped in a large white bath towel, her right foot, resting on a chair, being attended by an elderly chiropodist; this is one of the earliest of the many works that Degas was to devote to such subjects. The model was in all likelihood Joe Balfour, Estelle Musson Balfour Degas's daughter by her first marriage. Born in 1862, the child was eleven years old when this picture was done.

Lastly, Degas painted in Louisiana a group of children seated on the steps of a front porch leading into a rose garden *(18)*. This canvas may be identical with the one that the artist exhibited in 1876 at the second Impressionist show under the title *Cour d'une Maison (Nouvelle Orléans)*, although this designation does not exactly describe the subject.[18] This canvas was painted

16 Edgar Degas *Woman Arranging Flowers* (Mme Challaire?) *c.* 1872

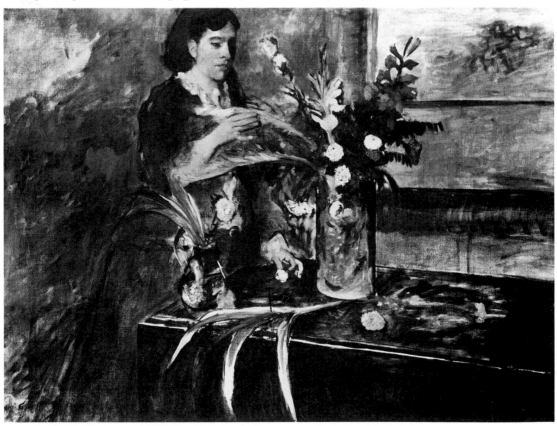

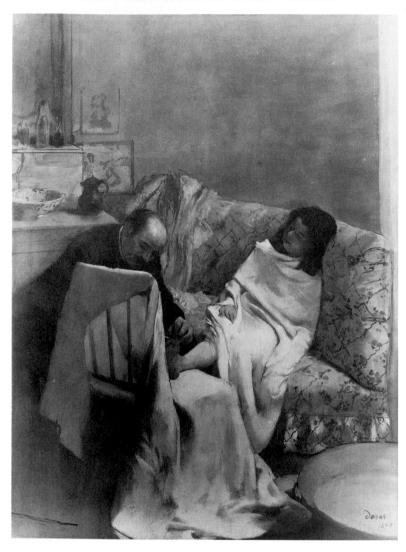

17 Edgar Degas
The Pedicure 1873
(Joe Balfour)

on the Millaudon plantation, located about fifteen miles below New Orleans, which belonged to friends of the Mussons and was often visited by them.[19]

Degas evidently spent all his time in New Orleans with his family. He made excursions to neighborhood plantations with them, went to the theater with them to see a group of actors mostly from Montmartre, and with his blind sister-in-law regretted the lack of opera during that season. Instead, he went to concerts, which he enjoyed only moderately. He read the French newspaper, doubtless *L'Abeille de la Nouvelle Orléans*, which kept him informed of the French national elections, of royalist agitation in France, and of the tribulations of the young Third Republic for which he felt no sympathy. He was amused to see the papers give M. Thiers what he calls 'expert lessons in Republicanism.' But he seems to have paid little attention to the confused political scene of Louisiana itself. None of his letters mention

38

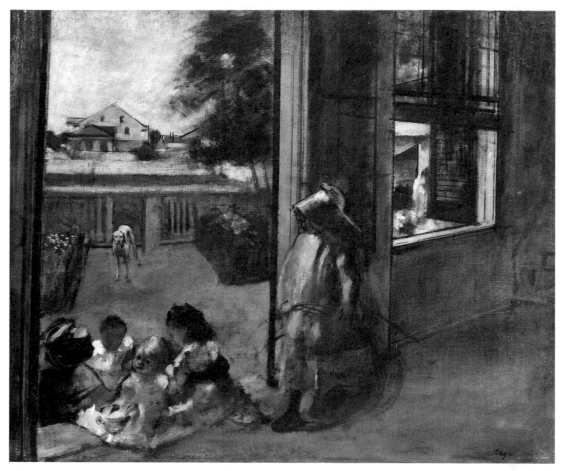

18 Edgar Degas *Children on the Porch of the Millaudon Plantation near New Orleans c.* 1873

that strange state of affairs there, the impeachment trial of the governor during which a Negro governor ruled the state from December 9, 1872, to January 13, 1873, while Degas was in New Orleans. Nor does he speak of the lamentable conditions in the South, of the numerous plantations sold under the tax collector's hammer, of the state debt, which rose to fabulous heights, and of the carpetbaggers. Yet he can hardly have ignored these events. Not only did his uncle suffer considerable losses during those years, but as a prominent citizen, president of the Factors' and Traders' Insurance Company, Michel Musson was named president of the Citizens' League, which was eventually to overthrow the reign of the racketeers. In his letters Degas speaks only of the success achieved by his two brothers. 'They make a good deal of money and, considering their age, hold a unique position here. They are liked and held in highest esteem, a fact of which I am very proud.'[20]

Even more than René de Gas's social position, it was the happy family life that seems to have impressed the painter, so deeply in fact, that he felt

inspired by his brother's example to consider matrimony—at least in his letters. 'It is something really fine to be married, to have nice children, and to be freed of the need for casual affairs. Good heavens, it is time to think about it.' And he informed his friend Rouart: 'I am seized with a mania for order. Even a good woman I do not regard as an enemy of this new existence. And would a few children of my own also be too much? No.' Yet he added: 'The women here are almost all of them pretty, and to the charms of many of them is added that hint of ugliness without which they would not be perfect. But I fear that their heads are as weak as mine, and two such noddles would be a funny sort of guarantee for a new household.'

Degas left New Orleans early in 1873, probably toward the middle of February. If he then abandoned, as he had foreseen, the artistic projects hoarded during his sojourn, he also seems to have given up the idea of getting married. What he did not abandon, however, were the paintings done in New Orleans. Curiously enough, he apparently did not offer any of them to his models. Most of these canvases were to remain in his Paris studio and only came to light at the auctions after the artist's death. It is possible that they were not yet finished when he left New Orleans and that he meant to complete them at home, which may also explain why he did not leave behind whatever preparatory drawings he must have done for the various paintings.

A series of important events was to preoccupy the painter after his return to France. In the fall of 1873 there was the burning of the Paris Opera, which temporarily deprived him of one of his favorite places of study; in February 1874, there was the death of his father in Naples; and shortly afterward, the opening of the Impressionists' first group exhibition on April 15, in the organization of which Degas took a very active part.

The death of his father had decisive and immediate effects on the painter's life. The affairs of the bank were found to be in a deplorable condition. Achille de Gas returned from New Orleans[21] and in Paris, together with his uncle Henri Musson, the former tutor of Auguste de Gas's children, endeavored to settle the numerous claims and save the honor of the name. They soon had to approach René de Gas to ask for the payment of the loan he had once contracted. In a letter dated Paris, December 10, 1875, Henri Musson informed his brother in New Orleans: 'You know from René of the closing down of his father's firm. Named liquidator in friendly capacity, I hope, if I am allowed, to arrange to pay 20% on account and 25% in five years. You must urge René to make honorable arrangements with his family to help them, by remittances three times a year, to fulfill the promises that will be made. He has a large debt. . . . '

Achille de Gas assisted his uncle in his efforts to satisfy the creditors. René paid them a visit in Paris to discuss the situation and on August 31, 1876, Achille wrote to Michel Musson:

'My dear uncle, René, who left us last Saturday, has reached you over there, no doubt in good health. He informed us of the happy outcome of his trip and acquainted us with the good hopes he has for the future of his firm. God grant that things turn out thus and that he at least succeeds in his undertakings. As for us, you know the condition in which our father's firm was placed at the time of his death; only on credit have I been able to support an enormous uncovered balance for two years, but that credit is at last exhausted, the firm's business was nearly at a standstill and we have, so to speak, no more clients. It was at last necessary to call a halt. Fortunately we have been able to avoid a worse catastrophe and to make arrangements on an amicable basis with our creditors. But payments to come in depend in large part, not to say entirely, on the remittances which René will have to make to put an end to his debt to his father's firm. This cannot be done immediately because he has commitments to Mrs Leisy [widow of his associate in New Orleans] and Mr Puech, and is not entirely master of the situation. We are obliged, Edgar, Marguerite [married to the architect Henri-Gabriel Fèvre], and I, to live altogether on a bare subsistence, in order to honor the promises we have made. I am trying to find another business for myself, but you know how slow and difficult that is.'

René de Gas was apparently unable to live up to his obligations because of new reversals in the cotton trade. His brother Edgar and his brother-in-law Fèvre thereupon paid out of their own pockets the various amounts owing, though neither of them was under any legal obligation to do so. Henri Musson wrote to his brother from Paris, 'I see Edgar denying himself everything, living just as cheaply as possible.' And new difficulties continued to appear. Besides the liquidation of his father's establishment, Achille saw himself and his guarantors, Edgar Degas and Fèvre, sued by the Banque d'Anvers for 40,000 francs; they were even threatened with having their furniture sold by the bank, which also threatened to sue René in New Orleans. After a judgment was rendered in the bank's favor in January 1877, Michel Musson was informed by his brother, 'Fèvre and Edgar, cornered by the Banque d'Anvers, pay with the greatest trouble by monthly installments.'

There can be little doubt that Edgar Degas suffered immensely from this situation which endangered the family name and which, for the first time in his life, obliged him to pay close attention to what he spent. He was now forced to earn money by selling his works. In his letters written in 1876–77 he begins to mention the 'troubles of all kinds with which I am burdened'; he complains about the necessity to 'earn my rotten life'; and with an irony tinged with sadness from now on he speaks of his works as his 'wares.' He felt humiliated when he had to request money from his dealer, Durand-Ruel, yet this was repeatedly necessary. He even saw himself hampered in his work and plans. He had to do pastels, which sold more readily, in preference to other things which interested him more. And when, in 1879, he planned with Pissarro, Bracquemond, and Mary Cassatt the publication of a periodical devoted to graphic art, Le Jour et la Nuit, he had to ask Caillebotte to back the project. In spite of the fact that Caillebotte was ready to put up some money,

this publication, which was particularly dear to Degas, never materialized, for, as he informed his associates, 'It is impossible for me, with my living to earn, to devote myself completely to that.'

Though he spoke openly about his necessity to earn a livelihood, Degas was extremely reluctant to reveal the circumstances that had brought this about. He could not, however, prevent his acquaintances from talking about this change in his way of life. But Caillebotte, for instance, in spite of his great admiration for the *artist* Degas, refused to make any allowance for his personal reverses and, early in 1881, wrote to Camille Pissarro: 'Before his financial losses was he really different from what he is today? Ask all who knew him, beginning with yourself. No, this man has gone sour. He doesn't hold the big place that he ought to according to his talent and, although he will never admit it, he bears the whole world a grudge.'[22] Ten years later, George Moore, who had known Degas about 1878, said in his *Confessions and Opinions*, 'It is rumored that he is a man of some private fortune, and a story is in circulation that he sacrificed the greater part of his income to save his brother, who had lost everything by imprudent speculation in American securities.'[23] Degas was so aroused by Moore's public mention of his private affairs that he refused ever to receive him again.

If René de Gas was slow in doing his duty, it may be said in his defense that his burdens were not light. After Jeanne (the painter's godchild), his wife had borne him in 1875 and in 1876, two boys named Gaston-Edgar-Achille and René-Henri. René's difficulties in providing for his large family were further aggravated by complications of an entirely different nature. Suddenly, on April 13, 1878, he departed from New Orleans, leaving behind a few words to explain his action. A divorce was subsequently pronounced in January 1879. This divorce lists only four children belonging to Estelle de Gas. Indeed, one month after being abandoned by her husband, the unhappy woman lost the youngest of her children, René-Henri. Six months later a frightful epidemic of yellow fever carried off Jeanne; and then, in April 1881, her eldest daughter, Josephine Balfour, and her eldest son, Pierre-Michel de Gas, died. Only two children survived, Odile and Gaston-Edgar-Achille de Gas. They were adopted in 1883 by their grandfather Michel Musson, so that they might henceforth bear the name Musson. Their mother resumed her maiden name and again called herself Estelle Musson. On the family tomb in the ancient New Orleans cemetery of Saint-Louis I, the name de Gas appears only for the three young victims of yellow fever: Henri, Jeanne, and Pierre.

After his departure, René de Gas married Mrs Léonce Olivier, née America Durrive, from New Orleans, and appealed to his brother Achille to go to New Orleans and take care of his business. Achille seems to have returned there in 1878 and to have entered the firm of Leisy and Company as a clerk.[24] In April 1879, together with one John Rocchi, he purchased this firm from his brother René and the widow of John Leisy. They continued the

business under the same name, but in September 1881, they dissolved their partnership. John Rocchi, merchant and factor, then remained the sole member of the firm.

According to the City Directory, Achille de Gas stayed in New Orleans until 1883. In the course of some differences between him and his uncle, Michel Musson testified, in February 1882, before the judge of the Civil District Court, 'I am old and partially paralyzed, without employment, poor and recently deprived of the pension which I have been receiving from the New Orleans Insurance Association since 1880, which enabled me to support my family, including my blind daughter, divorced wife of René de Gas.' The previous year, Fall Back, the Balfour plantation, had finally been sold at a heavy loss. There remained nothing of the former splendor, except the large house on the Esplanade, now much too spacious for the pitifully reduced family. Michel Musson died there in 1885. His daughter Estelle and her two children continued for a few years to lead a modest life in the huge mansion.[25]

After Achille's return to France, there seems no longer to have existed the slightest link between the Mussons and the de Gas's. It is said that immediately after René's departure, his father-in-law had discouraged any correspondence by returning unopened his letters addressed to his wife. Michel Musson's rancor apparently extended also to the painter, though Edgar Degas had had no part in the conflicts that divided the uncle and René and Achille.

Achille de Gas died in Paris in 1893. His death came as a blow to the painter. It is not known when Edgar Degas became reconciled with his brother René, except that in 1898 they spent a vacation together. René was then manager for the newspaper *Le Petit Parisien*. When the painter drew up his will, he designated Jean-Baptiste-René Degas residuary legatee. But after his death another will of a later date was found, which annulled the preceding one and indicated simply, apart from the annulment, that his inheritance would go to his natural heirs, who were: 1, Jean-Baptiste-René Degas; and 2, the four Fèvre children (by his sister Marguerite).

Estelle de Gas-Musson died in 1909. Eight years later the painter died. Only René de Gas survived. Of the 12,000,000 francs left by Edgar Degas after the sale of his studio, René inherited 4,388,650. This fortune enabled him to leave the modest lodging he had occupied in the rue Lepic and to move to a large apartment in one of the most fashionable quarters of Paris. When he died in 1921 a great part of his inheritance[26] remained and this became the subject of a bitter fight between his two surviving children—the de Gas-Mussons—in New Orleans, and the three children from his second marriage—the de Gas-Oliviers. Only after a ten-year battle was the money left by Edgar Degas divided equally among all of René's descendants. Thus was closed the last chapter of the history, which—exactly one hundred years before—had linked the de Gas's of Paris and the Mussons of New Orleans.[27]

NOTES

1. A document on the family genealogy, established in 1869, and which Auguste de Gas's son René apparently took to New Orleans, where it was in the possession of his son, relates that the 'de Gas family, de Gast and even de Guast comes from Lower Languedoc and from the town of Bagnols, whose name it carried for several centuries. Its origin goes back a very long time. On Nov. 8, 1670, it was confirmed in its ancient nobility at the diocese of Uzès and on this occasion was listed in the catalogue of noblemen of the Languedoc province. The de Gas family bore the name of Bagnols until about the year 1500, and at this time it took the surname of de Gas, which it used exclusively. It was known from the beginning of the thirteenth century. . . .' The shield of the family de Gas, nobles of Bagnols, of St-Gervais, of St-Marcel, etc. (p. 26), was: 'Ecartelé aux 1 et 4, coupé emmanché d'or et d'azur; aux 2 et 3 d'or, au lion de gueules, la queue entrelacée; sur le tout, coupé d'or et d'azur, l'or chargé d'un aigle naissant de sable et l'azur chargé d'un porc-épic passant d'argent. L'écu timbré d'un casque de chevalier orné de ses lambrequins.' (*Armorial Général de Montpellier*, 1696 fol. 537.) See also Riccardo Raimondi, *Degas e la sua familia in Napoli—1793–1917*, Naples: Arti Grafiche SAV, 1958, pp. 13–15 and pl. I.

But it seems that to obtain this impressive document, a member of the Paris branch of the Degas family simply hired a genealogist (as was the fashion in those days) who produced what was expected of him: a coat of arms and an aristocratic lineage that reached far into the past and authorized the use of the nobiliary particle. It is possible that the painter was aware of this belated and 'spontaneous ennoblement' since, shortly after the war of 1870, he began to consistently sign his works 'Degas.'

The aristocratic pretensions of Degas's relations have been deflated in a new biography recently published: Roy McMullen, *Degas, His Life, Times, and Works* (Boston: Houghton Mifflin), 1984, pp. 7–8.

2. The marriage certificate specifies: Laurent-Pierre-Augustin-Hyacinthe Degas, banker in Naples, residing there, lodged in Paris, rue de la Tour des Dames, born Aug. 19, 1807, son of René-Hilaire Degas, stockbroker, and of Jeanne-Aurore Freppa, both residing in Naples—Marie-Célestine Musson, born Apr. 10, 1815, underage daughter of Jean-Baptiste-Eugène-Germain Musson, former merchant of New Orleans, residing in Paris, No. 4, rue Pigalle, and of Marie-Célestine-Vincent Rillieux, deceased.

3. Since New Orleans was Spanish until 1803, several documents refer to the painter's maternal grandmother as Doña Maria Celeste Rillieux, daughter of Don Vizente Rillieux and Doña Maria Ironquet, wife of Don Juan Baptista Germano Esteban Musson.

4. The painter seems to have disliked his other names and once complained about them to Ambroise Vollard. He called himself Edgar exclusively. Until 1870 he is listed in the Paris Salon catalogues as EDGAR DE GAS; he also signed some paintings and documents this way.

5. See *The Journal of Julia Le Grand, New Orleans, 1862–1863* (Richmond, 1911), pp. 44, 46.

6. From Captain Balfour and from his younger brother, Horace (drowned in the Mississippi in 1868), she inherited a cotton plantation, Fall Back, in Bolivar County, 400 miles from New Orleans. But not until 1877 did Michel Musson, executor of their wills, manage to liquidate their estates. Fall Back was sold in 1881, loaded with mortgages.

7. Degas had already drawn and painted a great many portraits of the various members of his family which show a mastery of line that cannot be detected in these two sketches, one drawn on the reverse side of the other.

8. The New Orleans City Directory of 1868 lists De Gas Brothers, importers of wines and commission merchants, 3½ Carondolet, first floor, rear office. In 1869 their address is

186 Common Street. It remains the same until 1872. Their private address is given as Esplanade, corner Tonti Street, that is, the residence of their uncle Michel Musson. The latter's firm, Michel Musson and Co. (James S. Prestidge and John E. Livaudais), cotton factors and commission merchants, was located at 63 Carondolet.

9. The letters written by Degas from New Orleans to his friends Frölich, Rouart, and Dihau have been published in the second edition of Degas's letters (Paris, 1946), edited by Marcel Guérin, who kindly communicated another, still unpublished, letter to James Tissot.

10. As a matter of fact, Degas even paid attention to the new streetcars and informed his friend the engineer Rouart that 'A man called Lamm has invented an engine, said to be rather ingenious, which moves by means of steam with which it supplies the streetcars of the upper town. There was a lot of talk about the tramways in Paris; I shall bring you a description of this contraption.' (The

illustration is reproduced from Dr Lamm's patent.) Degas to Th. Rouart, New Orleans, Dec. 5, 1872; see *Degas Letters*, ed. M. Guérin (Oxford, 1947), p. 28.

11. A typical house of this kind – though its columns are not fluted – the residence of the Spanish consul, was right opposite the Musson mansion.

12. The building 63 Carondolet still stood in 1945, but the premises had been completely altered.

13. In 1872 the offices of De Gas Brothers were at 186 Common Street; Achille lived at 87 Royal Street, René lived with his father-in-law. In 1873 the brothers moved their office to 3 Carondolet. In 1874 they separated; René's office was at 2 Carondolet.

14. See below, 'The Realism of Degas,' pp. 47–55.

15. However, not even one such preparatory drawing is known.

16. Nothing seems to have come of this. The painting was exhibited in 1876 as *Portraits dans un Bureau (Nouvelle Orléans)* at the second Impressionist show and was bought in 1878 by the museum in Pau.

17. This portrait has always been considered as representing Estelle de Gas and is catalogued as such in the Louvre collections. I owe the identification of the model to Mr Gaston Musson, son of René and Estelle de Gas.

18. The fact that this painting does not seem to be finished makes it even more unlikely that it is identical with the *Cour d'une Maison* exhibited in 1876. The latter may be lost.

19. Information by courtesy of Mr Gaston Musson. To judge from the age of the children, the baby in front may have been René's daughter Odile, the boy behind her, his son Pierre, the girl seated at right his niece Caroline Bell (there exists a separate study of this child), and the girl standing, his stepdaughter, Josephine Balfour.

20. It seems not without interest to note that, according to Meier-Graefe, the Reinharts of Winterthur, ancestors of the famous collectors, were agents for De Gas Brothers in Switzerland.

21. The City Directory of New Orleans does not list Achille de Gas from 1874 to 1878, while René stayed with John Leisy, with whom he associated himself in 1875 under the firm name of Leisy and Company.

22. G. Caillebotte to C. Pissarro, Jan. 24, 1881; see J. Rewald, *History of Impressionism* (New York, 1973), p. 448.

23. G. Moore, *Confessions and Opinions* (New York, 1891), p. 510.

24. The City Directory lists René de Gas (Leisy and Co.), 43 Baronne Street, for the years 1879 and 1880, although he was no longer in New Orleans. Achille, who had not been listed since 1873, appears again in the Directory in 1879 as clerk at Leisy and Co. He is listed as such for the two following years, 1880 and 1881, with his private residence at 22 South Rampart. He appears under this address, but without any in-

dication of a business connection, for the years 1882 and 1883. After 1883 neither of the two brothers is listed as residing in New Orleans.

25. The house has since been divided into three entirely separate residences. Of these, only the central one bears some resemblance to the building of which it was originally a part.

26. He left a number of Degas's early sketchbooks to the Cabinet des Estampes of the Bibliothèque Nationale, Paris.

27. I am indebted to the late Gaston Musson of New Orleans, then the only surviving child of René and Estelle de Gas, for the extremely kind help he offered me in assembling the material for this article and for the patience with which he checked dates and facts. In New Orleans I also received generous assistance from Maître André Lafargue; Miss Josie Cerf, secretary of the Louisiana State Museum Library; Mr Stanley C. Arthur, director of the Louisiana State Museum; from the clerks of the Civil District Court, where I was able to retrieve many family papers; and from Mr Arthur Feitel, acting director of the Isaac Delgado Museum. I am also grateful to Miss Agnes Mongan, Keeper of Drawings, Fogg Art Museum, for many suggestions. The late Marcel Guérin in Paris, editor of *Les Lettres de Degas*, offered me invaluable help in connection with photographs, documents, and important information.

This article was originally published in August 1946, before the Lemoisne catalogue of Degas's oeuvre appeared (P. A. Lemoisne, *Degas et son oeuvre* [Paris, 1946]). Lemoisne, as well as Jean Sutherland Boggs in her excellent book on the artist's portraits, do not always agree with the identifications of Degas's sitters as reported here on the basis of information obtained from Gaston Musson (whose sister had been Lemoisne's source in a number of instances). All the information that I obtained in personal meetings and in letters from Mr Musson and which I was able to check subsequently with court records and other sources of which he himself had no knowledge turned out to be perfectly correct. I therefore see no reason to doubt the various facts with which he was kind enough to provide me, although he may well have erred concerning the identity of some of the relatives and friends of the family who had sat in New Orleans for his uncle Edgar Degas. Yet I have not wanted to make any changes in this study, written almost forty years ago, which had been read and approved by Mr Musson before its publication.

In 1965 this study was reprinted in an exhibition catalogue, *Edgar Degas—His Family and Friends in New Orleans*, Isaac Delgado Museum of Art, New Orleans, May 2–June 16, 1965. It appeared there with two other essays: James B. Byrnes, 'Degas, His Paintings of New Orleanians Here and Abroad'; and Jean Sutherland Boggs, 'Degas, The Painter in New Orleans.' These essays contain further and valuable material on the subject.

The Realism of Degas

To Marianne Feilchenfeldt

Whenever they quarreled, which happened more or less frequently, Manet seems to have reproached Degas for painting historical scenes at a time when he himself was already studying contemporary life; and for Manet the epithet 'peintre d'histoire' was the worst insult he could think of. Degas invariably replied that he was proud to have painted horse races long before his friend discovered this subject. Degas could hardly deny, however, that when he met Manet around 1862 he was painting historical compositions which in their themes, though not in their conception, were closely linked to those done at the Ecole des Beaux-Arts. If it had taken Degas longer than any of his friends to detach himself from the Ingres tradition, the reason was simply that he had deliberately absorbed the master's principles and was more conscious than the others of the possibility of harmonizing these principles with a realistic approach to contemporary life.

Indeed, as early as 1859 Degas had traced for himself a program devoted exclusively to the life of his own times. 'Do expressive heads (in the academic style), a study of modern feeling,' he wrote in his notebook. 'Do every kind of object in use, placed, associated in such a way that they take on the life of the man or woman, corsets that have just been removed, for instance, and that retain, as it were, the shape of the body, etc.'

Such a corset may actually be found in Degas's *Interior* in the McIlhenny collection, painted around 1875, and an abandoned glove is represented in the *Portrait of Mme Hertel*, dated 1865, in the Metropolitan Museum, New York.

Whereas Ingres, preoccupied with his style, told his sitters how he wanted them to pose, Degas was more interested in doing, as he said, 'portraits of people in familiar and typical attitudes, above all in giving to their faces the same choice of expression as one gives to their bodies.' Seeing only the pictorial and never the political possibilities of a subject as Courbet had occasionally done, Degas endeavored to approach the world around him with the eye of a curious but impassive observer. His realism was based not on a social program but on the urge and determination to record some of the most

First published in *Magazine of Art*, January 1946. This article appeared without notes

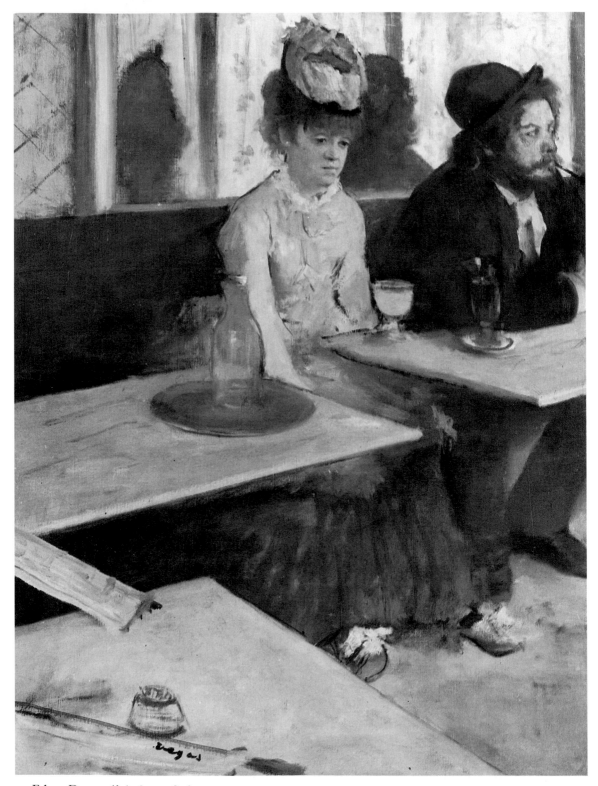

19 Edgar Degas *Absinthe c.* 1876

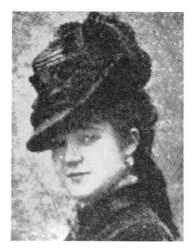 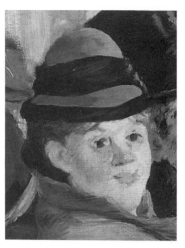 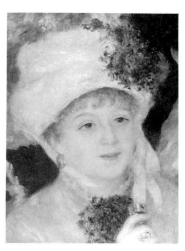

20 Photograph of Ellen Andrée 21 Edouard Manet *At the Café* 22 Auguste Renoir *Luncheon*
 (detail) 1878 (detail) 1878

characteristic traits of individual models, as well as the more general ones of his time.

The way in which he proceeded is strikingly illustrated by his famous painting *Absinthe (19)*, posed for at the Café de la Nouvelle Athènes by his friends the engraver Desboutin and Mlle Ellen Andrée *(20–22)*, a much appreciated model at the time and later a stage celebrity after joining Antoine's theatrical company. Degas indeed tried to give her body the same expression as her face, yet he seems to have gone beyond her individual features by insisting on a particular attitude to such a degree as to create an image of a certain Parisian type rather than a portrait of the young woman. Renoir and Manet, who painted the same actress, offer quite different likenesses of her, so different in fact, that it is difficult to recognize the same person in the three paintings. Manet was obviously more interested in the opposition of lights and shadows in the background atmosphere of the café in which Mlle Andrée appeared, than in a psychological approach. In Renoir's painting it is the lady herself who is 'glamorized,' if this word may be used, just as are all the women he painted. Those who knew his models usually agreed that Renoir represented them, in the words of one contemporary critic, 'as if the painter had seen them not in this world . . . but in some cheerful elysium of light and color adapted to their merry and kindly genius.' Degas cared little for this 'genius'; he wanted, as he had said, to do 'expressive heads' and must have chosen Mlle Andrée with the intention of developing the expression of an absinthe drinker.

The painting was to raise animated controversies. Walter Crane called it a 'study of human degradation,' and George Moore saw in it a 'lesson' against alcoholism. Although Moore later repented for having introduced moral

49

considerations into his art appreciation, he could not help describing the woman painted by Degas as some alcohol addict of the French lower classes. The actress was neither. She later insisted that the glass of absinthe was actually the drink of her neighbor, Desboutin.

Degas held with Delacroix that nature was a dictionary in which one finds only words, the elements that make phrases and stories. Realism meant to him not so much the faithful representation of an individual model or object, but the ability to perceive and to render some typical aspects of his time. Beyond the individual, he knew how to discover social, professional, or human types. But in exploring these exclusively for their pictorial possibilities, he escaped the danger of creating merely historical documents.

Degas frequently acknowledged that he had been deeply interested and stimulated by the novel *Manette Salomon* which the Goncourt brothers published in 1866, when Degas was thirty-two years old. The central figures of this book are artists, and one of them expresses in a long soliloquy what may be considered the authors' own credo, a credo to which Degas wholeheartedly subscribed:

'All ages carry within themselves a beauty of some kind or other, more or less close to earth, capable of being grasped and exploited. . . . It is a question of excavation. . . . It is possible that the Beauty of today may be covered, buried, concentrated. . . . To find it, there is perhaps need of analysis, a magnifying glass, nearsighted vision, new psychological processes. . . . The question of what is modern is considered exhausted, because there was that caricature of truth in our time, something to stun the bourgeois: realism! . . . Because one gentleman created a religion out of the stupidly ugly, of the vulgar ill-assembled and without selection, of the modern . . . but common, without character, without expression, lacking what is the beauty and the life of the ugly in nature and in art: style! The feeling, the intuition for the contemporary, for the scene that rubs shoulders with you, for the present in which you sense the trembling of your emotions and something of yourself . . . everything is there for the artist. . . . The nineteenth century not produce a painter!—But that is inconceivable. . . . A century that has endured so much, the great century of scientific restlessness and anxiety for the truth. . . . There must be found a line that would precisely render life, embrace from close at hand the individual, the particular, a living, human, inward line in which there would be something of a modeling by Houdon, a preliminary pastel sketch by La Tour, a stroke by Gavarni. . . . A drawing truer than all drawings . . . a drawing . . . more human.'

Degas's 'intuition for the contemporary,' his desire to achieve that line which would 'precisely render life' had led him to search almost systematically for new angles and aspects. In his early notebooks he had already jotted down, 'Never yet have monuments or houses been done from below, from close to, as one sees them when passing by in the street.' And he had set up a whole list of various series in which he might study contemporary subjects: a series on musicians with their different instruments; another on bakeries seen from a

variety of angles, with still lifes of all kinds of bread and tarts; a series on smoke—smoke of cigarettes, locomotives, chimneys, steamboats, and so on; a series on mourners and undertakers in various kinds of black veils, gloves; still' other subjects, such as dancers, their naked legs only, observed in action, or the hands of their hairdressers; and endless impressions—cafés at night with the 'different values of the lamps reflected in the mirrors.'

Degas even visualized a new approach such as only the movie camera has been able to realize fully. According to his notes, he intended to draw the profile of an immobile model or object while he turned around it, ascending or descending. Or else, he imagined his subject as reflected in a mirror, studying it while giving different inclinations or positions to the mirror. He also thought of placing himself close to his model and beneath it, so that its head would appear against the crystals of a suspended chandelier.

Degas was never to treat many of the subjects listed in his notebooks, others were to play a dominant role in his work throughout his life; but, as he soon found out, more important than a great variety of subjects were the spirit, the inventiveness, and the skill with which they were approached and exploited. 'I want to see nothing but my corner and dig away obediently,' he wrote in 1873. 'Art doesn't grow wider, it recapitulates.' Curiously enough, the more original Degas was in his conception and composition, in what has been called the 'mental side of painting,' the less he seemed preoccupied with initiating new techniques or color schemes. Quite the opposite, he strove to remain within the path of tradition as far as execution goes and thus succeeded in giving even to the extraordinary a natural appearance.

Roaming behind the scenes of the Paris Opera, Degas discovered a great variety of new subjects which, seen from different angles, offered unusual aspects and lent themselves admirably to the kind of pictorial exploration of which he dreamed. He paid frequent visits to the classes where the ballet master trained groups of young girls, the so-called little *rats*, for their difficult and graceful task. Here he found what interested him most: movement, not free and spontaneous, but studied and precise exercise, bodies submitted to a rigorous discipline, gestures dictated by an inescapable law, as were the movements of the horses he liked to observe at the races.

'You need natural life,' Degas used to say to his Impressionist friends, 'I, artificial life.' Yet the difference between him and the others, in whose group shows he participated, was not entirely defined by this statement. He apparently considered their approach to nature too passive and disapproved of their complete fidelity to a chosen motif. Their principle of not omitting or changing anything, their sole preoccupation with their immediate sensations, made them, in his eyes, slaves of the chance circumstances of nature and light. Degas, on the contrary, in working from memory was able to concentrate on the essential and to discard unnecessary details. He could thus achieve greater realism by insisting on the dominant character of his subjects or by stressing a

23 Edgar Degas *The Rehearsal c.* 1873. Note, in contrast to fig. 24, the stairwell and columns

specific aspect. He was the master of his inspiration. He felt free to modify the features of his subjects according to compositional need. The series of paintings of the *foyer de danse* at the Paris Opera bears ample evidence of his procedure.

In the early seventies Degas painted numerous canvases of ballet classes, either at the Opera or, after this burned down in the fall of 1872, at the temporary quarters where the corps de ballet studied until the new building by Charles Garnier was opened. It is difficult to say whether his paintings represent the foyer of the old Opera, rue Le Peletier, as is generally assumed, or the provisional premises; whichever they depict, it is obvious that Degas took great liberties in representing them *(II, III)*. In frequent instances he painted variants of the same subject, and these variants not only represent the dancers in more or less different attitudes, they also show noticeable changes in the foyer itself. A comparison of such versions reveals that he actually imagined for each canvas a particular setting, no doubt very close to the real *foyer*, yet containing a host of details invented, transformed, or eliminated for the occasion *(25, 26)*. Degas took the same liberties with the actual subjects he represented. In a letter to a friend (which, unfortunately, is not dated), asking

52

for a pass to see the dance examinations at the Opera, Degas confesses, 'I have painted so many dance examinations without having seen any that I feel a little ashamed.'

In the same way in which he followed the races, registering in his memory every position of the horses so as to be able to paint them in his studio, he took only occasional notes at the dancing classes, relying on his memory for the works he planned. Many of his sketches were done apparently without any intention of using them for a specific work. If they happened to be suitable for some composition, he might still have a model pose in a corresponding arabesque and observe her movements. He used to say, however, that the best way to work from a model was to study her on the ground floor and then to rush up to the attic, where the actual drawing ought to be executed. Undisturbed by the particular features of the model, he could thus focus his attention on the elements that especially interested him. Degas's realism consisted in the expert mixing of acute observation, details stored in his memory, and a certain degree of imagination. Only in later years, when his

24 Edgar Degas *The Rehearsal c.* 1873

25 Edgar Degas *The Dance Class* c. 1874. Note, in contrast to fig. 26, the diagonal floorboards and the richly architectural doorway, ceiling moldings, and marble pilasters

eyesight began to weaken, does he seem to have worked directly from the model.

Whereas his Impressionist friends insisted with daily growing emphasis that they could represent what they saw only by studying the subject while they worked, Degas adopted the opposite principle. Throwing off the 'beautiful joke of nature,' he endeavored to observe without actually painting and to paint without observing. The paintings of the *foyer de danse* which he did in this fashion deeply impressed no other than the surviving of the two authors of *Manette Salomon* himself. Indeed, Edmond de Goncourt seems to have been among the very first to recognize the true character of Degas's effort. After visiting the painter at his studio in 1874, Goncourt noted on February 13 in his journal:

'Yesterday I spent the afternoon in the studio of a painter named Degas. After many attempts, many bearings taken in every direction, he has fallen in love with the modern and, in the modern, he has cast his choice upon laundresses and dancers. I cannot find his choice bad, since I, in *Manette Salomon*, have spoken of these two professions as ones that provide for a modern artist the most picturesque models of women in this time. . . . And Degas places before our eyes laundresses and

54

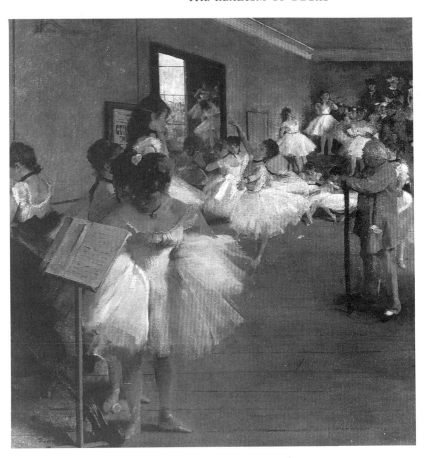

26 Edgar Degas *The Dance Class c.* 1874. Here the floorboards are horizontal, the walls and moldings are simple, and a mirror takes the place of the elaborately ornamented doorway

laundresses, while speaking their language and explaining to us technically the downward pressing and the circular strokes of the iron, etc., etc. Next, dancers file by. It is the hallway of the dancing school where, against the light of a window, are fantastically silhouetted dancers' legs coming down a little staircase, with the brilliant spot of red in a tartan in the midst of all those white, ballooning clouds, with the vulgar contrast of a hideous ballet master. And right before us, seized upon the spot, is the graceful twisting of movements and gestures of the little monkey-girls.— The painter shows you his pictures, from time to time adding as comment his explanation by mimicking a choreographic development, by imitating, in the language of the dancers, one of their arabesques—and it is really very amusing to see him, his arms curved, mixing with the dancing master's aesthetics the aesthetics of the artist. . . . He is the man I have seen up to now who has best seized, in reproducing modern life, the soul of this life.'

27 Photograph of Achille Emperaire

Achille Emperaire and Cézanne

To Raphaël Chiapetta

They formed a small, lively, and boisterous group, the friends who gathered at Aix around young Cézanne. Their appearance, their insolent sureness of themselves, their flaunted disdain of everything conventional, visibly displeased the peaceful bourgeois of the small quiet city. If Cézanne, by his manners, his careless attire, and his purposely loose language placed himself at the head of his comrades, his friend Achille Emperaire couldn't pass unnoticed either. His large head—his gentle gaze, the high forehead surrounded by still abundant hair, with a heavy mustache and a pointed goatee—was supported by the body of a dwarf, a thick-set torso with long and thin extremities, which gave the poor man an eccentric, not to say grotesque, appearance.

Nearly all the friends of the group painted more or less seriously. It is even possible that among the early works attributed to Cézanne are some executed under his eyes by various comrades, above all, A. F. Marion,[1] Justin Gabet, and Achille Emperaire; there were also the historian Numa Coste, Joseph Huot, an architect, the sculptor Philippe Solari, Chaillan, and others.[2] Often they posed for Cézanne, whose favorite models seem to have been the poet Valabrègue and Achille Emperaire. Cézanne made of the latter, notably, a famous full-length portrait, more than six feet high. It shows a dwarf whose musketeer's head dominates a fragile body with spindly limbs *(VI)*. This strange personage, dressed in an intensely blue flannel robe that opens above the knees to show long, purple drawers and red slippers, is seated in a huge, upholstered armchair with a flowered slipcover; some even suspected that he was enthroned on a *chaise-percée*. It took audacity to submit such an outrageously unconventional work to the Salon jury, but that is what Cézanne chose to do in 1870, obviously prepared to see his provocative, not to say preposterous likeness of his friend rejected by the jury, which promptly did just that.

Born in Aix in 1829, Achille Emperaire was ten years older than Cézanne. While most of their friends, once the enthusiasm of youth had dulled, were to

First published in French in *L'Amour de l'Art*, May 1938

abandon their paintbrushes, remaining at best Sunday painters, Emperaire, in spite of enormous difficulties, pursued an artistic career. Forced to struggle all his life for survival, he found himself hindered from developing freely and from fully realizing his potential.

Very little is known about Emperaire's life; he numbered for a while in Paris among the students of Couture, whose influence is revealed in certain of his paintings *(28)*. After he returned to Aix, he went back to Paris several times, subsisting on some fifteen francs a month, sometimes supporting himself by copying pictures in the Louvre. Only three letters that Cézanne sent him have survived; they date from the first weeks of 1872, prior to Emperaire's arrival in Paris, sometime around the middle of February 1872. There are also strange reports of this stay which lasted until June 1873 in a group of letters Emperaire addressed to friends in Aix.

Though Cézanne offered to put up his friend, his own position was rather precarious. He was living in Paris with Hortense Fiquet who, on January 4, 1872, had borne him a son. Whereas the painter seems to have kept his mother informed of these developments, he carefully hid his liaison from his father who was in the habit of opening all mail addressed to any member of his family. This meant not only that the artist had to subsist on his bachelor's allowance while supporting Hortense and the baby, but also that he could not even discuss his situation with his mother. It was then that he asked

28 Thomas Couture *Harlequin and Pierrot*

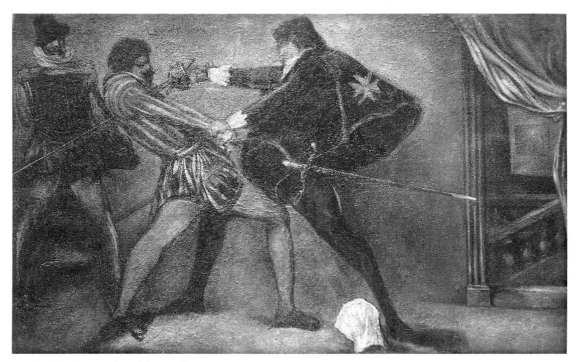

29 Achille Emperaire *The Duel*

Emperaire to act as a go-between. Early in January he thus wrote to his friend (possibly enclosing the news of the birth of his son):

'My dear Achille, I would like to ask you to transmit the enclosed letter to my mother. Please forgive me for bothering you so frequently. It would be a great pleasure for me to hear from you. Please address your letter to Monsieur Paul Cézanne, [Paris] 45, rue de Jussieu, or to Cézanne, c/o Monsieur Zola, 14, rue de la Condamine. . . . Should you need some tubes of paint I could send them to you.'

When Emperaire requested that Cézanne try to obtain a free passage to Paris for him, the latter replied on January 26, 1872:

'I have just seen Zola. . . . He still needs four or five days before he can give a definite answer. He has already tried hard to get a pass, but has not yet succeeded. . . . Please be patient for a few more days. . . . I need not tell you that I would be very happy to see you. You will be somewhat cramped at my house, but I gladly offer to share my modest quarters with you.

'When you are about to leave Marseilles, please be good enough to write to me briefly and tell me the time of your departure and the approximate time of your arrival. I shall then come along with a wheelbarrow and transport your luggage to my house. I live in what used to be rue Saint-Victor, now rue de Jussieu, opposite the wine market, on the second floor. . . . If, as I expect, you have a great load of luggage, take only the necessary and send the rest via freight. I must, however, ask you to bring bed linen, as I cannot lend you any.'

59

On February 5, 1872, Cézanne finally had to inform Emperaire that neither he nor Zola had been able to obtain the requested favor, adding: 'Should you be able to undertake the journey at your own expense, do so. You can stay with me.' After repeated apologies for his unsuccessful attempts, Cézanne concluded: 'Please believe me that, in spite of this failure, I am your devoted friend, who does not wish anything better than to be somewhere else but in the mess in which he actually finds himself, and which prevents him from being of any help to you.' And as a postscript Cézanne added: 'I have had some damned trouble about which I'll tell you.'[3]

Somehow Emperaire managed to scrape together the money needed for the trip; on February 19 he was able to inform friends in Aix that he had arrived in Paris. 'Paul was at the station. I went to his house in order to have some rest and then spent the night with a friend who is a sculptor.' But four weeks later, on March 17, he reported: 'Paul is not very well set up; also there is a noise which could awaken the dead. As I couldn't help myself, I accepted [his hospitality], but even if he offered me a kingdom, I would not stay with him.' Later that same month, Emperaire announced: 'I have left Cézanne.—It was unavoidable.—In this respect I could not escape from the fate of others.—I found him abandoned by all.—He no longer has a single intelligent or affectionate friend. Zola, Solari, and all the others are no longer mentioned. He is the most astonishing product one can imagine.' Yet Achille was obliged to return every day to the rue de Jussieu, for it was there that he had to await the jury's answer concerning his entry to the Salon.

After having left Cézanne, this entry to the Salon became Emperaire's sole preoccupation in Paris. He had had the surprising idea to show his works to the venerated Victor Hugo. Here is how he informed his friends of the decision:

'I am going to see the great Victor to submit my portfolio and to ask him to select two subjects for the Salon. . . .

'The sight of the giant does not frighten me—and I go to him with a moist eye and a firm step.

'Hugo!

'I shall thus have seen to the bottom of everything. . . .'

It is not known whether Emperaire was able to accomplish this maneuver; in any case, there are no further references to it in his letters. Besides, his entry was refused by the jury. But he soon met a poet, Raoul Lafagette, of whom George Sand had said: 'What he does is often bad, sometimes very beautiful, rarely mediocre.' Emperaire made friends with the young poet who was in communication with the 'great Victor,' and owned some of his books with dedications. With great emotion Achille related to his friends how Lafagette had made a 'bold and frank review' of a passage of the *Travailleurs de la Mer* 'which not only was accepted but received full credit from the author.' And he copied the beautiful letter that Hugo had addressed to his friend:

30 Achille Emperaire *Still-Life*

Hauteville House, 8 Sept. 72

Your article, my dear and worthy poet, carries the imprint of your noble spirit. It is a lofty and beautiful page. You do well to point out your disagreements with me.—No one, however, would be more worthy than you to have and to express the sentiment of the infinite. Monsieur Proudhon called that mysticism,—but he was a narrow soul and you are, you, a great heart: he was a rhetorician and you are a poet.

I shall support you with all my heart with Charles Blanc, if you believe that I can be of assistance.

I remain your friend.
Victor Hugo

Whereas Hugo had been able to intervene, and with success it seems, on behalf of his young colleague, Achille Emperaire remained without support, a provincial lost in Paris where he spent painful months. All his letters, covered with a fine and tight handwriting, but very legible and a little feminine, are evidence of his distress. One of these letters deserves quoting; its strange, obscure, and stilted style seems to depict the author rather well, and it contains, moreover, an altogether astonishing passage concerning Paul Cézanne, 'son of the banker.'

61

'Mine is really a sad sojourn; in this country one can only covet in ignorance. It is simply a misleading mirage. . . . In addition to the disgrace with which it burdens the most worthy, since still today, and even more than ever, the place is for the nonentities and the vile ones, I have to hold against it for having deprived me of the last anchor of salvation to which it seemed that I was able to attach myself, when for a moment I trusted friends and things. But since I started out on this sea of whose reefs I am well aware but which is always turbulent, I am anxious to finish with a situation difficult to describe.—And to say good-bye to this exile of superhuman struggle and of constant sadness.—Besides, I have attempted the impossible and am no stronger than the strongest.—Excepting instinct (it was necessary to lean on something) you would have a madman before you.—It is this stoicism which causes their admiration.—They do not appear to comprehend that only when one does not have anything to learn anymore is it possible to confront everything. . . . Most of them are interesting from the point of view of organization, but all of them, they have some support.—None of them, except this poor Solari, is strictly obliged to worry about tomorrow. If they do not manage, it is for lack of order, but they will never say that it was necessary to give in to unrest and insomnia and to neglect the cult [of the beautiful].—When I think about this phenomenon of helplessness in which I have seen the recompense and the prize of my desperate struggle for so long, I have almost criminal tendencies.—There is so much to say on this unqualifiable subject, true monster if ever there were one (in the scientific meaning of the word) that I have always postponed the question.—For finally one often asks oneself what is or could well be the person some of whose actions you have seen which don't resemble anything, no, nothing like what was presented to my stupefaction after twenty-four hours of being with him.—It is because there were, for us at least, two beings under this cover and the son of the banker had nothing in common with the inhabitant of the rue de Jussieu. No, nothing to compare with such dissonance. Here, however, although I do not have the intention of going further, I must confess that I was on guard when confronting this rough indecisive nature, disturbed without reason.— No! God is my witness, that I had seized up my man.—There is in such a case, that is to say when it is a question of a subject of this category, a rule of conduct free of any deception.—One says, and this is indisputable, the man is in the work—or the work is the man, and I clearly regret to have sometimes refused to see the lout and the boor in the one who—yielding to some transient movements of logic and good faith— revealed to the one who assuredly has had the most to suffer and to regret his approach, some instincts in complete opposition to his own.—But I was obliged to forget the present and to think of the future.—Without being guilty of anything but infinite misery, I often considered as a powerful auxiliary in this I shall almost say kind of scoundrel (if you forgive the word), when I thought about a last effort in Paris. But deception of deceptions! nothing is comparable to the change which struck me and the consequences that followed. Not only did I see nothing come toward me, but I have had to do terribly to hold up the mass which threatened to crush me.—One day, if God be willing (to use the old saying) we shall discuss all that there is to tell about this matter. For today so be it.'

Before leaving Paris for Aix, Emperaire was to experience one last disappointment, which he described in a letter of June 1873: 'Apart from all

31 Achille Emperaire *House in front of Mont Ste-Victoire* Drawing

other sorrow, I am more than ever furious not to have at my disposal the big crate which you know. I wasn't present when my luggage was delivered to rue de Jussieu and my noble host decided to destroy it. Owing to this fortunate circumstance, I am now faced with even more expenses.'

But the coldness that Parisian life had established between Cézanne and Emperaire eventually melted under the sun of Provence. Happy to meet later in Aix, the two friends once again became closely linked. The 'son of the banker' in 1878 even intervened with Zola, this time to obtain for Achille 'a job as slight as it may be,' for the latter found himself in a most painful situation. A few years hence Emperaire would become in Paris a financial administrator for the Société des Artistes Français.

According to what the *Encyclopédie Départementale des Bouches-du-Rhône* says of him,

'Emperaire, comprehensive artist, reasoned better about art than he executed it. His exalted admiration of Titian became a source of his impotence. He produced little. During many years there remained on his easel a "scene of a duel" [*29*], of

extravagant romanticism and a female nude whose pelvis filled the whole canvas. . . . We still remember him as a man of small stature, a little hunchbacked, with a head of a musketeer of Louis XIII, his saffron-dyed moustache, and who went through life with a cane or an umbrella placed under his overcoat, from behind, in the fashion of a sword.'

Some forty years after his death Achille Emperaire was still remembered in Aix as a poor devil who sold pornographic pictures to the university students. If he were really obliged to earn his living in such a manner, there can be no doubt that he did this debasing work to be better able to dedicate himself to his art. Yet it could also be that his frankly erotic drawings were considered in those days to be outright 'dirty.'

Although a friend of Cézanne's, Achille Emperaire was able to escape his influence (which is not a slight achievement) and his work denotes a surprising personality and a very strange character. His drawings—for few of his paintings are known, and those are generally in a rather bad condition *(30)*—have an exquisite sensitivity and suggest, by the manner in which the white and black merge into all the nuances of gray to create volume and

32 Achille Emperaire *Reclining Nude* 1874, drawing

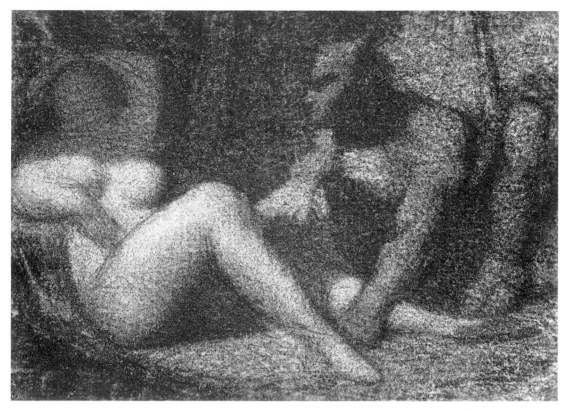

33 Achille Emperaire *Nude with Faun* Drawing

atmosphere, the drawings of Redon and Seurat *(31–34)*. His nudes have the fullness of form, the abundance of curves, the poetry of line that we admire in Renoir and Maillol, while the romantic inspiration of Emperaire sometimes brings him close to Delacroix and especially Monticelli, a fellow Provençal. But the names of Seurat, of Maillol, of Delacroix, are cited here solely to show the level on which certain of the works of this completely unknown artist can be compared. He probably never met either Seurat or Maillol, yet he is connected with their manner of seeing because he was searching, as they, for the plasticity of forms, as well as for all the nuances from black to white, which permitted him to 'modulate' his drawings, as Cézanne would say. With the latter he shared his admiration of Delacroix, and in Paris he certainly studied that master's art.

It seems that Cézanne fully appreciated the work of his friend, for who else but Achille Emperaire could have been the artist and the comrade of his youth of whom he speaks in a letter to Gasquet: 'If I had been given the chance to 'realiser,' it is I who would have remained in my corner with some of the studio colleagues with whom we used to go to drink a stein of beer. I still have a good friend from those days, ah well, he didn't succeed, just the same he was

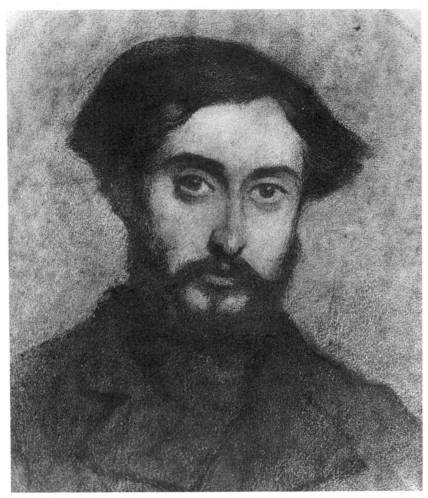

34 Achille Emperaire *Portrait of a Man* Drawing

devilishly more painter than the bemedaled and decorated tramps that make one sweat.'

Two years after Cézanne had written these lines, in 1898, Achille Emperaire died in Aix, and although he was 'devilishly more painter' than the official masters, his name was only saved from oblivion by the portraits Cézanne had made of him. May the knowledge of his work help in rendering justice to his eminent qualities as an artist!

In 1983 the Municipal Council of Aix-en-Provence named a street of the town after Achille Emperaire.

35 Achille Emperaire *Nude*

36 Achille Emperaire *Nude*

NOTES

The documentation for this study was collected with the kind cooperation of the late Edouard Aude, honorary curator of the Méjanes Library, Armand Lunel, the late Marcel Provence, curator of the Museum of Old Aix, who put Emperaire's letters at my disposal, the late Louis Giniès, the late Marcel Arnaud, curator of the Museum of Aix, the late Maurice Raimbault, curator of the Arbaud Museum at Aix, and the late Joseph Ravaisou, son of the painter who was a friend of Cézanne's.

I am deeply indebted to M. Denis Coutagne, Curator of the Musée Granet, Aix-en-Provence, and to my friend M. Raphaël Chiapetta of Aix-en-Provence for their untiring help with the illustrative material of this chapter.

1. A painting of the Church of Saint-Jean-de-Malte at Aix, catalogued by L. Venturi, *Cézanne—sa vie—son oeuvre* (Paris, 1936), under No. 49 and dated by him 1866–68, was discovered, upon cleaning, to bear the signature of A. F. Marion. A very meticulous drawing of the same subject, in one of Cézanne's early sketchbooks, is, or rather was, initialed 'A. F. M.,' this signature having since been removed.

2. Maurice Raimbault has assembled in a study on 'Une lettre de Cézanne à Joseph Huot,' *Provincia*, Bulletin de la Société de Statistiques et d'Archéologie de Marseille, fasc. 2 1937, a number of useful details on Cézanne's early friends. On this subject see also Bruno Ely, 'Cézanne, l'école de dessin et le musée d'Aix,' in *Cézanne au Musée d'Aix*, Aix-en-Provence, 1984.

3. Cézanne's letters to Emperaire were first published by Victor Nicollas, *Achille Emperaire* (Aix-en-Provence, 1953); they are included—together with excerpts from Emperaire's letters to friends in Aix—in *Cézanne, Correspondance*, nouvelle édition revisée et augmentée (Paris, 1978), pp. 139–42.

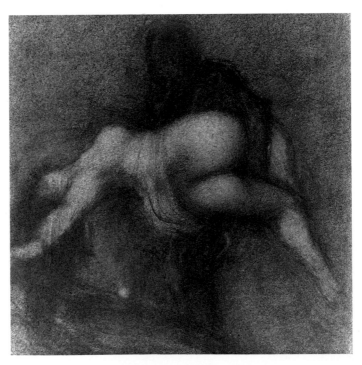

Achille Emperaire *The Rapt*

Cézanne and his father

To Paul Mellon

The strong-willed personality of Paul Cézanne's father apparently impressed all who came in touch with him. Emile Zola, who was not yet ten when his father died and who usually sided with his friend whenever a conflict pitted son against father, knew the banker well. He also knew that the latter deeply resented what he considered Zola's interference that strengthened Paul's penchant for an artistic career, which the banker steadfastly opposed. It is not surprising, then, that in 1869 when Zola first conceived his series of Rougon-Macquart novels as a tremendous fresco of a 'family in the modern world,' he should have referred in his preparatory notes to Cézanne and his father. Theirs was possibly the only father-son relationship with which he was intimately familiar.

According to Zola's initial notes, among the problems with which he intended to concern himself was 'the influence of the feverish modern environment on the impatient ambitions of the characters. The actual environment—locale and place in society—determines the class of a character (worker, artist, bourgeois: myself and my uncles, Paul and his father).'[1]

Thus, from the beginning, the young novelist planned to rely on his personal experiences, of which the future painter and his father formed an extensive part. In the notes relating to one of the central figures of the fourth novel in the series, *La Conquête de Plassans* (which appeared in 1874), Zola speaks more specifically of the old banker: 'Take the type of C . . . 's father, mocking, republican, bourgeois, cold, meticulous, stingy; depict his home life; he refuses his wife any luxury, etc. He is, moreover, garrulous and, sustained by his wealth, doesn't care a rap for anyone or anything.'

This is one of the few firsthand reports on Cézanne's father, and it is not exactly flattering. The outspoken, authoritarian, shrewd banker was a self-made man whose humble beginnings were doubtless remembered by many members of Aix's rather exclusive society, although, as partner in the only bank of the town, he wielded considerable influence. He was a picturesque figure about whom legends sprang up, both favorable and unfavorable;

First published in *Studies in the History of Art*, 1971–72, National Gallery of Art, Washington, D.C.

mostly the latter *(37)*. On the other hand, his integrity and acumen must have been a matter of public record, for how otherwise explain that after the collapse of the Second Empire the retired banker, by then seventy-two years old and never having held any elective office, found himself designated by acclamation as member of the provisional municipal council? (He was put on the finance committee, but did not care to attend any meetings.)

Louis-Auguste Cézanne, born in 1798, had thoroughly learned the trade of hatter, the production of felt then being a major industry in Aix. Having done well in this business, he was able, during the revolutionary year of 1848, to acquire the only local bank, which had failed in the political and economic crisis. It took courage and foresight to do so, for the newly established Second Republic seemed to be headed for trouble. A hardened republican, Louis-Auguste not only had confidence in the new government, he must also have seen that difficult times could be beneficial to moneylenders, provided they knew how to operate wisely. Operate wisely he did and eventually proved to be tremendously successful.

While still dealing in hats, Louis-Auguste had met a local girl sixteen years younger than himself; they were married in 1844, after she had borne him a son, Paul, in 1839, and a daughter, Marie, in 1841. A second daughter, Rose, was born ten years after the wedding had been performed. Obviously, the father could not be 'rushed' into any decision. One thing becomes clear: if he reached the ripe age of forty-six before marrying and legitimizing his two children, it was evident that he did not care in the least what his fellow citizens might think or say. Among the maxims he readily propounded and which his son was always to remember were such sound principles as, 'Don't get too excited, take your time, and act with caution,' or 'Whenever you go out, know where you are headed.' No doubt the old man took his own advice and fared well by it.

By the time Louis-Auguste Cézanne had become a prosperous banker, his fondest dream apparently was that his eldest child and only son should succeed him at the bank and build into a family business the firm that he, through hard work, had put on a solid foundation. In 1859, the year Paul turned twenty, the banker acquired a manorial estate just outside of Aix, the Jas de Bouffan. The mansion itself was very run-down, but with it came a farmhouse and thirty-seven acres of land, mostly profitable vineyards. The price reputedly was 90,000 francs (Zola, in his first job in Paris at the time, was earning 60 francs a month). This purchase was considered ostentatious in Aix, 'the whim of a parvenu,' but, as usual, the banker was completely indifferent to the reactions of others.

It must have been at some time during the previous year, in 1858, that young Cézanne became conscious of his calling, though it is of course impossible to fix the very instant or to ascertain how 'serious' he was at first. All we know is that at about that time there seems to have begun what Zola, in

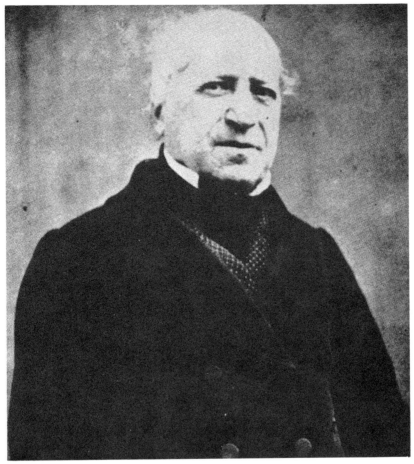

37 Photograph of Louis-Auguste Cézanne, the artist's father

a letter of March 1860, called his friend's 'two-year struggle' against his father's opposition to an artistic career. When Paul passed his final school examinations late in 1858, it was decided that he enter the venerable University of Aix. The father was doubtless proud to provide his son with the higher education he himself had not received and to see him register at the law faculty, law being considered in France the key to everything. The son complied with his father's desires. To do otherwise would have been almost unthinkable. Obviously, he was being groomed to climb that social ladder on which the banker was determined to launch his descendants, knowing full well that his own access to it was barred. Paul seemed unhappy with the career his father was envisioning for him, but that was certainly no deterrent to the elder Cézanne. His own success having confirmed the banker in what he considered the rightness of his philosophy, he was convinced that the ambitious plans he had formed for his son would eventually justify the pressure he had to exert in order to obtain obedience.

The young Paul continued, as in the past, to write poems, mostly in a mocking vein (which did not prevent Zola from discovering great promise in them), translate Latin verses, plan tragedies, and paint. His apparent lack of purpose made it much easier for the banker to have his own way. Indeed, the son of this robust realist (some called him 'rapacious and tough')—made of the same fiber as his energetic and far-seeing contemporaries who were accomplishing the Industrial Revolution—turned out to be a hopeless dreamer. Withdrawn and shy, Paul was at the same time romantic and boisterous, exuberant and unstable, overconfident and moody, hesitant and stubborn, proud and melancholy, sensitive and insecure, suspicious and irascible. He was also quite immature.

In his father's eyes, the son's inclination for art did not at first take on alarming proportions. Since the end of 1858, at the very time when he began his law studies, Paul had been enrolled at the evening classes of the municipal drawing school where tuition was free. He also occasionally copied some sweet and dull works at the local museum, with which his mother seems to have been very happy. Meanwhile he asked Zola to obtain information about a project they had discussed together, that of competing for some prize of the Academy in Paris, 'provided, of course, it won't cost anything.' Evidently, his father did not give him any funds but otherwise let him be, as long as he attended his university courses. Nor did the banker seem to have had any objections to turning over to Paul the walls of the more or less dilapidated large living room at the Jas de Bouffan which, little by little, his son covered with an assortment of murals.[2] While these activities did not yet cause the father any apprehension, they did prompt him to warn his son, 'Think of the future; one dies with genius but one eats with money!'

In December 1859, after one year of study, Cézanne passed his first examinations, though by then law had become quite repulsive to him. Yet, strangely enough, in his many letters to Zola, he practically never speaks of painting. The first time he mentions his dreams of becoming an artist, of going to Paris and finding a studio there is in a letter of June 1859, in which he reports at length his burning though unrequited love for 'a certain Justine' with whom he had not yet exchanged a single word and who, moreover, was infatuated with one of his friends. This project 'à la Murger' seems to have evolved more around his juvenile passion for the girl than his own serious plans for the future.

However, by the end of that same year, Zola's letters to his friend (those Cézanne wrote to him are lost) indicate that Paul had now decided to be a painter. Thus it was only after one year at the drawing school that Cézanne became confident of his destiny. Even then he was still torn between determination and indecision, frequently considering it best to appease the banker and earn a law degree before leaving for Paris to study art. Zola was exasperated by Paul's indecisiveness, unable to understand why Paul would

agree to waste more years on law if he meant to abandon it ultimately. But Paul obviously dreaded discussions with his father and put these off to gain time, no doubt hoping that something unforeseen might occur to soften his father's attitude. By now, however, the conflict must have been in the open, and the banker could no longer pretend to be unaware of how Paul felt about law on the one hand and art on the other. He certainly could not comprehend how a son of his—brought up to 'face realities,' raised in a home where the word 'art' was probably never pronounced, taught, as everyone else in the household, to respect the father's wishes—could have gotten it into his head to devote his life to covering canvases with pigment (a pleasant pastime, possibly, but definitely not a respectable 'profession').

Confronted with this situation, Louis-Auguste Cézanne, true to his background and his convictions, decided to bend the son to his own stern will. It seems inconceivable that he might have acted differently, that he might have told Paul that he sympathized with his yearnings, that he wanted him to choose the career that most attracted him, that he did not care whether he made a financial success of it provided he found satisfaction in 'self-expression,' that he had the means to support him and would do so gladly as long as he could assure the son's happiness.

Though generally accepted today, such an attitude was absolutely unheard of then. Moreover, according to his elder daughter, the banker, while not a tyrant, was quite 'unable to understand anyone except those who worked in order to get rich.' But there was more at stake for him than the mere exercise of his authority; he must have felt that, by protecting him against his youthful fancies, he acted in his son's own interest.

Those who have indicted Louis-Auguste Cézanne for his intransigence have searched for all kinds of hidden indications to show the extent to which Cézanne suffered from his father's incomprehension and even hated him. They have been helped, of course, by hindsight and the awareness that the emerging painter *was* a genius, something his father did not, and could not, know. They have overlooked the fact that the banker acted according to deeply felt principles which were those of his class and his time.

A glance at the early life of Cézanne's fellow Impressionists show that they fared no better with their families. Pissarro had to help for five years in his middle-class father's store until, after running away, he was allowed to become an artist. Bazille's patrician parents insisted that he study medicine; after two years they also permitted him to attend art classes; only after four years, however, and after having failed in his examinations, was he allowed to abandon medicine. Sisley was sent to England for two years in preparation for a commercial career. Monet certainly experienced the greatest hardships with his well-to-do grocer-father who appears to have been not only overbearing, but actually petty and cruel (though nobody has as yet attempted to explain what the elder Monet's lack of humanity did to the psyche of his son). Only

73

Manet and Degas escaped such difficulties, but their fathers were not self-made men, and Degas's family even showed real appreciation of art. Renoir's parents were poor and unable to help their son, who—having been brought up not to expect anything — learned early to fend for himself. It would be idle to speculate whether Cézanne was any worse off than the others, except to say that he probably would not have been able to shift for himself (a fact that cannot have escaped the banker), and that his father seems to have been less coarse and brutal than Monet's.

In February 1860, when life at home became unbearable because of Paul's reproachful glances, brooding silences, and barely contained rebellion, his father offered to let him go to Paris, with the condition that his teacher at the local drawing school approve the action. It was a conciliatory move that raised great hopes, but also an extremely shrewd one, since the teacher, as Zola immediately suspected, was not eager to lose a pupil and told the banker that Paul could still learn a great deal in Aix. The disappointment was too much for the young man, who now abandoned himself completely to discouragement and apathy. The father had won the first round, yet his son was so deeply affected that he considered renouncing all his dreams; he began to doubt his own talent and no longer felt himself possessed by the desire to paint. Even Zola's letters could not shake his inertia and despondency. This was more than the father had bargained for and it must have been at this time that the banker authorized Paul to abandon his law studies.

While he took up his brushes with new-found enthusiasm, Cézanne continued to suffocate in his stale and frustrating surroundings, longing to join Zola in Paris and to plunge himself into the stimulating atmosphere of the capital. His father finally realized that nothing would be gained by further resistance and acquiesced to the departure, though he did not yet consider himself vanquished. He felt certain that Paul would be disillusioned in Paris and come back to resume his studies. The trip was decided on so suddenly, toward the end of April 1861, that Cézanne could not even inform Zola of his impending arrival. After their three-year battle, the banker proved himself a gracious loser; he not only accompanied his son to Paris (he probably had to attend to some business there), but also took his daughter Marie along. Together they would find appropriate lodgings for the painter, commensurate with the modest though sufficient allowance he was to receive. Much to Zola's surprise, Paul's father did not seem to hold any grudges against him and insisted that they all dine together.

Louis-Auguste may have been inordinately headstrong, but he was far from primitive; he certainly knew his son well and, to a certain degree, 'understood' him without, however, being ready to capitulate before Paul's complicated personality. While he may have felt that his son's lack of stability called for particularly strict discipline, he must also have been impressed with the young man's tenacity, a characteristic he probably owed to paternal genes.

74

The only thing that obviously completely escaped him was the question of his son's talent, but this, it would seem, was of minor importance to the banker, since even the most promising artist would have made an unlikely successor for his business.

Cézanne's father had been right: after the expectations built up during years of hopes and dreams, Paris soon disappointed the awkward and unsociable provincial, completely out of tune with the active and sophisticated city. Zola, though wrapped up in his own concerns, tried his best for the friend who did not know a soul in the capital, but after about five months the painter could stand it no longer and fled into what must have appeared to him the protective folds of Aix, of the Jas de Bouffan, and of his family.

By giving in, the father won the second round. His victory appeared complete almost beyond expectations when the son seemed to abandon all thoughts of art and actually resigned himself to enter the paternal bank (rather than resume his law studies). Yet it was a short-lived victory; Paul could not conceivably find happiness behind a pay desk. By now Louis-Auguste must have realized that even his son's submission would not make a banker out of him. Being a realist, he understood that no stubbornness would ever achieve the impossible and—having been convinced—yielded at last. In this way the third and final round was won by the painter, who now obtained an allowance from his father and was free to pursue his artistic goals.

The future was to reveal that whatever agreement father and son entered into was never to be a perfect one. There were many occasions of friction in the course of which the banker used the purse strings to assert his authority, the only means left to him and of which he availed himself with vindictive nastiness. While this humiliated the artist, particularly in later years, it does not alter the basic fact that at the age of about twenty-three Paul Cézanne gained freedom from financial worries and could devote himself completely to his calling, in a way totally unknown to Monet, Renoir, or Pissarro.

Despite his periodically strained relations with the banker, the young Cézanne certainly was not too badly off, and yet it is precisely in his earliest utterances that some scholars have attempted to find clues to a peculiar father-son relationship. They have gone over the childish drawings and immature poems of the teenager for revelations of the adolescent's psyche, oblivious to the fact that these juvenile products were meant to be funny and that no analysis of them should be undertaken without some allowance for a young man's fancy, parody, and satire (an allowance that demands from the analyst that he himself show a faint sense of humor).

Examining a burlesque poem contained in a letter to Zola of November 1858, Theodore Reff has endeavored to detect in the young author not only hidden guilt complexes and sexual fantasies, but also an 'unconscious desire to eliminate his own father as a rival and threat.'[3] Kurt Badt went further

when he sought to discover in a lugubrious drawing (in another letter to Zola, of January 1859) analogies with Dante's Ugolino and ventured the theory that Cézanne hated his father, dreaming to see 'fate catch up with the "sinner" who, after his death, will wind up in hell and there be turned over to him, the son,' so that he, the artist, can take revenge by devouring his own father's head, the very one that had evolved the devilish plan of letting him starve spiritually.[4]

It is of course almost impossible to argue with this search for obscure significance and highly individual interpretation, at least not without venturing on the thin ice of psychoanalytical speculation. In any case it seems considerably 'safer' to confine oneself to established facts. Since it has long been realized (despite today's extreme permissiveness) that discipline and even punishment provide the child with proof of parental care and concern, one can assume that the young Cézanne, with all his yearnings, resentments, and transports of anger, found in his father the steadying element he needed, the authority that protected him from his own lack of decision. If there was unconscious hatred, there was also love, the love-hate relationship so common between father and child. It is certain that the Jas de Bouffan, where the painter usually found a haven and to which he returned for many decades, remained for him, as he was to say—even some ten years after the banker's death—*la maison de mon père*![5]

But more important still is the one testimonial that has been completely neglected: the series of portraits Cézanne did of his father, whom he represented in more paintings and drawings than Manet, Monet, Renoir, or Pissarro ever did of their respective fathers. Cézanne's early models were obviously drawn from the small circle of his family and friends. Since he either abandoned or destroyed many of his works of those years, it is impossible to establish an exact count. From the paintings that have survived, however, it would seem that despite his veneration for his mother, Cézanne hardly ever asked her to pose, whereas her brother, Dominique Aubert, was his most frequent model, possibly because he was particularly 'pictogenic.' He seems to have been readily available and willing to don all kinds of disguises, to be painted as a monk, a lawyer, or whatever. Next to this uncle, the banker appears to have been his son's favorite model. From the likenesses that are known, it would seem that he agreed to pose provided he could read; he was getting on in age and was probably no longer active as in former years. Three portraits exist, of which the first two are full length and rather large; they must have required several sittings, whereas the much smaller heads of the uncle were often 'dashed off' in one afternoon.

The earliest of the three portraits shows Louis-Auguste Cézanne strictly in profile, seated—somewhat uncomfortably—on a chair that appears almost too frail for his considerable bulk *(38)*. He is absorbed in a newspaper, wearing an unusual visored cap, doubtless because he was bald and, like many

38 Paul Cézanne *Portrait of the Artist's Father* c. 1865

Frenchmen, in constant fear of drafts. (He seems always to have worn, even indoors and while dozing, this or a similar, unvisored headgear, which were possibly the residue of his hatter's stock.) This first likeness was probably done around 1865, when the artist was in his mid-twenties and the banker approaching seventy. It is painted rather coarsely, with some parts sketchily indicated, while the features are modeled in contrasts and executed with a certain realism that had not as yet appeared too frequently in the young man's work, though it was to emerge now with increasing frequency in portraits and still lifes.

What is peculiar about this painting, which measures $66\frac{3}{8} \times 45\frac{1}{2}$ inches (168.5 x 115.5 cm), is that it originally was part of the decorations of the vast living room at the Jas de Bouffan where it was placed in the center of a spacious niche, flanked on either side by two of a sequence of the four seasons.[6] Painted directly on the plaster,[7] its appearance at the focal point in the largest room of his parents' home was not the result of some leisurely dabbling on an empty surface but represented, on the part of the artist, a deliberate effort to allocate to his father the most dominant spot in the entire house. The parental authority is thus freely acknowledged here, and on the painter's own terms, not as something imposed upon him by paternal tyranny, but rather as a confirmation—and to a certain degree acceptance—of an inescapable reality.

Cézanne's second portrait of his father *(VII)*, even larger than the preceding ($78\frac{3}{4} \times 47\frac{1}{4}$ inches) (200 x 120 cm), donated by Paul Mellon to the National Gallery of Art in Washington, is without question the most important of the three likenesses the artist painted of the banker. It is also one of his rare works so fully documented that even its date of execution is known. Indeed, on November 2, 1866, Antoine Guillemet, a young painter Cézanne had met in Paris and who was then visiting him at Aix (and trying to obtain from the banker a more substantial allowance for his son), in a letter to Zola mentions one of their friend's recent canvases, 'a portrait of his father in an armchair which looks very good. The painting is "blond" and the effect is splendid; the father looks like a pope on his throne were it not for *Le Siècle* that he is reading.'

This portrait is much less hesitant and/or sweeping in its execution than the first one. Painted in parts with a palette knife, it shows—on a large surface—the same vigor that distinguishes so many of the more spontaneous likenesses of the uncle which must date from the same period. Following on the heels of the more romantic and groping earlier expressions of the young artist, this vigor and strength prompted him to plan a series of quite big canvases of which almost none has survived. (Doubtless inspired by the example of Courbet and Couture, as well as many Salon painters, not only Cézanne but Manet, Monet, Bazille, Renoir, and even Pissarro were then executing works of large scale.)

39 Paul Cézanne *Sheet of Studies with Sketch of the Artist's Father Reading a Newspaper* *c*. 1866, pen and ink (for the portrait sketch)

Unlike the first portrait with its rather primitive profile representation, this one shows the banker in front view, seated more comfortably in a stuffed armchair set at an angle by means of which an illusion of depth is created, enhanced by the shadows cast by the model's forward-reaching feet. This illusion is further, and more subtly, underlined by a small still life that hangs on the wall behind the high-backed armchair (the latter also appears in a few other paintings done at the Jas de Bouffan).[8]

Though the picture does not appear quite as 'blond' as one may expect from Guillemet's description, it is certainly less dark than many of Cézanne's previous works; indeed, the tobacco-brown background is considerably lighter than the small still life that appears almost black by contrast. And the flowered slipcover of the chair provides a light setting against which the somber coat and cap of the father are powerfully set. Moreover, the central

79

feature of the canvas is the large, unfolded, blank sheet of newspaper whose masthead, in bold letters, is clearly visible, upside down.

Notwithstanding the fact that the palette knife technique demands a fairly rapid execution, while the pigment is not yet dry, this portrait—if only due to its size—must have required repeated sittings to which the artist's father submitted while reading *Le Siècle*. Founded in 1836, it had been the first inexpensive newspaper (40 francs a year) and had enjoyed a tremendous popularity. Thirty years later it still had 44,000 subscribers and was by far the most widely read of the French dailies. It had a tradition as the voice of the 'constitutional opposition,' that is, as the advocate of the principles of 1789 and 1830; under the Second Empire it obviously took an anti-government position without, however, exceeding the bounds set by law. Louis-Auguste Cézanne must have found the paper very much to his liking (as doubtless did his son, who, while not particularly interested in politics, loathed Napoleon III, 'the tyrant'). If, in the artist's likeness of his father, the masthead mentioned in Guillemet's letter of November 2, 1866, was replaced by that of *L'Evénement*, this had nothing to do with the banker's republican reading habits.

L'Evénement had been launched in October 1865 by the enterprising director of *Le Figaro*, Henri de Villemessant, who was more interested in circulation than in editorial opinions. Within little more than a year, in November 1866, the paper ceased to appear,[9] but in April and May it had offered Zola a platform for his first art criticism. At his own request, the young novelist, then twenty-six, had been entrusted by Villemessant with the Salon review, not because he had any experience in art matters, but more likely because he was a contributor to *Le Figaro* and because the editor was doubtless willing to gamble on a little-known and not too expensive author.

Zola's eagerness to write this series of articles is easily explained by the fact that through Cézanne and his friends, such as Guillemet and Pissarro, he had met a number of artists more or less of his own generation, most prominent among whom was Manet. In their company he had listened to, and participated in, many discussions concerned with new principles that were eventually to lead to Impressionism. Zola had found in the unconventional ideas of these painters, and in their obstinate attachment to nature, many elements akin to his own literary tendencies. Thus he was anxious to formulate their common views not only by proclaiming what he admired, but just as much by attacking the celebrities of the day whom they abominated. When the Salon jury of 1866 rejected, among others, the entries of Manet (who had obtained a *succès de scandale* with his *Olympia* at the previous Salon), Renoir, and Cézanne (who had fully expected to be refused[10]), Zola seized the occasion to lash out at the enemy. He devoted an entire article to his friend Manet, something absolutely unheard-of, considering he was writing a Salon review and the painter was not represented in the exhibition. His

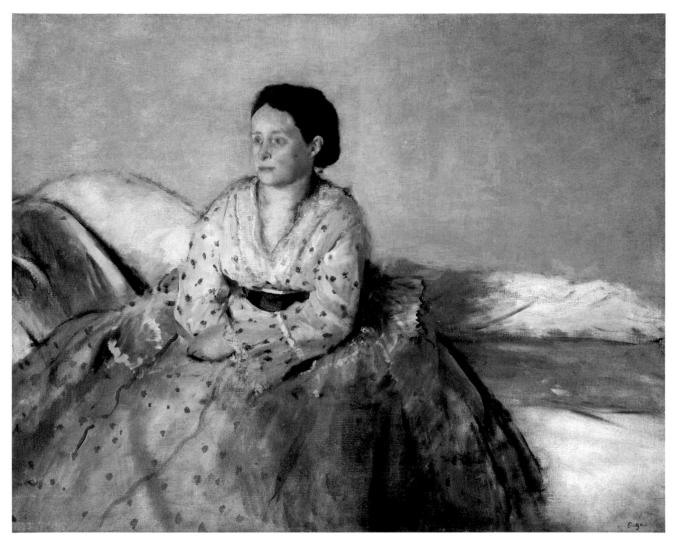

1 Edgar Degas *Madame René de Gas* 1872–73

II Edgar Degas *Foyer de Danse* 1873–74

III Edgar Degas *Foyer de Danse* 1873–74

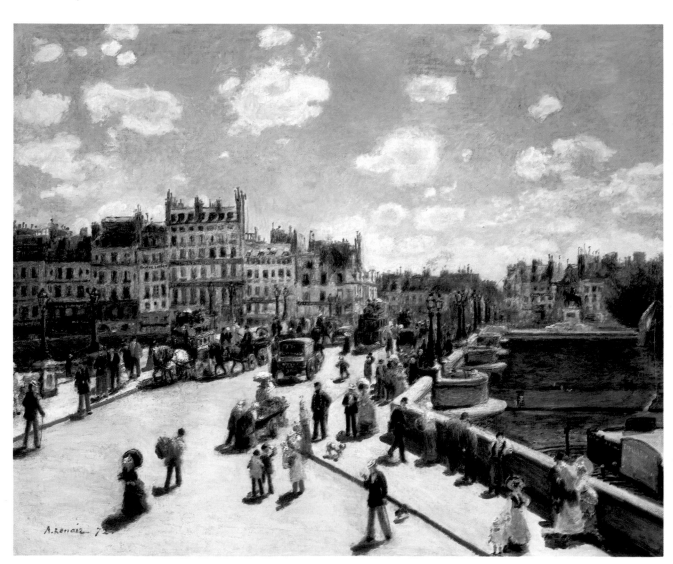

IV Auguste Renoir *The Pont Neuf, Paris* 1872

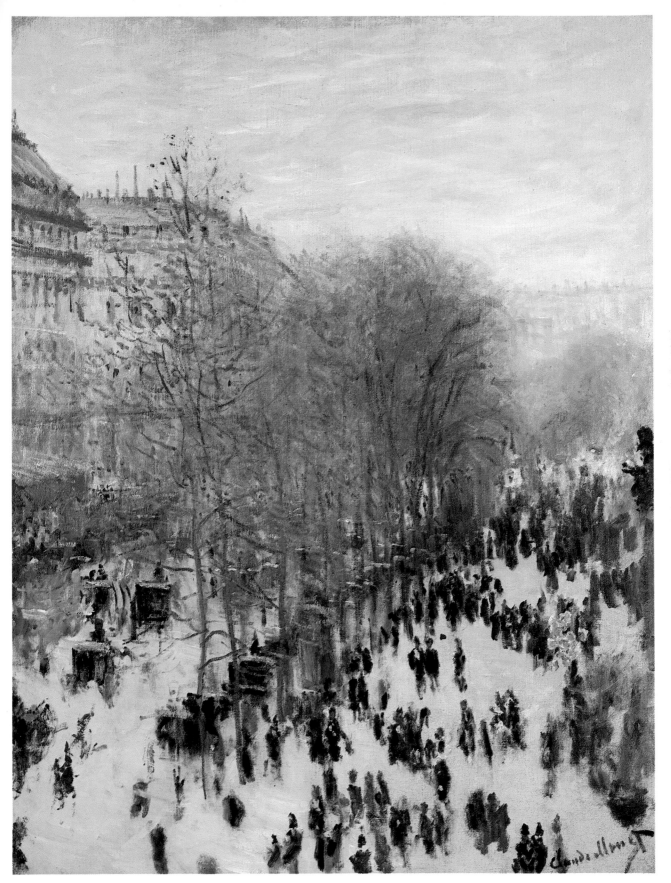

V Claude Monet *Boulevard des Capucines, Paris* 1873

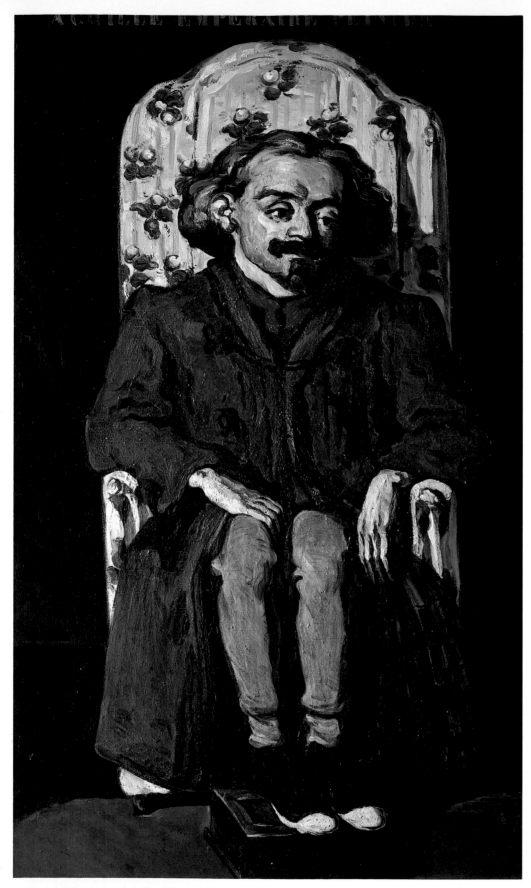

VI Paul Cézanne *Achille Emperaire c.* 1866

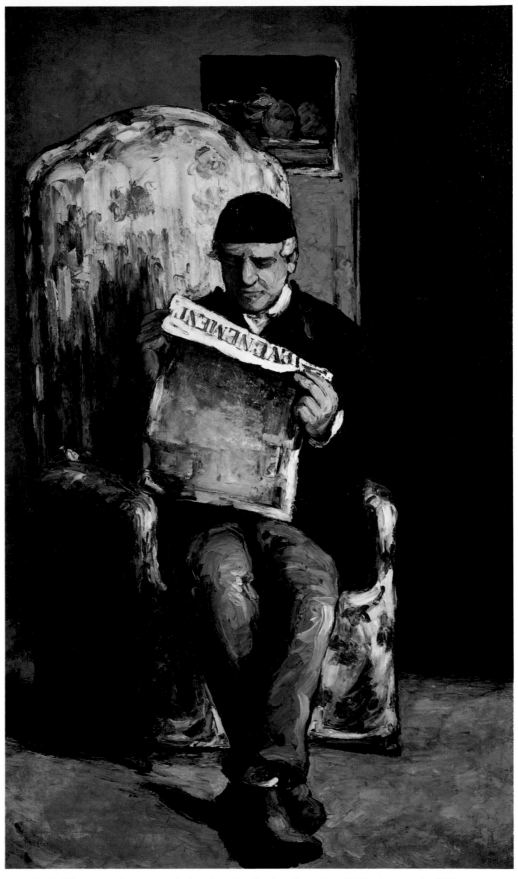

VII **Paul Cézanne** *Portrait of the Artist's Father Reading 'L'Evénement'* 1866

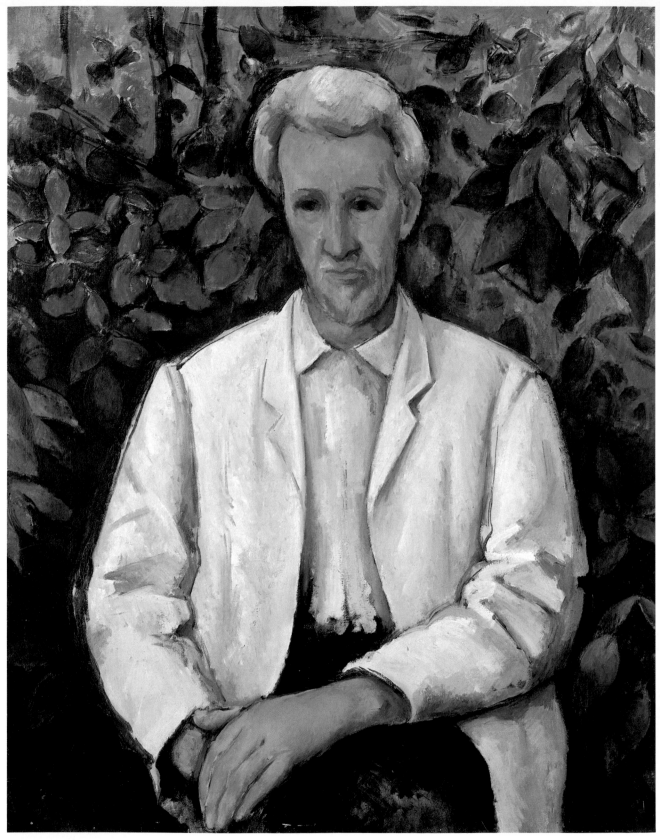

VIII **Paul Cézanne** *Victor Chocquet in Hattenville, Normandy c.* 1889

diatribes caused such an uproar that Villemessant put a stop to Zola's performance before he could complete his task. Zola thereupon decided to issue a pamphlet containing the articles that had appeared. At the head of this brochure he put the proclamation, 'That which I seek above all in a picture is a man and not a picture.'

In his series Zola had not spoken of Cézanne who, though also rejected, was—unlike Manet—still completely unknown. But now, in lieu of a preface to the articles, Zola wrote a long dedication in the form of a letter to his boyhood friend. It was a very personal, warm, even affectionate letter in which Zola said:

'For ten years we have been discussing art and literature. We have lived together— do you remember?—and often daybreak caught us still conversing, searching the past, questioning the present, trying to find the truth and to create for ourselves an infallible and complete religion. We have shuffled stacks of frightful ideas, we have examined and rejected all systems, and after such arduous labor have told ourselves that outside of powerful and individual life only stupidity and lies exist.'

Cézanne must have been deeply touched by Zola's public acknowledgment that the writer's forcefully expressed views on art were rooted in their long years of friendship. Was it as a sign of gratitude that in the portrait of his father he replaced the masthead of *Le Siècle* with that of *L'Evénement* where Zola's controversial articles had originally appeared? Was it because *L'Evénement* had just suspended publication that he wanted to preserve its name for posterity? Was it because he hoped to give reality to what must have been a wishful dream: his father immersed in Zola's articles (in which, no doubt, the banker had not the slightest interest)?

If the painter intended this portrait as an indirect homage to his friend, he evidently would have done better to let his father hold Zola's small brochure, titled *Mon Salon*, with which his own name was connected. This, however, would have required an altogether different composition and even, in the absence of the large sheet, a different pose of the model. Since it is quite obvious that the banker was actually reading *Le Siècle* while sitting for his son, the change of the paper's masthead came as an afterthought and obliged the artist to redo only a small section of his work. It seems impossible not to recognize here Cézanne's intention to make the painting more meaningful and relevant without altering his artistic concept. Only his most intimate friends could have known that *L'Evénement* did not relate merely to a short-lived newspaper, but those few must have realized that the painter was establishing a link between the man who provided for him (and was to do so for the rest of his life) and the friend who had exerted the most important single influence on his adolescence and early years as an artist.

Since Louis-Auguste Cézanne was not particularly fond of Zola, precisely on account of this influence, he may have resented this 'falsification' of his likeness, this introduction of an element that was patently foreign to him. But

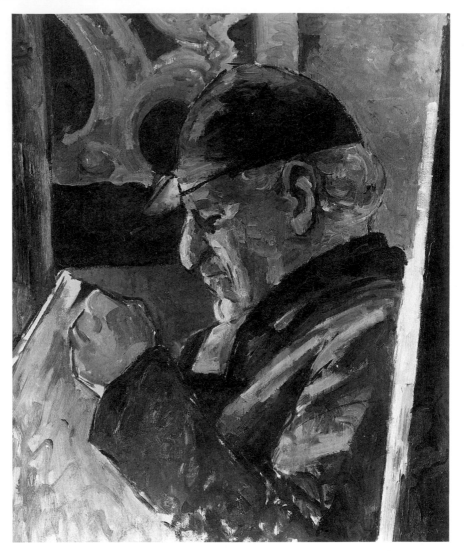

40 Paul Cézanne *Portrait of the Artist's Father* 1870/71

by now he had resigned himself to the situation and probably did not even care. In any case, a few years later he posed for a third portrait, executed in 1870–71, possibly while his son was hiding from conscription at the Jas de Bouffan *(40)*. As the first one, this portrait shows the banker strictly in profile, again wearing his cap and reading a paper; it is considerably smaller than the others, only $21\frac{5}{8} \times 18\frac{1}{8}$ inches (52.4 x 46 cm) and appears, at least in part, to be unfinished (it may be a section of an originally larger canvas).

After the Franco-Prussian War, Cézanne does not seem to have painted any more likenesses of the banker, though he did a number of drawings of him, usually in sketchbooks. The truth is that the relations between father

41 Paul Cézanne *The Artist's Father Reading in an Armchair* 1879–82, pencil (sketchbook page)

42 Paul Cézanne *The Artist's Father (dozing?)* 1879–81, charcoal drawing

and son suffered considerable deterioration in the following years, mostly due to the fact that in Paris, around 1869, the painter had met a young girl, Hortense Fiquet, who bore him a son in January 1872. While the artist's mother was taken into his confidence, the situation was carefully hidden from the father who, however, was nobody's fool. Thus a painful and sordid tug of war between the two men began, not because of the father's opposition to the son's artistic activity, but because the old man resented the fact that the painter, without being able to earn a penny, was keeping a family at his expense (and did not even have the courage to admit it). For several years Cézanne was to experience constant apprehension of being found out, while the banker avidly opened letters addressed to his by now almost forty-year-old son at the Jas de Bouffan and hunted for other indications of his 'guilt.' The painter meanwhile steadfastly denied his paternity, even in the face of overwhelming evidence.

Under these circumstances the Jas de Bouffan ceased to be a haven. Not

92

43 Paul Cézanne *The Artist's Father (and a chimney clock)* 1877–80, pencil (sketchbook page)

44 Paul Cézanne *The Artist's Father (reading?)* 1877–80, pencil, page of a sketchbook

only did Cézanne's correspondence turn into a major problem, it also became increasingly difficult for Hortense Fiquet to follow him in his erratic travels from north to south, where she had to hide with the child in communities near Aix so that the artist could occasionally visit with them. As the boy reached school age, around 1878, such trips back and forth between Paris and Provence became even more complicated. The unavoidable crisis broke out precisely in 1878 when the banker, angered by his son's inept lies, told him that since he pretended to be a bachelor, he would not need the usual allowance while staying with his parents. Unable to send any remittances to Hortense, who was then living in Marseilles, Cézanne first thought of looking for a job but eventually accepted help from Zola who offered to provide her with the necessary funds. 'I had hoped,' Cézanne wrote during these trying months to his friend, 'to find here the most complete tranquillity, but a lack of understanding between me and the paternal authority has a result that, to the contrary, I am more tormented. The author of my days is obsessed with the

94

45 (far left) Paul Cézanne *The Artist's Father Dozing (and head of a woman)* 1882–85, pencil (sketchbook page)

46 (left) Paul Cézanne *The Artist's Father (dozing? and the artist's son)* 1877–80, pencil (sketchbook page)

47 (right) Paul Cézanne *The Artist's Father (and Hortense Fiquet)* 1878–81, pencil (sketchbook page)

idea of affranchising me.—There is only one good way for this, which would be to let me have two or three thousand francs more a year and not to postpone until after my death his intention of making me his heir, since I'll be finished before him, that's for sure.'

There was, however, some unexpected relief about which Cézanne informed Zola on September 14, 1878, concerning his then eighty-year-old father: 'Papa has given me back 300 francs [obviously from his temporarily reduced allowance] this month. Unheard of! I believe that he makes eyes at a charming little maid we have in Aix; mother and I are in L'Estaque. What results!'

Eventually some kind of truce must have been worked out and the painter's allowance restored. In the spring of 1879, Cézanne was able to go to Paris and subsequently settle in Melun with Hortense and their child. It was not until the end of 1881 that he returned to Aix; early in 1882 he was back in Paris and vicinity until the autumn of that year, but after that he remained in the South

48 Paul Cézanne *The Artist's Father Writing (and study of a mantlepiece)* 1883–86, pencil (sketchbook page)

until the summer of 1885. It was evidently during his various sojourns at the Jas de Bouffan that he made most of the portrait drawings of his father,[11] frequently while the latter was reading. One of these drawings shows the banker in the same armchair as in the painting in which he reads *L'Evénement*, except that he now holds the paper at a greater distance, being obviously farsighted and wearing no glasses *(41)*. In other drawings the old man appears to be dozing and it seems easy to imagine the painter, in the peaceful atmosphere of the living room, reaching for his sketchbook once again to draw the familiar features and attitude of his motionless father *(42, 45)*. Cézanne's portraits do not always reveal warmth or any kind of emotional relationship with the sitter, yet in these drawings of the aged banker one does sense an undefinable tenderness, as though, while contemplating him, often without the model's knowledge, the painter had felt the deep-rooted links that nature and fate had established between him and this old man. On some of these sketchbook pages one also finds other studies: on one of them appears, together

96

49 Paul Cézanne. *Studies of the Artist's Father (near a fireplace)* 1883–86, pencil

with the banker's head, in reverse, a likeness of the artist's son, about five years old *(46)*; and on another, a drawing of Hortense Fiquet *(47)*. However one may wish to interpret this, it is certainly not without significance that we thus see the artist's father, in various portraits by his son, associated not only with Zola, but also with his son's own wife and child.[12]

The aging banker probably grew slowly weaker during his last years *(48, 49)*. He distributed at least part of his wealth among his children, although in those days inheritance taxes as well as fiscal control were practically nonexistent. It is not impossible that he merely wished to be relieved of some burdens. Be this as it may, it would scarcely seem that his children brought the old man much comfort and satisfaction. In 1881 his youngest daughter, Rose, had married; her husband, while astute and alert, did not show any particular business acumen and was to prove a better spender than earner. His elder daughter and favorite child, Marie, turned into an increasingly devout spinster. It was with resignation, and possibly bitterness, that Louis-

Auguste now complained, 'Paul will be devoured by painting and Marie by the Jesuits.'[13]

Doubtless it was Marie Cézanne who brought about the final 'reconciliation' of father and son. She obviously knew about the painter's liaison and may also have been aware of a mysterious love affair he had had in 1885. Disturbed by Paul's 'irregular situation' as well as by the illegitimacy of his child, and conceivably feeling that marriage—even with Hortense Fiquet, of whom she had a rather low opinion—would prevent any further, reprehensible escapades, she ceaselessly admonished her brother, 'Marry her—why don't you marry her!'

To straighten out the uneasy relations between her probably agnostic father and sinning brother must have become a sacred errand for Marie, anxious to secure the salvation of their souls. Her pious zeal was to reap its reward when she obtained the father's—weary?—consent to Paul's marriage. This is admittedly conjecture, yet how otherwise explain that the banker, aged eighty-seven, should have accepted the legalization of ties he had fought so strenuously for so many years, or that the son, certainly no longer in love with Hortense Fiquet and with whom, as the future was to reveal, he had no intention of living permanently, should have agreed to marry the mother of his by now fourteen-year-old boy? But on April 28, 1886, in the town hall of Aix-en-Provence, they married; both the artist's father and mother signed the official register. The witnesses to the religious ceremony, which took place the following morning at the church of Saint-Jean-Baptiste, were Cézanne's sister Marie and Maxime Conil, Rose's husband. Louis-Auguste Cézanne died on October 23, six months after the wedding, in his eighty-ninth year.

Within a few years a mutual friend was able to report from Aix to Zola that the painter 'has no financial troubles. Thanks to the author of his days whom he now venerates . . . he has enough to live.' The posthumous veneration was probably predictable, but what may appear less predictable was that Cézanne soon even imitated his father's high-handed methods. When his wife demurred at leaving Paris for the South, he simply cut her allowance in half and thus forced her to settle in Aix, while he continued to live with his mother and older sister at the Jas de Bouffan. This arrangement, he felt, would also enable him to spend six months in Paris every now and then.[14]

The history of the three portraits Cézanne painted of his father is only partially known. The one that adorned the niche at the Jas de Bouffan remained in place when the property was sold in 1899 after the death of the artist's mother. The new owner subsequently offered all the mural decorations of the living room to the French government, who declined the gift. They were eventually detached from the walls; the portrait of Louis-Auguste Cézanne was acquired by the American collector John Quinn, then entered the collection of the Reverend Raymond Pitcairn near Philadelphia

where it remained for many years until it was bought by the National Gallery of London.

The history of the portrait of Cézanne's father reading *L'Evénement (VII)* is not so clear. In his letter to Zola of November 2, 1866, Guillemet had implied that Cézanne planned to take this large painting to Paris, yet there is no proof that this intention was carried out. If he had wished to submit it to the jury of the 1867 Salon, Cézanne would most likely have signed it, something he neglected to do. Moreover, in 1870 he did submit a companion piece of identical size, the portrait of his friend Achille Emperaire, sitting in the same upholstered armchair with the same flowered slipcover *(VI)*.[15] This picture, which *is* signed, was rejected; it seems most unlikely that the artist would have presented it to the jury had his quite similar portrait of the banker been refused three years earlier. The Emperaire likeness eventually turned up in the shop of *père* Tanguy, who had to hide it from the painter because Cézanne had decided to destroy it.[16] Later it found its way into the collection of Auguste Pellerin in Paris whose heirs have donated it to the Louvre.

The portrait of Cézanne's father reading *L'Evénement* similarly wound up in the possession of Pellerin. Although Pellerin assembled the most extensive collection of paintings by Cézanne that ever existed (and began to do so while the artist was still alive), no records of his purchases are preserved. He seems to have bought from all the Paris dealers who—mostly before the First World War—handled Cézanne's works, especially Ambroise Vollard and the Bernheim-Jeunes, but also Jos. Hessel and others. In the absence of any information, it is impossible to establish whether the artist kept this likeness of his father as a souvenir or whether he disposed of it.[17] From Pellerin it passed to the latter's daughter, Madame René Lecomte, in Paris before it reached the National Gallery in Washington.

Cézanne did keep the third and smallest portrait of the banker *(40)*, which was eventually inherited by his son who later sold it. It is possibly the son, whom Cézanne adored, who helped revise the painter's opinion of 'the author of his days.' However, as he became acquainted with the problems of fatherhood (the boy was neither brilliant nor particularly industrious, but indolent, gentle, and good-hearted), Cézanne avoided passing on to him the banker's worn-out maxims and platitudes with which he himself had been raised. He found much kinder words when he told his son, 'Whatever mischief you may get into, I shall never forget that I am your father.' On the other hand, he also frequently expressed gratitude for Louis-August Cézanne and said repeatedly, 'My father was a man of genius; he left me an income of twenty-five thousand francs.'

NOTES

1. Unless otherwise indicated, all quotes are taken from J. Rewald, *Paul Cézanne* (New York, 1948; 1968), and Paul Cézanne, *Correspondance*, nouvelle édition revisée et augmentée (Paris, 1978), but some are here retranslated.

2. On these mural decorations, see Gerstle Mack, *Paul Cézanne* (New York, 1935), pp. 145–47, pl. 2, and Douglas Cooper, 'Au Jas de Bouffan,' *L'Oeil*, Feb. 15, 1955, pp. 13–16, 46, whose list, however, is incomplete since it does not include the so-called *Contraste* (L. Venturi, *Cézanne: son art, son oeuvre* [Paris, 1936], No. 87).

3. T. Reff, 'Cézanne's *Dream of Hannibal*,' *Art Bulletin*, June 1963, pp. 148–52. One of the minor flaws of this study is that it gives weighty consideration to details which the author simply misunderstands. While he explains that Cézanne, by saying that Hannibal falls asleep *du côté gauche*, picks 'a familiar equivalent of "wrong" in the symbolism of dreams,' he completely overlooks the fact that the crucial word in this verse is *débauche* and that Hannibal would have fallen asleep *sur la droite* or *sur le dos* provided they offered a rhyme with —— *auche*! Similarly he states (note 16) that the expression *faire la noce* 'suggests both an orgy and a wedding banquet.' It definitely suggests no such things to Frenchmen, and any reliable dictionary would have told him that *faire la noce* has nothing to do with nuptials and still less with an orgy or even sex, since it merely means 'to go on a spree, to have one's fling, to have a high old time.'

4. K. Badt, *Die Kunst Cézannes* (Munich, 1956), pp. 77–79.

5. One bit of rather startling information has come to light since this article appeared in 1972. In a hitherto unpublished note, Cézanne's brother-in-law Maxime Conil speaks of a room (or rooms) at the Jas de Bouffan filled with paintings which the banker would destroy after his son's departure. This story, if at all true, would have to be placed in the early years of the antagonism between father and son, long before Conil married the painter's sister Rose. Moreover, one may wonder why, under these circumstances, Cézanne would leave any paintings behind; a single experience of this kind should have been enough to prevent him from storing his canvases in a place where his father could get at—and damage—them.

Neither in his letters nor in conversation did Cézanne ever mention such occurrences. On the other hand, some of the pictures discovered by Conil may have been torn up by the artist himself (though it would appear strange that he preserved them, unless it was his mother who endeavored to save her son's work).

6. Cooper, 'Au Jas de Bouffan,' reproduces VII as one of the mural decorations of the Jas de Bouffan, confusing it with the portrait in profile (Venturi No. 25), *38*.

7. See *National Gallery Catalogues. French School: Early 19th Century, Impressionists, Post-Impressionists etc.* (London, 1970), pp. 24–25, No. 6385.

8. I. Elles has suggested, however, that the figure seems to be in contrast with its 'still life-like setting': 'The father, though in a lounging jacket and wearing a cap, does not sit comfortably in the armchair, barely leaning against its back, and he is not relaxed. Nor is he absorbed in the newspaper . . . which he holds in front of him, rather he barricades himself behind it. The paper remains a pretext. Even the picture that hangs on the wall in the background, a repetition of a still life by Cézanne . . . does not manage to create an intimate, cozy atmosphere in which the sitter could feel at ease and protected' (*Das Stilleben in der französischen Malerei des 19. Jahrhunderts* [Zurich, 1958], p. 107). This small still life can clearly be recognized as Venturi No. 62. It is symptomatic of the confusion concerning the chronology of Cézanne's work that Rivière should have dated the portrait 1868 (instead of 1866), and the still life that appears in it 1873, rather than 1865.

9. I am indebted to M. Michel Melot,

Conservateur at the Bibliothèque Nationale, Paris, for information concerning the newspapers *Le Siècle* and *L'Evénement*.

Renoir also placed *L'Evénement* in evidence in his large composition *At Mother Anthony's* (Nationalmuseum, Stockholm), painted in 1866.

10. Cézanne is known to have sent two works to the Salon of 1866. One was his portrait of Antony Valabrègue (Venturi No. 126), National Gallery of Art, Washington, D.C. (Gift of Mr and Mrs Paul Mellon, 1970), which is stylistically related to the likeness of his father executed later that same year. The other may have been the still life dated 1865 (Venturi No. 59), Cincinnati Art Museum. Both works are signed.

11. It seems worth mentioning that only a single drawing of Cézanne's mother is known, which shows her asleep in an armchair; see A. Chappuis, *The Drawings of Paul Cézanne—A Catalogue Raisonné* (Greenwich, London, 1973), No. 397. Chappuis suggested the date 1877–80 for this drawing.

12. The late Adrien Chappuis, who was then preparing his catalogue raisonné of Cézanne's drawings (see note 11 above), helped me locate all the artist's drawings representing his father and provided most of the photographs of these; the dates here assigned to these drawings conform to those suggested by him.

The book by Wayne Andersen, *Cézanne's Portrait Drawings* (Cambridge, Mass., 1970), appeared after this article was written.

13. Quoted in Ch. Flory-Blondel, 'Quelques souvenirs sur Paul Cézanne par une de ses nièces,' *Gazette des Beaux-Arts*, November 1960, p. 301.

14. But this scheme did not work in the long run, his wife not being easily subdued. By 1896 Cézanne complained to a friend that he 'had to go to Paris or return from there according to her orders.'

15. Painted at the Jas de Bouffan, 1867–68 (Venturi No. 88). See also above, 'Achille Emperaire and Cézanne,' pp. 57–68.

16. See E. Bernard, *Souvenirs sur Paul Cézanne* (Paris, 1921), pp. 50–51.

17. A photograph of the painting in the Vollard archives shows horizontal cracks, indicating that the picture must have been rolled at some time (this was possibly the reason for its subsequent relining). However, the presence of such a photograph in his archives does not necessarily mean that Vollard ever owned this work.

50 Paul Cézanne *Portrait of Armand Guillaumin c.* 1872, pencil, page of a sketchbook

Cézanne and Guillaumin

To Charles Sterling

Among the few cordial relationships Cézanne formed with fellow artists was his friendship with Armand Guillaumin, but very little is known about it. The two painters apparently met around 1862 at the famous Académie Suisse in Paris, Guillaumin being about twenty-one at the time and Cézanne exactly two years older. Both soon became friendly with Camille Pissarro, then already in his early thirties. In 1863, all three participated in the Salon des Refusés.

Cézanne and especially Pissarro were not too well off, but Guillaumin's position was even worse. He had come to Paris at sixteen to work in an uncle's shop. Since his family was opposed to his artistic vocation, he eventually took employment with the Paris municipality and for a number of years labored 'like a slave,' spending three nights a week on his job so as to be able to paint during the day.[1] Around 1868 he may have assisted Pissarro who, in order to earn a few pennies, had accepted a job to paint blinds. In any case there is a canvas by Guillaumin showing his friend at this humble task.[2]

Guillaumin seems always to have kept in touch with Pissarro and Cézanne. In the fall of 1872, while working for the administration of public roads, he joined them at Pontoise, and Pissarro stated in a letter, 'Guillaumin has just spent a few days with us; he works at his painting by day and his ditches at night. What courage!'[3] It could well be that a drawing by Cézanne which represents Guillaumin—it shows many similarities with some of the artist's self-portraits[4]—was done at that time *(50)*. Possibly during one of these same meetings Cézanne presented his friend with a likeness of his companion, Hortense Fiquet *(52)*, who had just borne him a son. The small picture seems to have been done around 1872; it appears in one of Guillaumin's paintings, propped against the wall of his studio *(51)*.[5]

Higher up on that same wall hangs an unusually large view of the Seine at Paris which Guillaumin had painted in 1871 *(54)*. Cézanne seems to have been attracted by this superbly composed and impressive picture. At some point in the middle seventies this landscape must have hung much lower on

First published in 'Etudes offertes à Charles Sterling,' Presses Universitaires de France, 1975

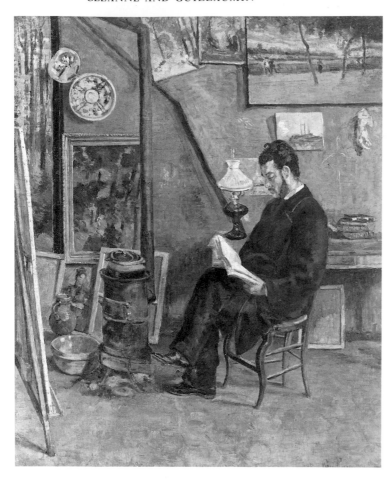

51 (left) Armand Guillaumin
*Pissarro's Friend Martinez in
Guillaumin's Studio* 1878

52 (below left) Paul Cézanne
*Portrait of Hortense Fiquet
c.* 1872

53 (below) Paul Cézanne
Self-Portrait 1873–74

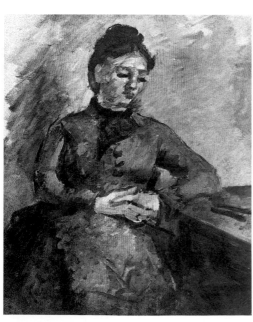

54 Armand Guillaumin *The Seine at Paris* 1871

the wall, for in a self-portrait Cézanne executed in front of a mirror, Guillaumin's canvas appears behind him, seen of course in reverse, as he perceived it in the mirror *(53)*.[6] The size of this canvas makes it likely that Cézanne painted this self-portrait in his friend's studio rather than in his own. He may have done so, however, before he settled next door to Guillaumin in 1875. Although there is no record of early spats between Cézanne and Hortense Fiquet, it is of course possible that Cézanne, from time to time, took refuge at Guillaumin's and worked there to avoid domestic scenes.

In the early seventies, Guillaumin, Cézanne, and Pissarro were frequent guests of Dr Paul Gachet at Auvers-sur-Oise, not far from Pontoise. The doctor's great passion was etching and he had installed a printing press in his house, which all his artist friends were invited to use. Among the few etchings Cézanne ever made—all executed at Auvers—is a copy after one of Guillaumin's river scenes with boats that belonged to the physician.[7] Cézanne also etched a portrait of Guillaumin *(65)*.[8]

In 1874, Pissarro, Cézanne, and Guillaumin participated in the first exhibition of the Impressionist group. In the catalogue, the latter two listed their address as 120, rue de Vaugirard, but this does not necessarily mean that they shared a studio there. Guillaumin may still have been living with his

55 Armand Guillaumin *The Seine at Bercy* 1873–75

mother at 73, rue de Bouffon yet may have found it more convenient (for the return of his canvases or other reasons) to use Cézanne's place, the more so as Cézanne spent part of that year in Auvers and, later, in the South. They must have seen a good deal of each other in those days and their association was to become even closer when, in January 1875, Cézanne moved to 15, quai d'Anjou, while Guillaumin lived at number 13. As Guillaumin's neighbor, Cézanne may now have actually watched his friend paint some of his views of the Seine and the nearby Austerlitz Bridge. But only once did he himself represent a subject typical of Guillaumin, whose pictures of the riverbanks with boats and barges, cranes and stevedores, carts and laborers are legion.

It had always been supposed that Cézanne's *Seine at Bercy (56)* was painted in Guillaumin's company, although stylistically the work did not seem to date from the time they had lived next door to each other, and although Cézanne—who generally set up his easel in elevated places to avoid onlookers—here seems to have chosen a site on the busy banks of the Seine. When an identical landscape by Guillaumin turned up a few years ago *(55)*,

56 Paul Cézanne *The Seine at Bercy* 1876–78

the problem became even more puzzling. The similarities between the two works were too great to be explained by the assumption that the artists had stood side by side as they painted their canvases. Would they have chosen exactly the same attitude of the shoveling man in the foreground, the same profile of the white horse, the same position of the crane?

Comparing the two originals, the late Hans Platte found Guillaumin's approach more 'naturalistic' and Cézanne's more 'abstract.'[9] He concluded that Cézanne must have *copied* his friend's painting and, in the process, lost the direct contact with the motif that Guillaumin had maintained. This is confirmed by a testimony which seems to have been unknown to Platte: when Cézanne's version was exhibited at the Orangerie in Paris in 1936, Jacques Blot, whose father had been a close friend of Guillaumin's, declared that—in his opinion—it was a copy. He added, 'Guillaumin himself told me that Cézanne copied some of his paintings of the quais.'[10]

Cézanne not only copied Guillaumin's picture, he also made drawings after it. On a sheet now cut in two, three sketches after the shoveling man appear

among other drawings and doodles *(57)*.[11] While they do, to a certain extent, have the 'ring' of spontaneous studies made in the open, they are in the company of two other copies: a turbaned man, after an illustration in Charles Blanc's *Ecole espagnole*; and a male nude seen from the back, a detail from Marcantonio's engraving after Michelangelo's *Battle of Cascina*.[12] This would indicate that the sheet represents random studies made in the studio. It is strange, however, that the attitude of the shoveling man differs in the last of these three sketches. In two, his arm is held at some distance from the body, as in Guillaumin's painting, but in the third the arm is much closer and the handle of the shovel does not appear beyond it, denoting a different grip. This could mean that Cézanne caught various stances of the laborer, yet it also brings to mind incidents involving Vincent van Gogh.

According to what Guillaumin himself told an acquaintance, he somewhat dreaded Vincent's visits to his studio on account of his excitability. On one occasion, van Gogh flew into a rage because he thought that the movement of the laborers on a canvas representing men unloading a barge had not been depicted correctly. With an imaginary spade he started to demonstrate the various positions. On other occasions he was likely to strip to the waist for a better display of anatomical details.[13]

It would seem conceivable that Cézanne and Guillaumin likewise—though less violently—discussed the pose of the man with the shovel, and that Cézanne illustrated his views by sketching a slightly different attitude after having twice represented the one adopted by his friend. In any case, when he copied Guillaumin's painting, he followed the model for the shoveling man.

Once before, Cézanne had reproduced the work of a friend. Around 1872, when he began to paint out of doors, he had copied, on a reduced scale, a view of Louveciennes by Pissarro so as to familiarize himself with his mentor's technique.[14] Now, a few years later, he apparently borrowed Guillaumin's picture in order to study it closely. This time the copy was practically the same size as the original. But while repeating the elements of the painting rather faithfully, Cézanne did not proceed slavishly. Through the application of regular, often square brush strokes and occasional impasto, his copy gained a tighter structure and a completely different texture, most noticeable in the clouded sky. At the same time he softened as well as brightened the colors, providing new accents, such as the red of the barge and the green of the crane, where Guillaumin had used duller tints.

To judge from other, dated works by Guillaumin, his *Seine at Bercy* was painted around 1873–75, probably closer to the earlier date. At the beginning of 1876 Cézanne left the quai d'Anjou; his copy seems to have been done not while he lived next door to Guillaumin, but a little later. Indeed, Charles Sterling observed, 'The regular, square brush stroke and the color, in which blue dominates, seem to indicate a later period.'[15] One might almost see here an attempt by Cézanne to evaluate the effect and possibilities of the square

57 Paul Cézanne. Study Sheet 1873–77, pencil

brush stroke he was then developing when applied to a typical Impressionist work. Viewed in this context, three other copies he made at about the same time could be considered as similar 'tests.'

What has been called Cézanne's 'constructive stroke'[16] was evolved around 1877. It appears in four copies executed roughly between 1877 and 1879. The first of these,[17] probably painted after a Second Empire engraving, represents a Rococo vase. If, as is generally presumed, this flower piece was included in the third Impressionist show, which took place in April 1877, it must of course have been finished before the spring of that year. In this case, the very methodical application of square brush strokes could mean that the artist reworked the canvas at a slightly later date. Another copy of the same period,[18] known to have been shown in the 1877 exhibition, represents a tiger made after a black-and-white lithograph by Barye. In this painting, too, the grid of the brushwork is more rigid than in the copy after Guillaumin's landscape. That the execution of the latter is less systematic may be explained by the fact that Cézanne now dealt with a *colored* work that limited the range of his interpretation. Also, the purpose here was, after all, to copy rather than to paraphrase. The copy after Guillaumin was followed in 1879 by a snow scene of Fontainebleau forest,[19] executed after a photograph. Here the slanting, square brush strokes form a closely knit pattern throughout the

58 Armand Guillaumin *Edge of a Wood* (near Issy-les-Moulineaux?) 1876

canvas. Thus, Cézanne's four copies, made after completely dissimilar models, illustrate the evolution of a particular technique that he was slowly to loosen up in the eighties.

Since Cézanne did not paint many copies, these four chronologically related works form a special group in his oeuvre. It does not appear impossible that, by using such models, the artist felt liberated from the strain that the intense scrutiny of his 'motifs' must have represented. Simultaneously, he could better concentrate on his brushwork, which in those years constituted a major preoccupation: first to master the problems of open-air painting, and later, to overcome the unstructured pictorial organization of the Impressionists. In two and possibly three of these copies Cézanne could even *invent* the colors, but in his painting after Guillaumin he merely transformed chromatism and execution in an obviously conscious

59 Paul Cézanne *Edge of a Wood* (near Issy-les-Moulineaux?) 1876

attempt to revise his friend's more spontaneous and more submissive approach to nature.

Cézanne's relations with Guillaumin did not stop there. In 1875, when Monet could not manage to assemble a second Impressionist show and when it even became doubtful that he would ever be able to reconstitute the group, Cézanne and Guillaumin accepted Pissarro's suggestion to join a new association of artists, a 'cooperative' formed by one Alfred Meyer, who had shown with Monet and his friends the previous year. Monet did succeed in raising the funds for a new exhibition in 1876, but neither Cézanne nor Guillaumin participated in it, the former having submitted a painting to the Salon jury (which rejected it), and the latter having been so absorbed by the demands of his job that he felt insufficiently prepared.

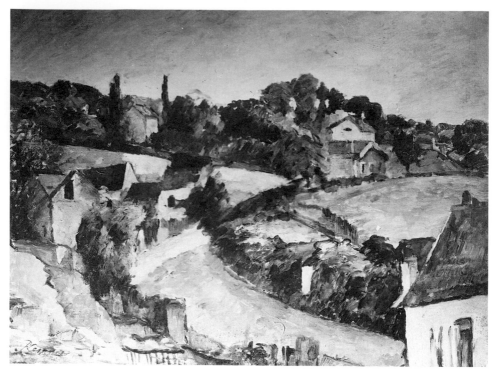

60 Paul Cézanne *Turning Road c.* 1877

While Cézanne was in Provence from the beginning of 1876 until the end of August, he corresponded with Pissarro about both Meyer's group—of which he became increasingly critical—and Monet's. Within days of his return to Paris he saw Guillaumin and dined with him and his mother.[20] It was Guillaumin who now filled him in on past events and future projects concerning their friends. On September 10, 1876, Cézanne informed his parents:

'I went to Issy [-les-Moulineaux] to see my friend Guillaumin. . . . I learned from him that the exhibition organized by our group of painters went very well last April. . . . According to what Guillaumin told me, I am one of three new members of the society who are to be included [in next year's exhibition], and that I was very warmly defended by Monet at a dinner meeting that took place after the exhibition when a certain Lepic protested my admission. I have not yet been able to see Pissarro [at Pontoise], nor any of my other acquaintances, because I set to work as soon as I arrived.'[21]

Issy-les-Moulineaux, outside Paris, was one of Guillaumin's favorite haunts. After Cézanne met him there in September, they seem to have painted the same landscape *(58, 59)*.[22] Guillaumin's canvas is dated 1876, and the colors of Cézanne's work point to the fall season. It would even appear as though

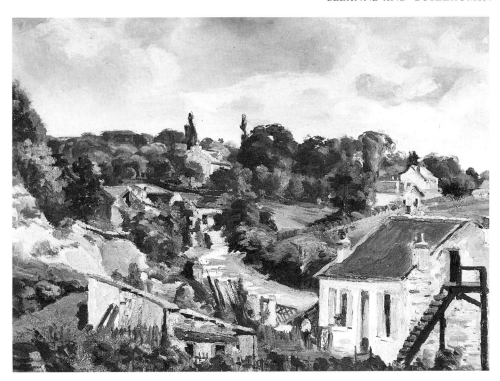

61 Armand Guillaumin *Turning Road c.* 1877

Cézanne joined his friend at a spot where the latter had already begun to paint, since there is still foliage in Guillaumin's version, whereas the trees in Cézanne's canvas are almost bare. Cézanne's brushwork is much freer than in the copies he may have started to make a short while later.

Toward the end of February 1877, Guillaumin wrote to Dr Gachet, 'Cézanne still works at his place, and a great deal.'[23] Evidently, out-of-door work being impossible at that time of the year, Cézanne could devote himself in the studio not only to still lifes or portraits, but also to occasional copies. Whether Cézanne was still Guillaumin's neighbor on the quai d'Anjou in February 1877 is not known, but by March he and his small family must have moved to 67, rue de l'Ouest, across the Seine and close to the Montparnasse quarter. This is the address under which Cézanne is listed in the catalogue of the third Impressionist group exhibition in which both he and Guillaumin participated. As soon as Monet found a backer for this new venture, the two friends, as well as Pissarro, resigned from Meyer's Union Artistique,[24] whose show opened two weeks before that of the Impressionists. Neither Cézanne nor Guillaumin, however, took part in the rather disastrous auction sale which some of the Impressionists organized after the close of their exhibition.

During that same year of 1877 Cézanne worked once more with Pissarro at Pontoise and appeared shortly thereafter in Auvers. In August, he wrote to

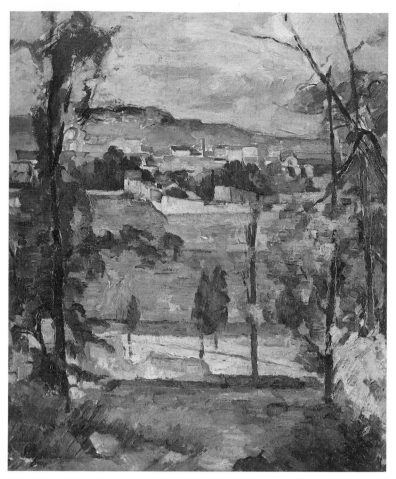

62 Paul Cézanne *Landscape c.* 1879

Zola from Paris: 'I go every day to the park at Issy where I make studies. I am not overly discontented, but it appears that a profound despair reigns in the Impressionist camp. Rivers of gold are not exactly flowing into their pockets and their work is withering on the vine. . . .'[25] No doubt, Cézanne had again met with Guillaumin at Issy and it was the latter who acquainted him with the difficulties experienced by their friends (among whom, besides Guillaumin, only Pissarro was in constant touch with him).

Unfortunately, two other landscapes that attest to Guillaumin's and Cézanne's close companionship of those years are not dated, nor is it known where they were painted. But one of them, which on stylistic grounds could be assigned to around 1877, may represent a site near Issy *(60, 61)*. The two friends seem to have set their easels on an elevated spot, looking down on a house in the right foreground and on a winding road that disappears into distant hills. Guillaumin apparently occupied a place to the right of Cézanne; their two canvases are of almost identical size.

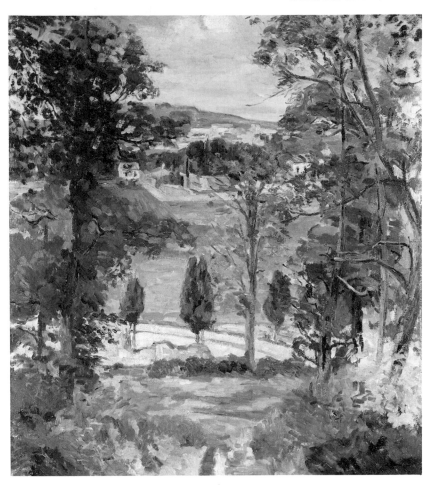

63 Armand Guillaumin *Landscape c.* 1879

Somewhat later, around 1879, the two artists worked together again, this time using vertical formats *(62, 63)*, as they had when they had painted side by side for the first time. In this case, too, their canvases are of practically the same composition and they seem to have stood very close together, but—strangely enough—once again there is more foliage on the trees in Guillaumin's landscape than in Cézanne's. In the lower right corner of both paintings appears a bush with yellow leaves, indicating once more that the season may be fall. In Cézanne's work there are traces of diagonal and square brush strokes, though they are not applied systematically; however, these strokes can be observed mostly in the foreground. One may wonder whether the artist proceeded so slowly while depicting this autumn scene, concentrating on specific areas, that by the time he 'reached' the top of the canvas the wind had swept the leaves away.[26]

There are no further indications of Cézanne and Guillaumin having painted the same motif, though other such instances may as yet be

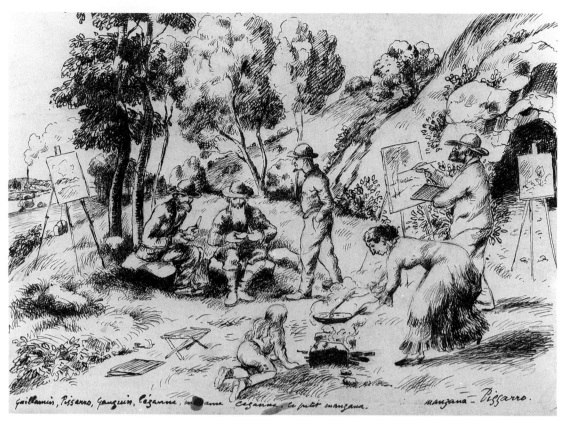

64 Georges Manzana-Pissarro *Impressionist Picnic* (Guillaumin, Pissarro, Gauguin, Cézanne, Mme Cézanne, and Manzana-Pissarro) Pen and ink, inscribed, 'Souvenir de l'été 1881'

undetected. And there is of course also the possibility that they worked together but stood at such angles to each other as to observe and represent completely different views from the same spot. In later years, Pissarro's son Georges Manzana (born in 1871) drew from memory an amusing scene near a riverbank, in which he assembled Guillaumin, Pissarro, Gauguin, Cézanne, Mme Cézanne, and himself *(64)*. Since all of them were friends and frequently visited with Pissarro, they may indeed have worked together by the Oise river. It is known that Pissarro, Gauguin, and Cézanne met in Pontoise during the summer of 1881, and Guillaumin probably joined them. The drawing is inscribed, 'Souvenir de l'été 1881.'

For subsequent years there are no signs of any more links between Cézanne and Guillaumin, except that from 1888 to 1890 Cézanne was back at 15, quai d'Anjou, where he had stayed in 1875–77, next door to Guillaumin. Yet nothing about their relations at that period has come down to us. By that time Guillaumin was married. Many a close friendship has been broken up when the wives of two old companions could not get along with each other, but it is

116

by no means known whether this was the case here. Cézanne did not keep the letters he received and Guillaumin requested that the personal papers he had saved be ultimately destroyed. In the absence of any data it can only be presumed that the unusually cordial amity of the two painters eventually dissolved.

After 1877, Cézanne never again joined the Impressionist group, whereas Guillaumin, though absent from the fourth exhibition (1879), appeared in all the following shows (1880, 1881, 1882, and 1886). In 1884, he was the only old-time Impressionist to participate in the first Salon des Indépendants which, toward the turn of the century, invited Cézanne to its yearly exhibitions. By then the two artists had lost touch.

In 1891, one of the bonds Guillaumin held paid a special premium—by lottery—of 100,000 francs and he retired from his job, able at last to devote himself completely to his painting. Cézanne, meanwhile, had broken with Zola, married Hortense Fiquet, inherited a fortune from his father, and increasingly withdrew into himself. After many years of great difficulties both artists were now financially independent, but Cézanne began to avoid most, if not all, of his former friends. Signac was never to forget how, as a young man, he was walking one day along the Seine with Guillaumin who had been his master when he was first beginning. When they caught sight of Cézanne

65 Paul Cézanne *Portrait of Armand Guillaumin* 1873, etching

coming toward them and were ready to greet him with effusion, they saw him making gestures, begging them to pass him by; amazed and deeply moved, they crossed the street and went on in silence.[27]

Around 1893, when Ambroise Vollard decided to become an art dealer, not only Pissarro (who had also lost contact with Cézanne), but also Monet, Renoir, and Guillaumin advised him to take an interest in the painter from Aix whose work, since the recent death of *père* Tanguy, nobody handled and who was known only to a few artists and writers, not having exhibited in Paris for over fifteen years. Among the initiate it was probably no secret that Cézanne and Guillaumin had once been friends, yet when Vollard finally opened Cézanne's first one-man show late in 1895, Pissarro reported, full of indignation, to his son Lucien:

'Would you believe that [the dealer] Heymann has the cheek to advance the absurdity that Cézanne has always been influenced by Guillaumin? Then how do you expect outsiders to understand anything! This monstrosity was expressed at Vollard's. Vollard turned blue.'[28]

NOTES

1. On Guillaumin's early years, on which not much is known, see C. Gray, *Armand Guillaumin* (Chester, Conn., 1972).

2. Reproduced in J. Rewald, *History of Impressionism* (New York, 1946), p. 164, and (1961), p. 192; also Gray, *Guillaumin*, p. 5, fig. 6. The painting, measuring $18\frac{1}{8} \times 15$ inches (46 x 38 cm), is now in the Musée Municipal, Limoges.

3. Camille Pissarro to Antoine Guillemet, Pontoise, Sept. 3, 1872; see J. Rewald, *Cézanne: Sa vie, son oeuvre, son amitié pour Zola* (Paris, 1939), p. 196.

4. This drawing was first identified as representing Guillaumin by W. Andersen, *Cézanne's Portrait Drawings* (Cambridge, Mass., 1970), p. 204, No. 226; the author compares it with a Guillaumin self-portrait of 1878 (Gray, *Guillaumin*, p. 19, fig. 29). A. Chappuis agrees with the identification but suggests that the drawing corresponds more closely to a self-portrait of *c*.1875 (ibid., p. 108, pl. 4). Actually Gray reproduces two

other self-portraits that are even more closely connected with this drawing; they show Guillaumin's head in an angle comparable to the one of Cézanne's sketch (ibid., frontispiece, dated 1872, and p. 149, pl. 61, *c*.1872).

5. What little is known about this painting is related in J. Rewald, 'Theo van Gogh as art dealer,' *Studies in Post-Impressionism*.

6. This fact, not mentioned when this study first appeared, was brought to my attention by both Robert W. Ratcliffe of the Courtauld Institute in London and Theodore Reff of Columbia University.

7. The picture, painted in Sept. 1871, is now in the Louvre. On the etching, see P. Gachet, *Cézanne à Auvers: Cézanne Graveur* (Paris, 1952); also J. Cherpin, *L'Oeuvre gravé de Cézanne* (Marseilles, 1972), No. 1.

8. See Gachet, *Cézanne*, and Cherpin, *L'Oeuvre gravé*, No. 2.

9. H. Platte, 'Zu einem Bild von Armand Guillaumin,' *Museum und Kunst: Beiträge*

für Alfred Hentzen, ed. H. W. Grohn and W. Stubbe (Hamburg, [1969–70]); both paintings are reproduced in color, figs. 58 and 59. The painting by Guillaumin and the article by Platte were brought to my attention by Walter Feilchenfeldt, Zurich.

10. J. Blot, 'Cézanne et Guillaumin [Letter],' *Beaux-Arts*, June 26, 1936; this document was brought to my attention by Robert W. Ratcliffe.

11. The connection between the shoveling man and Cézanne's painting was first observed by A. Chappuis, *Les Dessins de Paul Cézanne au Cabinet des Estampes du Musée des Beaux-Arts de Bâle* (Olten-Lausanne, 1962), vol. 1, p. 61, fig. 26; vol. 2, No. 66. On the verso of the right-hand sheet is the watercolor Venturi No. 844, whose existence may have caused the separation of the sheet.

12. These identifications were made by Chappuis, *Dessins de Cézanne*.

13. See G. Coquiot, *Vincent van Gogh* (Paris, 1923), pp. 136–37, quoted in J. Rewald, *Post-Impressionism: From van Gogh to Gauguin* (New York, 1956), p. 38.

14. See L. Venturi, *Cézanne: Son art, son oeuvre* (Paris, 1936), No. 153, and L. Venturi and L.-R. Pissarro, *Camille Pissarro: Son art, son oeuvre* (Paris, 1939), No. 123. The Pissarro landscape is dated 1871 and measures $43\frac{1}{4} \times 63$ inches (1.10×1.60 m); Cézanne's copy measures $28\frac{1}{2} \times 36\frac{1}{4}$ inches (73×92 cm).

15. C. Sterling, catalogue (second, revised edition) of the Cézanne exhibition, Musée de l'Orangerie, Paris, 1936, No. 49, p. 83. Sterling suggests the date of 1877–78 instead of Venturi's 1873.

16. See T. Reff, 'Cézanne's Constructive Stroke,' *Art Quarterly*, Autumn 1962, pp. 214–27.

17. Venturi, *Cézanne*, No. 222.

18. Ibid., No. 250; its model was identified by T. Reff, 'New Sources for Cézanne's Copies,' *Art Bulletin*, June 1960, p. 149.

19. Venturi, *Cézanne*, No. 336; it is reproduced, with the photograph after which it was done, in J. Rewald, *Paul Cézanne* (New York, 1948), figs. 58, 59; (New York, 1968), figs. 55, 56.

20. See Guillaumin's letter to Dr Gachet, Paris, July 2, 1876, in P. Gachet, *Lettres impressionnistes au Dr. Gachet et à Murer* (Paris, 1957), pp. 70–71. This letter cannot have been written in July but should instead be ascribed to Sept. 2, 1876.

21. See J. Rewald, 'Une Lettre inédite de Paul Cézanne,' *Mélanges Kahnweiler* (Stuttgart, 1966), p. 247.

22. The relation between the two landscapes was first noticed by Robert W. Ratcliffe.

23. Guillaumin to Dr Gachet, Paris, Feb. 24, 1877, in Gachet, *Lettres impressionnistes*, p. 73.

24. See Guillaumin's letter to Dr Gachet, Feb. 27, 1877, ibid., p. 73, note 1; also Rewald, 'Une Lettre inédite,' pp. 246–48.

25. Cézanne to Zola, [Paris] Aug. 24, 1877, in Paul Cézanne, *Correspondance*, nouvelle édition revisée et augmentée (Paris, 1978), p. 158.

26. That Cézanne was apt to work from the bottom of a canvas toward the top is illustrated by an unfinished landscape such as Venturi No. 175, which dates from 1882.

27. See Rewald, *Cézanne: Sa vie, son oeuvre*, p. 341; this incident was told to the author by Signac himself.

28. Camille Pissarro to his son, Paris, Dec. 4, 1895, in Camille Pissarro, *Letters to His Son Lucien* (New York, 1943), p. 277.

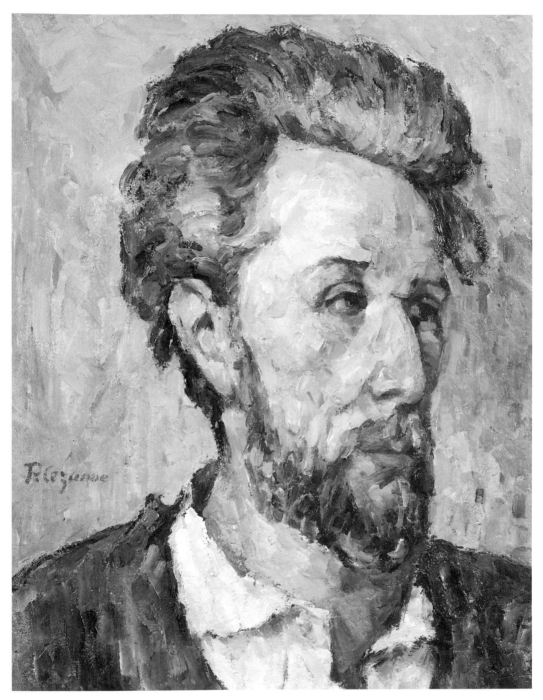

66 Paul Cézanne *Portrait of Victor Chocquet* 1876–77

Chocquet and Cézanne

To Sir Lawrence Gowing

Victor Chocquet was without doubt one of the most engaging personalites among the small group of supporters gathered around the Impressionists in the early years of their struggle for recognition. Yet little is known about the man whom Monet described as the only person he ever met 'who truly loved painting with a passion,'[1] while Renoir naïvely but admiringly called him 'the greatest French collector since the kings, perhaps of the world since the Popes!'[2] And Théodore Duret, the first historian of Impressionism, went so far as to assert that after 1877 Cézanne spent 'part of his time painting for him, in the city and in the country.'[3]

Most of what is known about Chocquet emanates from the circle of Renoir, whose friend Georges Rivière wrote at some length about this unusual patron, freely blending fact with fiction.[4] Renoir's son Jean subsequently enlarged upon the fiction, without adding many new facts.[5] From their descriptions there emerges a fairly picturesque and eccentric figure, one of those 'originals' who provide excellent copy. In a recent book on great collectors, Pierre Cabanne has at least added a few unknown dates to Chocquet's biography.[6]

As is often the case, there seems to be some truth behind the anecdotes surrounding Chocquet, but this truth is much less colorful and shows more rationalism than might be expected. That Chocquet was poor in his youth and had to go without meals in order to satisfy his longing for works of art is not borne out by any known facts. That he occupied a rather modest position with the Paris administration of customs, though perfectly true, could be explained as a sacrifice practiced by a 'fonctionnaire' who preferred an inferior rank in the capital to dreary tours of duty in the provinces which might have entitled him to promotions. That he went without a topcoat in winter—even if accurate—need not have been an expression of parsimony. That he *unexpectedly* came into a small inheritance is certainly false, since his friends seem to have been perfectly aware of the fact that his wife stood to inherit a sizable fortune (she had what the French euphemistically call 'des

First published in the *Gazette des Beaux-Arts*, July–August 1969

espérances'). And that he stopped collecting once the expectations became reality is a tale easily disproved. Nevertheless, data on Chocquet are scarce and a good deal of what follows is conjecture, but conjecture based on undisputed facts and newly discovered documents.

Victor Chocquet was born in December 1821 in Lille, and thus was about twenty years older than Cézanne, Renoir, or Monet (which may explain why the painters referred to him as '*père* Chocquet'). He was one of eleven children of a manufacturer who also raised three orphaned nephews or nieces. Although his father, who is credited with having introduced mechanical spinning to Lille—famous for its textile mills—had seen better times, the family was not exactly poor. When the father died in 1854, Victor Chocquet inherited several buildings jointly with his brothers and sisters; he seems to have drawn a yearly income of about 1,000 francs from these holdings. (In 1861, a seamstress working twelve hours a day earned but 2 francs for her daily labors.)

It is not known at what time he went to Paris to work for the government, but in June 1857, when, at the age of thirty-five, he married, he was employed by the administration. The marriage contract specifies:

'Marriage under the dowry system between Victor Guillaume Chocquet, employee at the Ministry of Finance in Paris, 204, rue de Rivoli, and Augustine Marie Caroline Buisson, 60, rue de l'Arcade in Paris, underage daughter of Eugène Alexandre Charles Buisson, property owner in Paris, 17, rue de Rochechouart, and Amande Julienne Buisson, his wife.

'The intended sets up as dowry all benefits to come. A dowry settlement is made by Madame Buisson to the intended, her daughter, of an annual income of 1,000 francs—capital of 20,000 francs.

'Reciprocal disposition to the survivor for lifetime use of the benefits of the predeceased.'[7]

The bride, an only child, some fifteen years younger than her husband, was born in March 1837 at Nonant in Normandy, but had been raised in a fashionable boarding school in Paris. When she was ten, her parents had obtained a legal separation, in connection with which her father had settled on his daughter a capital of 25,000 francs. This money may have served for her education, since it is not mentioned among her assets in the marriage contract. It seems that financial reverses forced her parents to withdraw her from the boarding school when she was eighteen. It was not long after this that she met Chocquet. The fact that, though still a minor, she did not live with her mother might indicate that the latter did not reside in Paris but rather in Yvetot, a locality halfway between Rouen and Le Havre, whence she hailed.

The bride's mother was born in 1815 in Hattenville, a small village not far from Yvetot, lying toward the coast. Her maiden name was Buisson. Both she

and her brother, Augustin-François Buisson, had inherited various farms and properties in Hattenville and in the general region. It was in Hattenville that, in 1835, Victor Chocquet's future mother-in-law had taken for her husband another Buisson, Eugène-Alexandre Charles, who does not seem to have been related to her and about whom little is known. His few distant relatives eventually located were without exception of rather low extraction. His wife, on the other hand, not only held considerable real estate (the marriage contract of the Chocquets specifies that the bride's dowry was provided by her *mother*), but came from a locally prominent family. There was a wealthy cousin in Dieppe, a lawyer who had no direct heirs, and a more distant one in Rouen, a former Justice of the Tribunal of Commerce; more important still, her brother—Mme Chocquet's uncle—was a highly distinguished citizen, a lawyer in Yvetot, member of the Conseil Général (an elected body comparable to a departmental chamber), and one-time deputy.

According to what Renoir later told his son, Chocquet, whose position with the finance administration was a very humble one, had difficulties with his superiors and on several occasions might have lost his job were it not for a mysterious 'protector.'[8] This guardian angel doubtless was none other than his wife's deputy-uncle, although the latter's influence cannot have been very far-reaching. Indeed, Victor Chocquet never progressed beyond the level of 'rédacteur principal à la direction de Douanes,' which, in fact, was next to the lowest in the bureaucratic hierarchy. But since both he and his wife had a modest income, he may not have been too anxious to take on increased responsibilities with increased pay. As it was, everything seems to indicate that he loathed his work.

In the spring of 1861, a daughter was born to the young couple; she died in October 1865.[9] There was to be no other child. It has been said that the parents never completely recovered from this loss. Except for this tragedy, the union seems to have been a cloudless one. Even though Chocquet was not particularly happy in his office, even though he did not earn much, and even though, from all that is known, his wife did not share her husband's taste for art,[10] he found ways to gratify his passion for collecting not only paintings and drawings, but also fine pieces of furniture, silver, porcelain, and assorted objets d'art. There are stories according to which he always refused to sell his possessions and scornfully turned down the most tempting offers, yet he did resort to trading when he could not afford a coveted item, thus continually enlarging as well as 'upgrading' his collection. In any case, he does not seem to have spent much on his purchases. Like many a born collector, Chocquet must have had an unerring instinct for quality, doubtless enhanced by knowledge in the field of applied arts which enabled him to discover hidden treasures at secondhand dealers. With this went a degree of independence and the courage to rely on his own judgment. Among artists, his preference went to those who were still more or less neglected and consequently did not yet

command high prices. (It becomes obvious that Chocquet could not have indulged in his favorite pastime of hunting for masterpieces had he held a position in a small town somewhere near the French borders.)

In all likelihood, Chocquet had begun collecing while still a bachelor and little by little had assembled a group of works by his particular idol, Delacroix. After five years of marriage and shortly after his daughter's birth, he felt bold enough to write to the master in the hope that he would accept a commission for a portrait of Madame Chocquet. But the artist—who died the following year—declined because eye trouble had caused him to give up portraiture altogether.[11] Three weeks after Delacroix's refusal, Chocquet acquired an *Annunciation* by the master for 600 francs at the Vente Blanc of April 7, 1862. Two years later, Chocquet attended the auction sale of the contents of Delacroix's studio, and there bought an oil painting, *Bouquet of Flowers*, as well as a watercolor, *Mars-el-Kebir*.[12] These were Nos. 92 and 574 of the catalogue. It seems easy to imagine the pangs of hope and regret experienced by an ardent collector of limited means, who for more than a week watches several hundred works go by, possibly bidding unsuccessfully on quite a few (and not going to his office during that time?). Both works that Chocquet acquired were among the last half dozen of their categories; it is conceivable that either the bids slackened toward the end, or Chocquet put in higher bids for fear of not getting anything he wanted.

One large watercolor of flowers *(92)* escaped him. It was No. 614 of the catalogue, where it was accompanied by an unusual note. Indeed, this was a work of exceptional importance since Delacroix had singled it out in a unique clause of his will, insisting that it be placed in his posthumous sale. 'It is my express wish that a large brown frame [*sic*] representing flowers placed as if at random against a gray background be included in the sale. . . . ' The watercolor went for 2,000 francs to Achille Piron, the executor of the artist's estate. But the very next year, in an anonymous sale after the death of Piron, Chocquet was able to buy this remarkable work for only 300 francs.

Despite Chocquet's rather modest purchases at the Vente Delacroix, Philippe Burty, in a notice on the sale, named him among the well-known *amateurs* who attended the event.[13] Burty did not mention a novice collector who also bought two works by Delacroix at this auction, namely Georges de Bellio, a wealthy Rumanian living in Paris.[14] It is not known when Chocquet and de Bellio first met, but since both apparently had similar tastes in art and frequently went to auctions or made the rounds of Paris antique dealers, they were bound to become acquainted.

Near the end of 1865, Madame Chocquet's father died. Her husband seems to have thought very highly of him, for he wrote to relatives in Lille, 'He was an educated man, liberal, generous, perhaps too generous. . . . Marie has much grief, as do I.'[15] Could it have been his generosity that caused M. Buisson to die penniless? There is nowhere among the family papers the

slightest hint that his daughter inherited anything from him, although she was doubtless his sole legal heir. If Chocquet was attached to his wife's father, he apparently was much less fond of his mother-in-law, who seems to have lived with her bachelor-brother in Yvetot where the latter had bought a house in 1863 which he subsequently improved and enlarged through the purchase of properties along the border.

There is a gap of ten years in Chocquet's life about which nothing is known. These were the agitated years, overshadowed by the Franco-Prussian War of 1870–71 (at nearly fifty, Chocquet was obviously exempt from the draft). If the Chocquets remained in Paris during these events, they were not only cut off from their families—Madame Chocquet's deputy-uncle became mayor of Yvetot during the German occupation—but lived through harrowing days. The defeat of Sedan was followed by the siege of Paris, during which the forests around the city went up in flames; from their apartment high up in a building at 198, rue de Rivoli, facing the Tuileries,[16] they could have seen the glow at night. Then the symbolic one-day occupation of Paris, and finally the Commune. Before the insurgents retreated on May 24, 1871, they set fire to many public monuments, such as the Tuileries and the finance ministry in the Pavillon de Flore, an aisle of the Louvre extending along the rue de Rivoli. This time the Chocquets could not only have witnessed the conflagration, but would actually have been threatened by the blazes raging at an uncomfortably close range.

In the annals of art history, Victor Chocquet reappears on the occasion of the first Impressionist group exhibition in 1874, although in a negative way. It seems that he wished to visit the show, but was dissuaded by 'well-meaning' friends. Thus he did not see, among others, Cézanne's *House of the Hanged Man*, one of the artist's three works on exhibit, which was purchased by Count Doria for 300 francs. The next year, however, Chocquet did attend the public auction organized in March by Monet, Renoir, Sisley, and Berthe Morisot. Almost fifty years later, Monet said that after the sale he was introduced to Chocquet, who had bought one of his Argenteuil landscapes for 100 francs. 'It was with real tears that he said to me, "When I think that I have lost a year, that I could have been able to know your painting one year sooner. How has it been possible to deprive me of such pleasure!"'[17]

Unfortunately, this anecdote is contradicted by documented facts. Not only is there a letter of Monet's dated February 1876 which proves that at that time he had not yet met Chocquet, but the *procès-verbal* of the sale shows that the collector did not buy anything, even though the prices were ridiculously low.[18] As a result of the auction, however, Chocquet is said to have discovered in Renoir's work certain affinities with the much-admired Delacroix. He reputedly wrote to the artist on the very evening of the sale to compliment him and to ask whether he would be willing to do a portrait of Madame Chocquet *(67)*. Renoir immediately went to see this unexpected benefactor

who received him in his rue de Rivoli apartment filled with pictures and with precious eighteenth-century furniture. Later, Renoir was to remember: 'As soon as I met Monsieur Chocquet, I though about having him buy a Cézanne! I accompanied him to *père* Tanguy's where he took a small *Study of Nudes*.[19] He was delighted with his acquisition, and while we were returning to his home [remarked], "How well that will go between a Delacroix and a Courbet!" '[20]

However, the circumstances of this purchase seem to have been somewhat convoluted. According to what Renoir himself apparently later told a friend, Chocquet asked Renoir to keep the Cézanne for him, and during the following month whenever he invited the painter to dinner made it a point to ask him for his opinion of Cézanne in front of Madame Chocquet. 'I have a very fine one at home,' Renoir would say. 'It has its defects, but it is a beautiful thing.' On several occasions Renoir would bring the picture along but at the bottom of the staircase Chocquet would say, 'No, no, not today.' Finally, he did take it up. Madame Chocquet was horrified. 'Marie, let's see, Marie, it is not mine, it is Monsieur Renoir's.' But eventually Renoir took advantage of the absence of Chocquet to tell the whole story to his wife: 'Act as if you didn't know anything,' he suggested, 'you would make him so happy.'[21]

According to Tanguy's records, in 1875 he sold three paintings by Cézanne, each for 50 francs (which was even less than the average obtained by his friends at their auction). But these transactions took place on October 21, November 1, and December 30; if any of these involved Chocquet, at least seven months would have elapsed between his acquaintance with Renoir and his first purchase from Tanguy.[22] It is of course possible that Renoir had wished to finish Madame Chocquet's portrait and see the collector's reaction before drawing his attention to Cézanne. Renoir subsequently brought the two men together and, as Cézanne later said, it was Delacroix who served as intermediary between them.[23]

With regard to Monet, the only known fact is that early in 1876 Cézanne in turn took Chocquet to Argenteuil and inroduced the painter to the new Maecenas. Indeed, on February 4, Monet wrote the collector: 'I made Cézanne promise that he would come with you for lunch tomorrow, Saturday. If it doesn't bother you to have a very modest lunch, it would be the greatest pleasure for me because I couldn't be more pleased to make your acquaintance.'[24]

This letter establishes beyond any doubt that Chocquet and Monet had not previously met, so that his story of talking with Chocquet after the auction of March 1875 must be ascribed to faulty memory. The document also shows that by early 1876 Cézanne, usually extremely reserved and suspicious, was on cordial terms with Chocquet. (It is actually surprising that Monet should have asked Cézanne rather than his 'buddy' Renoir to bring the collector to

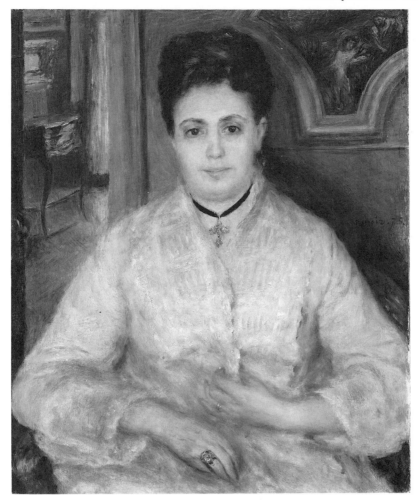

67 Auguste Renoir *Portrait of Mme Chocquet* 1875

Argenteuil.) Whether Chocquet had already acquired additional works by Cézanne since his initial purchase from Tanguy is not known, but he now bought an autumn landscape by Monet, probably directly from the artist; the visit to Monet's studio and the lunch were obviously arranged for the purpose of selling him pictures.

For the Impressionists, Chocquet appeared on the scene at a highly critical moment, when their pockets were empty and the outlook seemed particularly grim. By the time the painters opened their second group exhibition, in April 1876 (barely one year after Renoir had become acquainted with Chocquet), the collector was listed in the catalogue as lender of one landscape by Monet, another by Pissarro, and no fewer than six pictures by Renoir.[25] Among these were Chocquet's portrait *(68)*, which Renoir must have done since finishing the likeness of his wife, as well as two more paintings of Madame Chocquet,

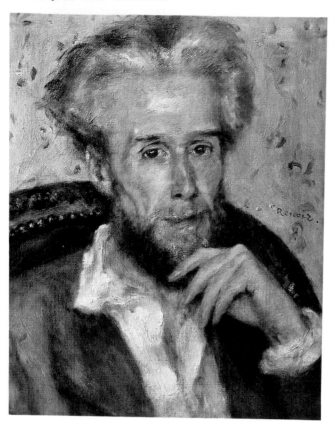

68 Auguste Renoir *Portrait of Victor Chocquet c.* 1875. This portrait was reproduced as frontispiece in the catalogue of the Chocquet collection, 1899

one standing in a black dress. In the other, titled *Woman Reading*, she is seated at an open window of their apartment with a view of the Tuileries Gardens in the background *(69, 70)*. Renoir also painted a small canvas of the view from this window, possibly as preparation for the likeness of Madame Chocquet. (Chocquet did not purchase this landscape study.)

Zola obviously knew Chocquet or at least knew of him. When he assembled preparatory notes for his novel *L'Oeuvre*, which appeared in 1886, he wrote concerning the collector, 'A former chief clerk . . . who had selected at Lantier's [i.e., Cézanne] the starkest works, which he hung next to his Delacroix's, predicting that they would achieve equal fame.'[26]

It would seem amazing that despite his restrained budget, Chocquet was able to acquire so many paintings by his new friends, even though their prices were low, and even though the artists were conceivably so touched by his love for their work that they lowered their prices still further for him. On the other hand, there are indications that Chocquet was loath to use his friendship with the artists to gain financial advantage. There is a typical incident, later remembered by Renoir, according to which Chocquet once begged him for permission to salvage a small self-portrait with which the painter had been so dissatisfied that he had thrown it away. Renoir did not dare refuse the favor,

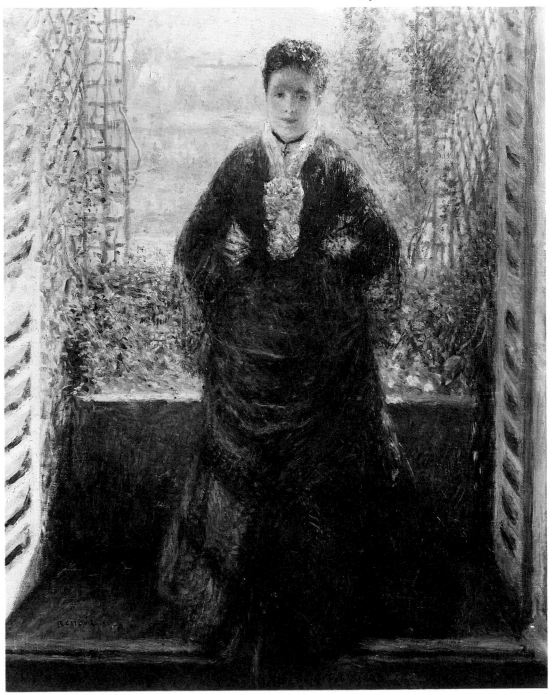

69 Auguste Renoir *Mme Chocquet in a black dress*, standing at the window of their apartment, rue de Rivoli *c.* 1875

but was embarrassed because he felt the work was unworthy. A few days later, Chocquet returned with some bank notes. The canvas had been greatly admired by his fellow collector Georges de Bellio, and Chocquet had sold it to him, grabbing the opportunity to raise some money for its creator.[27]

Chocquet and de Bellio may have met at the Impressionist exhibition of 1876, which the Rumanian must have visited repeatedly since he purchased no fewer than three paintings by Berthe Morisot. It is known that Chocquet spent as much time there as possible, turning into a kind of apostle, trying to share his admiration and pleasure with numerous visitors, whether he knew them or not.[28] The fervor of his support and his disinterested efforts on their behalf can only have endeared him further to the Impressionists, who were not used to such unrestrained as well as enlightened enthusiasm.

Since Cézanne was in the South during the exhibition, Chocquet provided him with detailed news and 'a large number of catalogues and newspapers,' both favorable and unfavorable, concerning the event.[29] In view of the fact that Cézanne did not participate in the show, it is not possible to determine how many of his works—in addition to those by Renoir, Monet, and Pissarro, which Chocquet lent—the collector may have owned at that time. We know that the Pissarro landscape lent by Chocquet in 1876 was painted in 1874, and we may presume that he usually bought recent works from the painters he knew. But does this also mean that in 1862, the year Delacroix declined to paint Madame Chocquet's portrait, the collector purchased a Courbet, a Tassaert, and a Delacroix, all of which are dated 1862, as well as another painting by Delacroix which came up in an auction that year? Whereas Chocquet obtained only one oil and one watercolor at the Delacroix sale, his collection eventually contained at least seven other paintings by the master (of a total of twenty-three) and twenty-two more watercolors (of a total of thirty-four), which bore the stamp of the studio sale but which his limited means had not permitted him to buy directly at that auction in 1864. As for the smaller version of Renoir's *Moulin de la Galette* which Chocquet owned, it is conceivable that it was actually commissioned by him after he saw the larger one (acquired by Caillebotte) which evidently was much too big for his crowded apartment; the painting is dated 1876 and could have been added to the collection that very year.

In the case of Cézanne it is even more difficult to establish probable dates of purchases, because no precise dates of execution are known for most of his works. Moreover, Chocquet acquired several of Cézanne's paintings that must have been done *before* the two met, such as V. 149, 156, and 171, all painted at Auvers in what might be called the artist's early Impressionist phase. But Chocquet apparently never purchased any of the painter's powerful 'black' pictures, executed before he began to work with Pissarro in Pontoise. On the other hand, he did own three watercolors by Cézanne of the middle sixties.

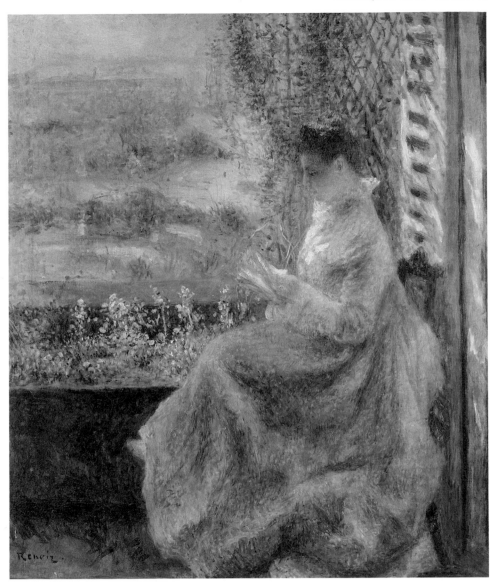

70 Auguste Renoir *Woman Reading* (*Mme Chocquet in a white dress* at the window of their apartment) *c*. 1875 (included as *La Liseuse* in the second Impressionist exhibition, 1876)

Unlike such fellow collectors as de Bellio and Caillebotte, who on occasion are supposed to have acquired canvases considered particularly 'unsalable' in an obvious attempt to help their artist friends, Chocquet did not necessarily buy directly from the painters (as Caillebotte always did).[30] His primary objective seems to have been to secure works that promised delectation. Since he bought exclusively for his enjoyment, he was also, to a certain extent, indifferent to prices, or at least could not be swayed because a painting was

131

cheap. A study of the few auctions that Chocquet is known to have attended shows that he was apt to pass up canvases by Monet or Sisley that went for fewer than 100 francs so as to bid a much higher amount for a picture by Berthe Morisot (who needed the money less than the others).

Except for public auctions there is, unfortunately, no record of when Victor Chocquet acquired what, and it is even unlikely that such a record ever existed. When his friend Philippe Burty was preparing a book on Delacroix and simultaneously assembling the master's letters, he asked Chocquet for his recollections of the studio sale as well as for a list of the artist's works in his possession; Chocquet replied very graciously, but suggested that Burty establish the list himself, 'convinced that you will do it more methodically and with more discernment than I.'[31]

It is only through conjecture and through secondary, often imprecise evidence that the story of Chocquet's friendship with Cézanne—who seems to have been closer to him than any other painter, even Renoir—can be pieced together. We know that they met through Renoir, probably during the latter part of 1875. Since he had recently commissioned Renoir to do a portrait of Madame Chocquet, it is possible that Chocquet asked Cézanne to paint another, unless he requested one of himself. It is also possible that the artist, always intimidated by women, insisted on painting a likeness of Chocquet rather than of his wife (the more so as she supposedly did not share her husband's high opinion of Cézanne). Whereas there exist at least two portraits of M. Chocquet and three of Madame by Renoir, Cézanne did no fewer than six of his friend—as well as several drawings—but none of the spouse.

Since Cézanne left Paris in the spring of 1876, sometime between the visit with Monet early in February and the opening of the Impressionist show on April 1, it appears doubtful that his first portrait of Chocquet was finished by then; it may not even have been begun. In view of Cézanne's slow working methods, and due to the fact that his model, still employed by the customs, was not always available for sittings, R. W. Ratcliffe is certainly right in presuming that the portrait, interrupted by the artist's absences from Paris, progressed only gradually.[32]

In a letter to Chocquet from Provence, Cézanne must have extolled the beauties of L'Estaque, a small fishing village between Aix and Marseilles, where he settled early in June for the rest of the summer.[33] Chocquet thereupon seems to have suggested that he paint some landscapes of the region for him. On July 2, Cézanne wrote to Pissarro:

'I have started two little motifs with the sea, for Monsieur Chocquet, who had spoken to me about them.—It is like a playing card. Red roofs over the blue sea. If the weather becomes favorable I may perhaps carry them through to the end. . . . There are motifs that would need three or four months work, which would be possible, as the vegetation doesn't change here. The olive and pine trees always keep

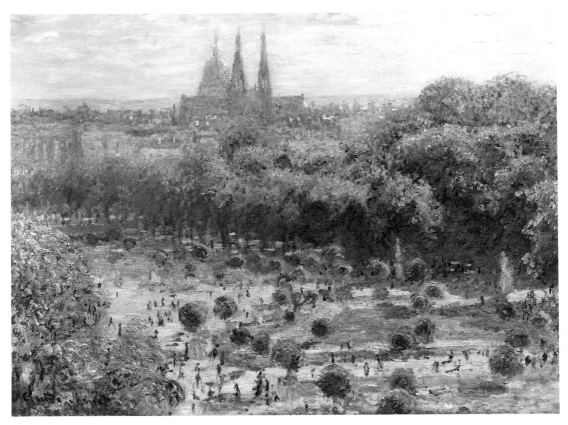

71 Claude Monet *The Tuileries*, seen from the Chocquet apartment, rue de Rivoli 1876

their leaves. The sun here is so tremendous that it seems to me as if the objects were silhouetted not only in black and white, but in blue, red, brown, and violet. I may be mistaken, but this seems to me to be the opposite of modeling.'[34]

This observation notwithstanding, it would appear that what Chocquet appreciated most in Cézanne's work, at least in the beginning, was precisely the 'modeling' although he simultaneously admired the softer touch and more iridescent palette of Renoir, as well as the nervous, sweeping, and often almost 'sketchy' execution of Delacroix.

While Cézanne was tackling views of l'Estaque for Chocquet, Monet—shortly after the close of the 1876 exhibition—availed himself of the splendid panorama afforded by the windows of Chocquet's apartment which had also attracted Renoir: in the foreground, the Tuileries Gardens; to the left, the Louvre; straight ahead, in the distance, the twin spires of Ste-Clotilde near the Dôme des Invalides.[35]

Monet painted at least four views from Chocquet's windows *(71)*. In a letter of June 7, 1876, to Georges de Bellio, he mentions his recent 'views of Paris,'[36] which he wished to show to this new partisan of Impressionism in the

133

obvious hope that he would buy one. Three of the four versions were sold fairly soon: one to de Bellio (now in the Musée Marmottan, Paris); a second to Ernest May (another early patron of the Impressionists); and the third to Caillebotte (bequeathed by him to the Louvre). If Chocquet acquired one, it could only have been the fourth and most sketchy canvas, yet there is no indication that one of the series ever belonged to him, although he ultimately owned no less than a dozen paintings by Monet.

Whether Cézanne had finished the two paintings for Chocquet when he returned to Paris early in September is not known, but he probably brought at least one L'Estaque landscape (V. 168) *(72)*. On the other hand, he now presumably proceeded with the portrait of his friend.

On November 19, 1876, the lawyer-uncle of Madame Chocquet died, leaving his entire estate to his sister, mother of Madame Chocquet, with whom he seems to have shared his house in the rue de Caudebec at Yvetot.[37] If the former deputy really had been the mysterious 'protector' of Victor Chocquet, then his death must have affected the 'chief clerk at the Board of Customs.' And that seems indeed to have been the case. On February 23, 1877, four months after the death of his wife's uncle, Chocquet handed in his resignation. He was then fifty-five years old, could expect only a modest pension, and apparently had to manage without any support from his well-to-do mother-in-law. Instead, Marie Chocquet soon wrote to her husband's favorite sister in Lille, Eléonore, a spinster, to ask for the remittance of funds owed them. Her letter provides a graphic description of their situation:

'I wanted to write you sooner, but Victor prevented me from doing so by saying, "Don't bother Nonore anymore with our accounts, they will wind up sending them after all. . . . " But I see that nothing comes. . . . Serious things have happened to us since my last letter, my good friend. Victor has requested his retirement, which was granted; it is now close to four months that he no longer goes to his office! I told you when I wrote you last time that he was not well, completely disgusted with his dreadful office and really at the end of his rope. . . . Therefore we are now reduced to very small means, and what is even more painful is that my mother does not seem to be aware of this in any way. Yet, she ought to know that Victor's pension will be paid out at the earliest in October, and that between now and then we shall not receive anything, absolutely nothing from the ministry! I have received a letter from her in which she invites us to spend the summer with her at Yvetot, but that scarcely appeals to Victor. Then, before leaving, wouldn't it be necessary to pay one's rent for July, one's taxes, one's insurance? Finally, to sum it up, we are really strapped; we are too proud to ask for anything, and meanwhile time goes by and our resources are running out. . . . I hope that you are not going to be distressed, but you must understand that under the circumstances Victor has the keenest desire to see the accounts settled. . . . '[38]

It is of course possible that Marie Chocquet somewhat exaggerated their condition in the hope of obtaining a prompt payment, yet it was certainly true

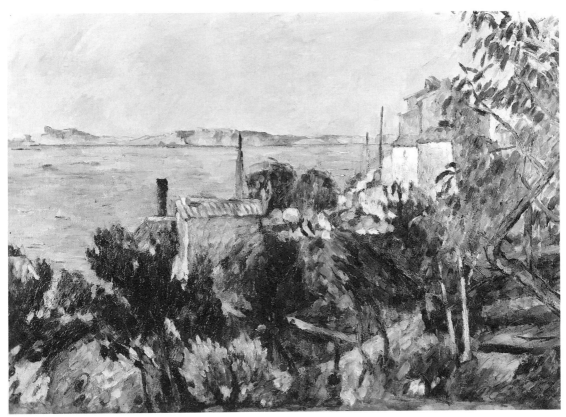

72 Paul Cézanne *L'Estaque c.* 1876

that with his passion for antique furniture and Impressionist paintings, Victor Chocquet could not have saved much of his meager salary. Despite his worries, however, Chocquet was free at last, free to do what he liked within the confines of his restricted budget, free to pose for Cézanne whenever the painter wished, free to spend all his time at the third Impressionist group exhibition which opened early in April 1877. And that is exactly what he did.

Whether as a result of financial difficulties or not, this time Chocquet's name does not appear among the lenders to the show, at least not of works by Monet, Renoir, or Pissarro, as he had contributed to the exhibition of 1876. On the other hand, de Bellio lent three Paris views by Monet (among which was one of the Tuileries painted from Chocquet's window) and three landscapes by Sisley. It is certain, however, that Chocquet did lend some of his Cézannes, such as his own portrait *(66)*, but it is impossible to enumerate his loans because Cézanne did not indicate *any* lenders for his entries.[39]

When the time came for Cézanne to list the works he would show with the group, he provided a series of titles that were so vague as to allow him to make his choice almost at the very last minute.[40] Indeed, the artist announced merely three still lifes; two flower studies; four landscapes, studies from

nature; as well as *The Bathers(Study, Project for a Painting)*; *Tiger*; *Figure of a Woman* (*Study from Nature*); *Head of a Man* (*Study*); and three watercolors (two *Impressions from Nature* and one *Flowers*). In addition, he sent at least one painting not listed in the catalogue, subsequently called *The Fishermen (73)*, which was hung over a doorway; it is described at length in an article by Georges Rivière.[41] It is not possible to establish with certitude which were the still lifes, the studies of flowers, or the landscapes shown by Cézanne, but of the remaining works, three can be identified. These are *Tiger* (V. 250); *Head of a Man* (V. 283), which was Chocquet's portrait; and *The Fishermen* (V. 243). All three eventually belonged to Chocquet, although it is conceivable that at the time of the exhibition he owned only his portrait and possibly *Tiger*. The project for a painting, *Bathers (74)*, may also have been Chocquet's, but it is not unlikely that Cézanne substituted the final version of *The Bathers* (V. 276) for the *Study* (V. 273) listed in the catalogue.[42]

The *Tiger* shows so close a relation to Delacroix that it was considered to have been inspired by him; it is in any case a painting that Chocquet was certain to appreciate. Theodore Reff has determined that it is actually a copy after a lithograph by Barye (of which Cézanne owned a print).[43] Even so, it could well be that Chocquet commissioned this copy.

73 Paul Cézanne *The Fishermen c.* 1875

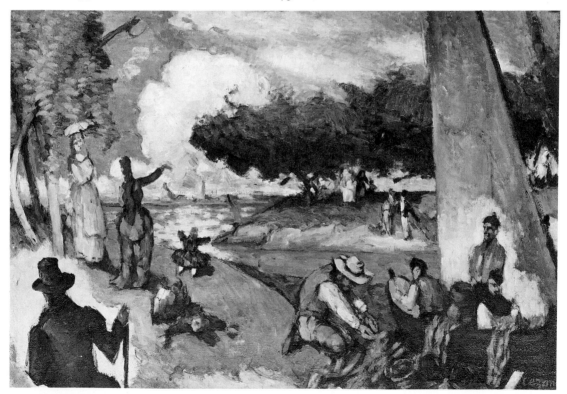

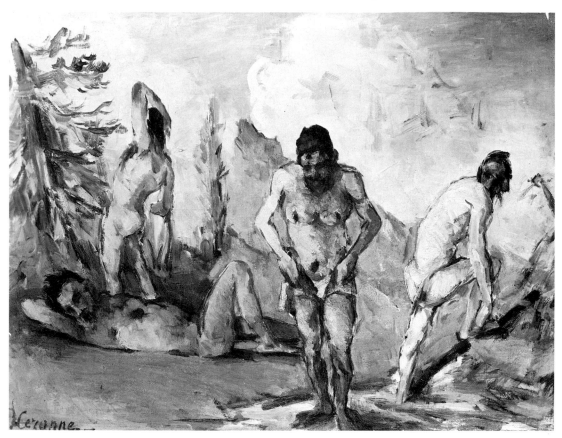

74 Paul Cézanne *Bathers* 1875/76

The Fishermen is a rather unusual work for Cézanne at this period of his evolution. He was then emerging from the phase during which he had worked from nature at Pissarro's side and had patiently accumulated small brush strokes to capture fleeting nuances and push visual veracity ever further. But here this process is applied to an imaginary scene where—in a setting not unlike a Monet Argenteuil landscape—a group of more or less incongruous figures appears, all sharply set against the sunlit background. It is a canvas distinguished by that heavy and firm modeling which seems to have particularly attracted Chocquet.

From the point of view of execution, the portrait of Chocquet *(66)* shows an even thicker impasto of superimposed brush strokes, not unlike *The House of the Hanged Man (87)*. Work on it, possibly begun during the latter part of 1875 and suspended when Cézanne left for the South in the spring of 1876, was doubtless pursued after the artist returned to Paris early in September 1876; in any case, by April 1877 the likeness was ready. The 'evidence of incessant revision and continual repainting,' which Roger Fry was one of the first to observe, led him to say that it 'has been carried on here until the whole

137

surface is heavily loaded with pigment which acquires a crumbled, granular surface. . . . When this happens the colour loses something of its saturation and clarity, it becomes almost turbid and opaque. But for all the obstinate endeavour of which this shows signs the firm cohesion of design, and the vigorous modelling, show how completely [Cézanne] was able in the end to express his idea.'[44]

Tiger, *The Fishermen*, and the portrait of Chocquet have one thing in common: all three are signed. Signed works are comparatively rare in Cézanne's oeuvre. In a general way, it seems that he signed canvases most frequently when he intended them for friends (though many of the pictures given to Zola, Pissarro, Guillaumin, Renoir, and others do not bear signatures), for an exhibition, or for a collector. Since the majority of the paintings purchased by Victor Chocquet are signed, it would seem that the latter insisted on a signature whenever this was possible. But these three oils, all shown with the Impressionists in 1877, share another peculiarity: they are signed in *red*. This fact has inspired Reff to formulate an ingenious hypothesis by which he attempts to remedy the lack of information concerning the works exhibited by Cézanne with the Impressiont group. Reff wonders whether the red signature is not a means of identifying the other paintings shown in 1877 by Cézanne under 'noncommittal' titles.[45]

This theory would make it appear as though Cézanne were systematic about such details as signatures, which he certainly was not. However, there was Chocquet, not only a lender but a friend, and one who did care about signatures. Having provided extremely vague titles for the catalogue so as to retain until the last minute a certain freedom of choice, the artist may very well have asked Chocquet for assistance in selecting the works to be shown. This selection undoubtedly was made in his Paris studio (he then lived at 67, rue de l'Ouest). The choice once made, Chocquet, according to habit, may have advised Cézanne to sign the chosen canvases, and this was done then and there, the same red color being used throughout.[46]

The facts are that Cézanne showed three still lifes and that there are three still lifes of that period with red signatures (V. 196, 197, and 207) *(78, 79)*. All three belonged to Chocquet. The artist exhibited only two flower pieces, yet there are at least four signed in red: V. 179 and 180 of the Auvers period, and V. 222 and 182 executed subsequently; the last one belonged to Chocquet. (Its companion, V. 181, also owned by Chocquet, is signed in bluish-gray; it seems conceivable that it had been signed previously, at the time the collector acquired it, and therefore no red signature was applied in this one instance.) As to the four landscapes on Cézanne's list, there are several from his Auvers period signed in red, but there are also four from around 1876. These are V. 464, 158, 168, and 171; all four belonged to Chocquet, V. 168 being the view of L'Estaque specifically painted for him *(72)*. This leaves only *The Bathers* (*Study, Project for a Painting*), which is signed in red, and *Figure of a Woman*

138

(*Study from Nature*), a work not yet identified. In other words, there are indeed enough paintings with red signatures to fulfill the premises of Reff's assumption, but what is more surprising is that practically all of them belonged to Victor Chocquet.

Obviously, the pictures listed here would have to have been executed before the April 1877 opening of the third Impressionist show; and Chocquet, despite his straitened circumstances, would have acquired ten or more paintings by his friend within about a year and a half. Moreover, virtually all of Cézanne's works in the exhibition would have been lent by Chocquet. It may not be easy to reconcile these facts and theories. Some of the pictures, particularly the still lifes, could have been painted *after* 1877, some may have been exhibited and reworked later, and some of Chocquet's purchases could have been made after the show, once his financial situation had improved. Yet the possibility remains that Cézanne's red signatures are associated with the third Impressionist exhibition. This would automatically increase Chocquet's participation in the event although his name appears nowhere in the catalogue.[47]

One thing is certain: Chocquet, liberated at last from his drudgery, spent all his time at the galleries, something he may also have done, of course, even if most of the Cézannes on view had not been his. Cézanne's work seemed particularly to excite the hilarity of the crowds, but the portrait of Chocquet was singled out for special mockery. The critic Louis Leroy, who had already distinguished himself by his snide commentaries in 1874, now advised his readers: 'If you visit the exhibition with a lady in a delicate condition, pass rapidly in front of the portrait of a man by Cézanne. . . . This head, its color the reverse side of boots, with such a strange appearance, might affect her too vividly and give yellow fever to her offspring before its entry into the world.'[48]

Rivière, who had helped his friend Renoir to organize the show, later remembered how outraged Chocquet had been by the attitude of the public and how he had endeavored relentlessly to convince stubborn visitors. He would challenge the laughers, make them ashamed of their jokes, lash them with ironical remarks. In animated, daily repeated discussions, his adversaries never had the last word. Scarcely had he left one group when he would be discovered someplace else, dragging a perverse art lover almost by force before the canvases of Renoir, Monet, or Cézanne and trying to make the other share his admiration for these unappreciated painters. He found eloquent phrases and ingenious arguments to convince his listeners. With clarity he explained the reasons for his partiality. In turn persuasive, vehement, domineering, he devoted himself tirelessly, without losing the urbanity that made him the most charming and formidable of opponents.[49]

According to Duret's recollections, Chocquet thus made quite a reputation for himself and as soon as he appeared, people amused themselves by teasing him on his favorite subject. He was always ready for them. He always found

the right word where his painter friends were concerned. He was above all untiring on the matter of Cézanne, whom he put among the greatest. Many visitors were entertained by Chocquet's enthusiasm which seemed to them a mild form of insanity.[50]

In his ephemeral periodical, *L'Impressionniste*, created for the duration of the show, Rivière printed the letter of a 'friend,' who can hardly have been anyone but Chocquet, and who supposedly wrote to him concerning Cézanne's *Bathers*: 'I do not know what qualities one would be able to add to this painting to make it more moving, more passionate, and I look in vain for the defects that it is reproached for. The painter of the *Bathers* belongs to the race of giants. Since he eludes all comparison, one finds it convenient to repudiate him; yet there are in art respected analogies, and if the present does not render him justice, the future will know how to rate him among his peers beside the demigods of art.'[51]

Chocquet's efforts were seconded by a rather unexpected ally in the person of Emile Zola who until then had not cared to express himself on the occasions of the Impressionist group exhibitions and had never been too complimentary about his old friend Cézanne. But this time he wrote a review in which he explained what Impressionism was, paid some compliments to Monet, and immediately after that proceeded to speak of Cézanne, 'who is unquestionably the greatest colorist of the group. In the exhibition there are some Provençal landscapes by him, that are of the most beautiful character. The canvases so strong and so deeply felt of this painter may cause the bourgeois to smile, but they offer nonetheless the aspects of a very great painter. . . . '[52]

Could it be that Chocquet had succeeded in rallying the novelist to his views? In any case, the collector's attitude at the show unmistakably revealed the extent to which he had committed himself to Cézanne, and this may explain why Duret could later say that from 1877 on the painter spent part of his time working for Chocquet.

After 1877, Cézanne never again exhibited with the group, nor does Chocquet's name ever appear as a lender of works by other Impressionists in the catalogues of their shows. Once the exhibition of 1877 closed, a second public auction was held, in which Pissarro, Renoir, Sisley, and Caillebotte participated. But the *procès-verbal* of this sale has been lost and there is no way of ascertaining whether Chocquet acquired anything.[53] In view of his financial predicament, he probably was not able to make any purchases.

Completely the master of his time, Chocquet might have decided to sit once more for Cézanne, who spent most of the year 1877 in and around Paris. A portrait by Cézanne, moreover, may not have involved any outlay, since the painter could have wished to thank his ardent defender by presenting him with it. According to Rivière, this new likeness (V. 373) *(75)* was painted in the dining room of Chocquet's apartment. Duret later remembered that

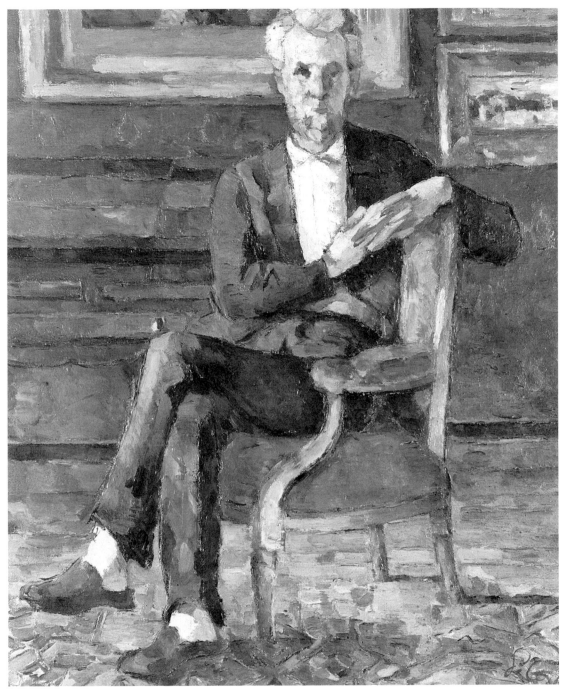

75 Paul Cézanne *Victor Chocquet seated in an Armchair* 1877

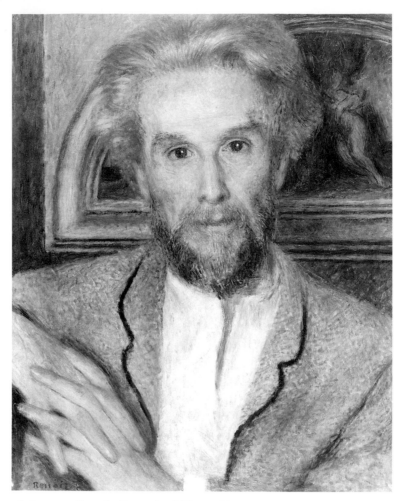

76 Auguste Renoir *Portrait of Victor Chocquet c.* 1875

around 1878 Chocquet was 'a thin tall man, with a high forehead crowned by white hair.'[54]

The pose the artist and model adopted for this new portrait seems to have been typical for Chocquet, since Renoir had already painted him in a similar attitude *(76)*; Lawrence Gowing has even wondered whether the pose had not been suggested to Cézanne by Renoir's portrait of their mutual friend.[55] In both paintings Chocquet is seen with fingers interlaced, one arm resting on the back of his chair, so that the slender hands appear almost suspended. But, whereas in Renoir's canvas this attitude looks completely relaxed, Cézanne seems to have captured a peculiar tension in the more rigid diagonal of the elongated fingers. In Renoir's likeness the collector also looks considerably younger, handsomer, and more romantic than in Cézanne's.

Cézanne has represented Chocquet in a carved and gilded Louis XVI armchair with purple upholstery, seated in front of an eighteenth-century

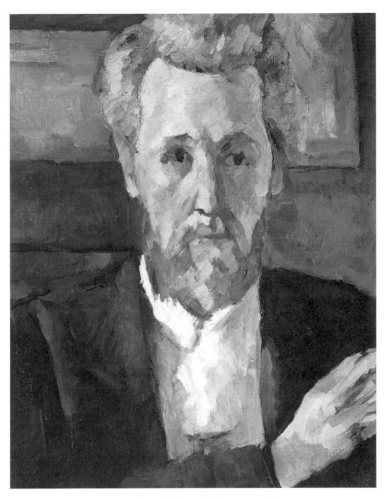

77 Paul Cézanne *Portrait of Victor Chocquet c.* 1877

writing desk *à dos d'âne*; behind him appear three golden frames whose paintings cannot be identifed. (Renoir had shown both Chocquet and his wife in front of oil sketches by Delacroix.) The same setting was used for another smaller portrait *(77)*, and the pose—certainly a comfortable one for long sittings, the angle from which Chocquet is seen, and even the position of the head in relation to the picture frames behind it are identical in both likenesses. The smaller painting is either a study for the other, or was part of an originally larger version of which Cézanne preserved only the head and bust.

It is surprising how little is known about the way in which Cézanne painted portraits. Vollard, who sat for him some twenty years later, wrote that the painter 'did not allow me to say a single word; he spoke freely while I was getting ready to pose, and during the too short moments of rest which he granted me.'[56] But since Vollard could be boringly 'chatty,' it does not necessarily follow that the artist always insisted on such complete silence.

143

Long sittings usually establish a profound relation between a painter and his model, especially when they are friends. While scrutinizing his features, the artist generally also penetrates deeply into his sitter's psyche, and questions and answers not only break the tension of this effort, but contribute to his exploration of the motionless partner. It seems likely, in any event, that the friendship between Cézanne and Chocquet was singularly strengthened by the many hours they spent together whenever the collector sat for yet another portrait. The painter thus gained a profound respect for Chocquet as a moral being, and the collector had a unique occasion to witness the slow and arduous fashion in which Cézanne struggled for expression, seldom satisfied with the results obtained. It must have been during these frequent sittings that the artist obtained the insight reflected in one of his letters to Chocquet: 'I should have wished to possess the intellectual equilibrium that characterizes you and enables you confidently to achieve the desired end.'[57] (This, however, was written many years later, after Chocquet had overcome the trials that plagued him after his resignation of 1877.)

Early in 1878 Cézanne returned to the South where he stayed at his parents' house, the Jas de Bouffan, outside Aix, while his companion of nearly ten years, Hortense Fiquet, and their six-year-old son, Paul, were living in nearby Marseilles because the painter had never found the courage to admit this liaison to his authoritarian father. Yet now Chocquet was unwittingly to precipitate a major crisis. In a letter of March 1878, addressed to 'Mons. Paul Cézanne, artiste peintre,' but opened by the old banker, Chocquet mentioned 'Madame Cézanne and little Paul.' Cézanne's father had long been suspicious of just that, and when the artist, despite the evidence, denied everything, he resorted to a very simple means of pressure: since his son pretended not to have any family and since he was then living on the parental estate, his monthly allowance could and would be reduced. The painter thus found himself in an inextricable situation and had to ask Zola for support, requesting that his remittances be sent directly to 'Madame Cézanne' in Marseilles.[58]

Cézanne may have been too embarrassed about the whole incident to mention it to Chocquet; after all, he was almost forty years old, unable to earn a living and still dependent on his father. But he may also have felt that this was not the time to ask the collector for financial help. It is possible, nevertheless, that among the many paintings of this period which Chocquet owned there were some purchased at this moment in order to relieve the painter's distress. The three still lifes with red signatures (V. 196, 197, and 207) *(78, 79)*, which may or may not have been shown at the Impressionist group exhibition of 1877, could have been painted around 1878 and could have been acquired by Chocquet—or even commissioned by him—during these critical months. Of these three works, one was executed in Aix (V. 207) *(78)*, since it features in its background one of the panels of the screen that the

144

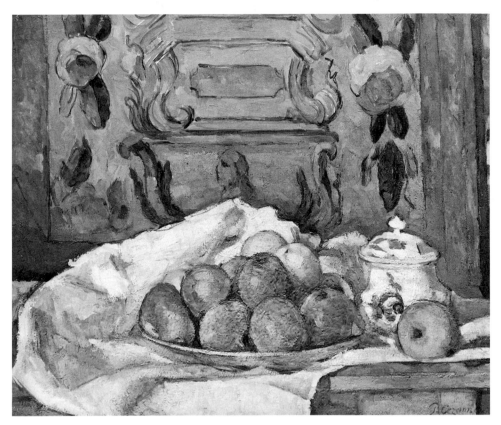

78 Paul Cézanne *Still Life with Apples* 1877–79 (painted at the Jas de Bouffan)

artist had made for his father (V. 2); but another (V. 197) *(79)* must have been painted in Chocquet's home. Indeed, as Ratcliffe has pointed out, the table, desk, or chest of drawers on which the various elements are assembled may have been one of the many Louis XV pieces of furniture that Chocquet owned; its refined workmanship, as well as the delicate 'flute à champagne,' distinguish this still life from the ordinary objects usually represented by Cézanne.[59]

Whether he painted a still life or a portrait there, Cézanne was obviously a frequent visitor at the Chocquet home where he not only found congenial company, but could feast his eyes on numerous oils, watercolors, and drawings by Delacroix. (Ultimately there were to be over eighty and it is likely that most of these were acquired before the collector became interested in the Impressionists.) It is one thing to admire a work of art in a museum or exhibition and another to handle it, to take it from the wall, examine it upside down or from the back, walk over to the window with it, let one's finger glide over its surface, or to take drawings and watercolors out of the portfolios where they are protected from the light, and to spread them out, assemble

them by date, or subject, or color, or other affinities. Although Chocquet is supposed to have proudly—and rightfully—declared, 'I do not need anyone to explain to me why and how I ought to like painting,' one can easily imagine how avidly he listened to Cézanne's enthusiastic comments in which a great painter marveled at the discoveries, virtuosity, and genius of a venerated master. Rivière reports that one day, when Chocquet 'had laid out a certain number [of Delacroix's works] on the living room rug to show them to Cézanne, these two supersensitive beings, on their knees, bent over the sheets of yellowed paper which for them were so many relics, began to weep.'[60]

Cézanne may actually have borrowed some works by Delacroix from Chocquet in order to copy them. In his youth he had copied *The Bark of Dante* (V. 125) and later, in Auvers, a scene from *Hamlet* after a lithograph. During the years of his friendship with Chocquet he did a watercolor after a *Medea* (V. 867) which is practically the same size as a small oil of the same subject that belonged to Chocquet.[61] (The watercolor is 38 x 25 cm and the oil was catalogued for the Chocquet sale as being 33 x 22.5 cm; the dimensions given in the catalogue are frequently inaccurate, doubtless because measurements were made without taking the pictures out of their frames.) In any case, Chocquet's *Medea* was considerably smaller than the large paintings in the Louvre and the Musée de Lille, which are supposed to have inspired Cézanne; he certainly did not make his copy from them. He also copied a *Hagar in the Desert* (V. 708), after an oil attributed to Delacroix that reputedly belonged to Chocquet, yet no trace of which can be found in the catalogue of the Chocquet sale.[62] Cézanne did not, however, copy a large watercolor of flowers by Delacroix which he particularly admired; this was not the one Chocquet had bought at the Delacroix sale, but one of the many that had escaped him but which he acquired subsequently.[63] Just as Chocquet had not cared to purchase any of Monet's views from his window, he did not add any of Cézanne's copies after Delacroix to his collection; nor did he follow the example of another Delacroix admirer, Jean Dollfus, who commissioned Renoir in 1875, the very year Chocquet and the painter first met, to make a copy of Delacroix's *Jewish Wedding* for him.

The link between Delacroix and the Impressionists was stressed once more in 1878 when Duret published a pamphlet in support of the painters, in which he not only listed the critics who admired them but stated, 'Men who have in the past proven their taste by assembling works by Delacroix, Corot, Courbet, today are forming Impressionist collections in which they take delight.' Among these collectors, Duret specifically named de Bellio and Chocquet.[64] It was almost ironic that Chocquet thus achieved recognition as a far-sighted collector at a time when he practically had to suspend all acquisitions.

Chocquet's only documented purchases of 1878 are rather modest ones. At an auction of February 18, at which de Bellio bought four landscapes by

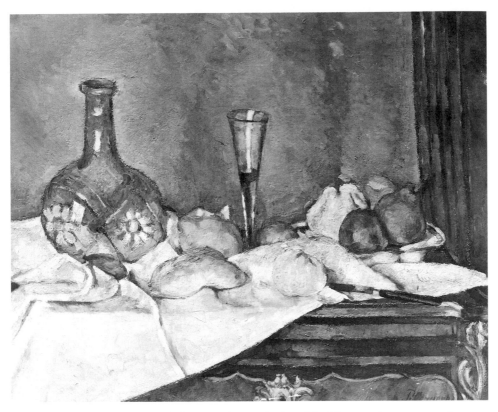

79 Paul Cézanne *Still Life*, *A Dessert* 1877–79 (painted in Chocquet's apartment in Paris)

Monet, one for 60 francs, another for 80, and two for 100 each, as well as a painting by Pissarro for 50 and one by Sisley for 84, Chocquet paid the comparatively high price of 260 francs for *Young Woman with Mirror* by Berthe Morisot.[65] A little later he was among the successful bidders at a judiciary sale through which Ernest Hoschedé, patron especially of Manet and Monet, was forced to part with the considerable group of Impressionist works he had assembled. The auction, held on June 5 and 6, occurred at a particularly unfavorable moment, when there was a marked slump in the demand for Impressionist paintings; as a result, prices were once more exasperatingly low. Whether or not his own situation had improved in the meantime, and despite the fact that he had just spent 260 francs for the Berthe Morisot, Chocquet could afford to pay 62 francs for *Women and Flowers* and 95 francs for an *allée* in autumn, both by Monet. (At the same auction, de Bellio acquired *Bridge at Chatou* by Renoir for 42 francs, a painting by Monet for 35, and Monet's *Impression: Setting Sun* for 210 francs.)[66]

The Hoschedé sale seemed to crush all hopes for a slow but gradual acceptance of Impressionism. Yet, through some unexplained indiscretion it now became known that the Chocquets stood to inherit a sizable fortune some

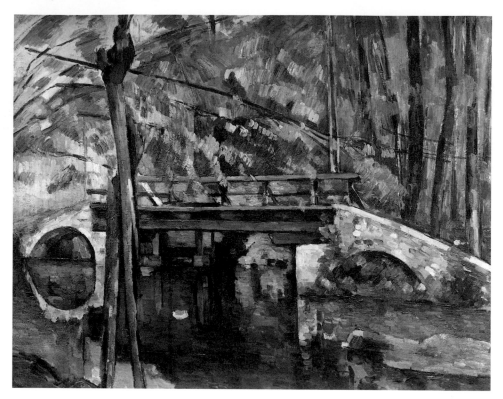

80 Paul Cézanne *The Small Bridge* (Maincy) 1879/80

day. Indeed, the critic Edmond Duranty informed Zola, 'The Hoschedé disaster will evidently upset the band of our *intransigeant* friends, but they are recovering some of their losses in the direction of Chocquet whose wife, someone told me, will one day have an income of fifty thousand livres.'[67]

Duranty was singularly well informed; while it has not been possible to establish the exact amount expected by Madame Chocquet,[68] he stated correctly that it was *she* who would inherit considerable wealth. How he found out is a mystery, especially since his closest friend among the painters was Degas, in whom Chocquet showed as little interest as he did in Gauguin or Mary Cassatt. The explanation is possibly that by then *everybody* knew of Marie Chocquet's prospects, although Madame Buisson was alive in Yvetot and enjoying good health. It is true, however, that she had no other heirs but her only child, the wife of Victor Chocquet. It is not known whether at any time she became aware of her son-in-law's predicament and decided to help out. The records available do not shed any light on this.

Except for *The Jetty* by Berthe Morisot, which he apparently acquired at auction in March 1879, no purchases of Chocquet's can be established for that year, though there may have been some, such as two important paintings by Renoir dated 1879. Chocquet may also have bought some more canvases

148

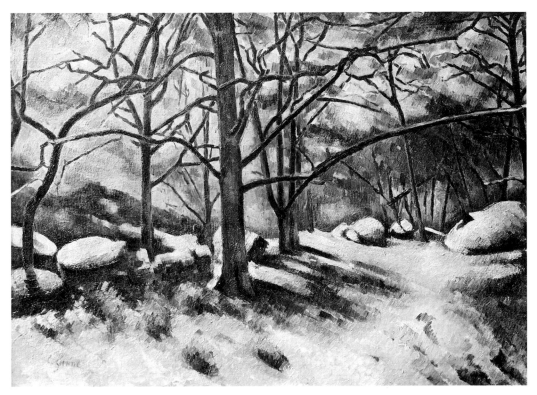

81 Paul Cézanne *Melting Snow c.* 1879

by Cézanne painted at L'Estaque in 1879 (V. 400) and around Melun where the artist had worked between the spring of 1879 and that of 1880. It was probably at Melun that Cézanne reached the apex of an evolution that had begun with the portrait of the seated Chocquet and had led him toward an ever-stronger emphasis on square and diagonal brush strokes. This 'constructive' stroke opposed a vigorous execution in favor of the more hesitant accumulation of small touches and helped Cézanne overcome the nuances of Impressionism through the tightly knit surface pattern whose texture takes precedence over the texture of the object represented. Even though this new approach broke radically with the 'modeling' so much appreciated by Chocquet, the collector did acquire two of Cézanne's finest works from Melun, *The Small Bridge* and *Melting Snow* (V. 396 and 336) *(80, 81)*.

The only known transaction of Chocquet's for 1881 is a lengthy discussion, in May, with a fellow collector, Charles Ephrussy, concerning an exchange of an important landscape by Monet which Ephrussy was willing to trade for four small canvases by Sisley owned by Chocquet.[69]

Early in 1882, Renoir was staying at L'Estaque. In a letter to Chocquet of March 2, he wrote how Cézanne had cared for him during a serious bout with

pneumonia, that the doctor would not yet let him return to Paris, where Cézanne planned to go shortly, and that he might spend his convalescence in Algiers.[70] That same month, Cézanne was back in the capital.

On March 24, 1882, Victor Chocquet's mother-in-law died in her home in the rue de Caudebec, Yvetot, at the age of sixty-five. The official notice states, 'She left as her sole heir Madame Augustine Marie Caroline Buisson, wife of Monsieur Victor Guillaume Chocquet, a property owner living off his revenues with whom she resides in Paris, No. 198, rue de Rivoli.'

The news must have spread like wildfire among Chocquet's painter friends. Some twenty years later, Monet supposedly told the British critic, Wynford Dewhurst: 'The Impressionists anticipated much and the studios were jubilant. Long-cherished plans were rediscussed; the Chocquet legacy was to be the source of a golden stream. But a great disappointment was to come. With the increase of M. Chocquet's riches came the decrease and final extinction of M. Chocquet's taste. He never bought another picture!'[71] This was patently untrue, since the collector not only purchased and commissioned more works by Cézanne, but also acquired at least two more paintings by Monet—*Cliffs at Varengeville*, dated 1882, and a landscape with haystacks, dated 1885—not to speak of an important canvas by Manet.

One of the first things the Chocquets did was to sign papers naming the survivor sole heir. They apparently went to Yvetot to handle the many

82 Photograph of an orchard and farm in Hattenville, Normandy

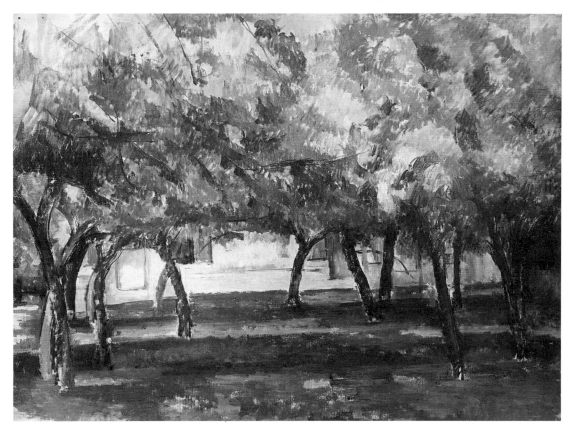

83 Paul Cézanne *Farm at Hattenville, Normandy c.* 1882

problems attending the inheritance and probably spent at least part of the summer in nearby Hattenville where the deceased was born and had owned several properties. Victor Chocquet had not cared to visit there as long as his mother-in-law was alive.

There are, among Cézanne's works of the North, four landscapes that have always been considered to represent farms and orchards in Normandy; these are V. 442, 443, 445 *(83)*, and V. 447. On stylistic grounds, Gowing has dated three of these circa 1882, pointing out that V. 447 'has the thin delicate drawing of the style of 1881. It would appear to have been painted soon after Cézanne's return to the North in the spring of 1882.' According to Gowing, the three pictures, V. 447, 445, and 443, were probably painted close together, with V. 443 'evidently the last of the three,' because color and touch here have become more robust and definite.[72] These works seem to represent the same orchard and buildings; V. 442, which shows a related subject, must have been done more or less simultaneously. All four feature the short-stemmed, wind-battered apple trees which to this day surround the low, whitewashed cottages of Normandy farms *(82)*. Quite a few of these farms are still to be

151

found in Hattenville, near the small church and town hall, and in the flat pastures and farmland of its vicinity. Rivière has in fact designated one of these paintings, V. 443, as having been painted in Hattenville.[73]

Although the date of circa 1886 suggested by Rivière is much too late, the identification of the locale is certainly correct. The most conclusive evidence, however, is that *all four* of these paintings originally belonged to Chocquet. Since Cézanne was in the North from March 1882 to the fall of that year—he worked with Pissarro at Pontoise and spent five weeks with Zola at Médan—it appears quite natural that Chocquet should have invited him to Hattenville. Doubtless lost in this small village where he could not associate with anybody and where he was faced with administrative tasks to which he was not accustomed, Chocquet must have been anxious to see his friend arrive with canvas and paint box. Cézanne's visit would have relieved his boredom, the more so as the painter, a true southerner, could be quite lively when congenial company permitted him to unbend. Cézanne's stay in Hattenville would have fallen into the period of summer vacations, which means that he would have been accompanied by Hortense and their ten-year-old son (Madame Chocquet and Hortense seem to have gotten along very well).

Strange as it may seem, even less is known about the manner in which Cézanne painted landscapes than about the way in which he did portraits. How long were the individual sessions he devoted to a motif? Did he return day after day to the same spot and work consecutively on a single canvas, or did he execute different landscapes simultaneously, for instance when conditions of weather or light changed? How long did it usually take him to complete a picture? Did he work exclusively in the open or was he apt to continue indoors? (It is known that he would occasionally retouch a portrait between sessions with the model.) Might he have taken with him unfinished landscapes of the North in order to pursue work on them at the Jas de Bouffan? There are no answers to these questions. It is therefore impossible to say whether those four paintings of Hattenville reflect the painter's normal productivity during two or three summer months, or whether he may have shipped them to Chocquet after finishing them in Aix where he returned in October 1882,[74] a hypothesis that may explain why none of them is signed.

If further proof were needed that Chocquet *did* continue to collect after 1882, it would be sufficient to mention that upon Manet's death in 1883, he attended the auction of his estate and acquired the large picture of Monet painting in his studio boat, for which he paid 1,150 francs. He may have first seen this work when it was exhibited in Paris in 1880, at a time when he was unable to make such a considerable purchase. Chocquet subsequently also bought a flower still life with white lilacs, which Pertuiset had lent to the 1884 Manet retrospective.

Strangely enough, Chocquet is not listed among the lenders to the large Delacroix exhibition held at the Ecole des Beaux-Arts in Paris in 1885. It

seems difficult to imagine that he should have refused to participate in this homage to the master, especially since his friend Philippe Burty was a lender, as well as another fellow collector, Count Doria. It appears that Chocquet now saw less of his painter friends because he spent more and more time in Normandy, either at Yvetot or Hattenville. As a matter of fact, he even added a second story to the residence in Yvetot that his wife had inherited from her mother and uncle. Simultaneously, he extended the family holdings in Hattenville and Yvetot by acquiring buildings, pastures, and small farms. Yet he kept his apartment in Paris and supposedly did not move any of his paintings or furniture to the country.

After his stay in Hattenville of 1882, Cézanne spent the next two years almost exclusively at Aix and L'Estaque, where he also worked in 1885, until May. Later he stayed with Renoir at La Roche-Guyon, between Paris and Rouen, and went to see Zola at Médan. Before returning to the South in August, he may have made a brief visit to the Chocquets.[75] In April of the following year, Cézanne finally married Hortense Fiquet, with his father's consent. Marie and Victor Chocquet must have sent him a particularly warm letter, which deeply moved the artist. In a long reply, written from Gardanne on May 11, 1886, Cézanne remarked: 'Your good letter, which was enclosed with the one from Madame Chocquet, testifies to a great equilibrium of the human spirit. Since I am struck by this serenity,[76] I am discussing it with you. Fate has not dealt me a similar portion; that is the only regret I have about things of this earth. As for the rest, I have nothing to complain about. . . . '[77]

Cézanne seems to have remained in Aix throughout the year 1887. His father had died at the age of eighty-eight on October 23, 1886—six months after the painter's wedding—and he may have had to assist his aged mother with the formalities of the inheritance as well as the administration of the estate. But in 1888 he was back in Paris. It was there that he painted *Mardi-Gras* (V. 552), for which the artist's son, then seventeen, remembered having posed with his friend Louis Guillaume. Unlike some of Cézanne's recent landscapes of Gardanne with their thin, turpentine-diluted paint that appears almost transparent and their precise and crisp linear design, *Mardi-Gras*, as with many other works to which he devoted long months, is heavily covered with pigment, especially in the area around the harlequin, as though the artist had found it difficult to detach the figure from the background. Once more this is a canvas in which modeling is achieved not only through color but actually through an accumulation of small brush strokes, such as Chocquet seems to have particularly liked. He who had almost exclusively concentrated on Cézanne's still lifes, portraits, and landscapes now acquired this large oil, one of the painter's most important figure pieces.

That same year, Chocquet also bought a painting by Monet, *The Haystack*, dated 1885 and first exhibited at the Galerie Georges Petit in 1886; at the Vente Charles Leroux on February 27–28, 1888, he bid 1,520 francs for it.

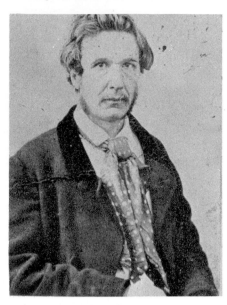

84 (left) Photograph of Victor Chocquet. Document found among Cézanne's papers

85 (right) Paul Cézanne *Portrait of Victor Chocquet* 1879–82 (drawn after the photograph, fig. 84)

86 (far right) Paul Cézanne *Portrait of Victor Chocquet* 1875/76, pencil drawing

Paris was then busily preparing for the Exposition Universelle scheduled for 1889 and Chocquet seems to have decided to do his utmost in order to have works by Renoir and Cézanne admitted. (Monet was already better known and did not need his help.) Chocquet got in touch with the critic Roger Marx, one of the organizers of the section for contemporary art, who was sympathetic to the Impressionists. But Renoir thwarted the collector's plans when he wrote directly to Marx: 'If you see Monsieur Chocquet, I would be very grateful to you if you did not listen to him when he speaks of me. When I shall have the pleasure of seeing you, I shall explain what is very simple, namely that I find everything I have done bad and that it would be extremely painful for me to see it exhibited.'[78]

Cézanne was much less reticent. He is known to have visited Chocquet in Hattenville during the month of June 1889, and there, although it was already late, plans for Cézanne's participation must have been worked out. With the help of Roger Marx and of Manet's friend Antonin Proust, Chocquet maneuvered to get one of Cézanne's paintings accepted.[79] The artist selected *The House of the Hanged Man (87)*, which had been acquired by its owner, Count Doria, at the first Impressionist show in 1874. Doria promised Chocquet to lend it,[80] but when the time came to prepare the catalogue, the picture no longer belonged to him. The catalogue entry reads: 'No. 124, Cézanne, born in Paris [*sic*]. *The House of the Hanged Man* (owned by Monsieur Chocquet).'

What must have happened is that Chocquet was carried away by this canvas, which embodied all the qualities of Cézanne that he cherished. Driven by the irresistible urge to own it, he apparently suggested an exchange, whereupon Count Doria accepted a trade for Cézanne's *Melting Snow* (V.

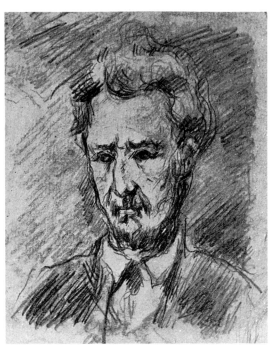

336) *(81)*, with which Chocquet may have been willing to part because he still owned another landscape, *The Small Bridge* (V. 396) *(80)*, executed in Cézanne's peculiar square and diagonal brush strokes of the years 1879–80.

During the June 1889 visit to Hattenville, Cézanne also painted a new portrait of his friend, posing in a white coat, still with a snowy mane, but features drawn in the open, against a backdrop of dark leaves (V. 562) *(VIII)*. It is the last likeness the artist did of the collector. In earlier years Cézanne had made several studies after a photograph *(84)* which showed Chocquet as a much younger man (V. 532) *(85, 86)*.

At the end of that same year, Cézanne once more requested the loan of *The House of the Hanged Man*, this time of course directly from Chocquet, for the exhibition of the group Les Vingt in Brussels to which he had been invited.[81]

Although the Chocquets apparently did not spend much time in Paris anymore, they began looking for larger quarters where their fine furniture and their collection could be installed to greater advantage. They found a small *hôtel particulier* of the eighteenth century at 7, rue Monsigny, opposite the Théâtre des Bouffes-Parisiens, an otherwise quiet street off the rue du 4 Septembre, between the Opera and the Bourse. On March 22, 1890, Victor Chocquet signed the papers and paid 150,000 francs for the building, comprising a cellar, four floors, and an attic, a small courtyard, a wooden staircase, everything in good condition.[82] In a letter of August 1890, Madame Cézanne expresses sympathy for the chores of Madame Chocquet: 'You must be very busy with your house for it is no small undertaking to repair and

155

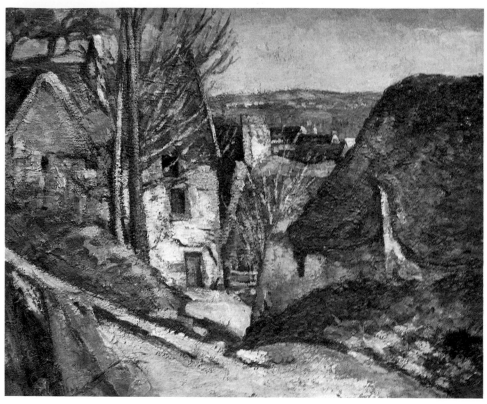

87 Paul Cézanne *The House of the Hanged Man c.* 1873

install four floors. I hope it will be done quickly and that you will be at your ease there and that you won't regret too much the trouble it is giving you.'[83] Moving doubtlessly proceeded only slowly, and it has been said that Chocquet found it difficult to get used to the new surroundings, especially to the absence of the splendid view and the perfect light he had enjoyed in the rue de Rivoli. Now that he had ample space for his pictures and other treasures, they no longer looked quite as cheerful as they had before.

It must have been for the new house that Chocquet commissioned Cézanne to do a pair of very long and narrow decorative panels, probably to go over doors (V. 583–584). He also bought a still life of a vase of tulips (V. 617) which, on stylistic grounds, can hardly have been painted before 1890–91.

Victor Chocquet did not live either to enjoy his new home or deplore its shortcomings. He died there on April 7, 1891, in his seventieth year. He was buried at Yvetot and, as had been arranged previously, his entire estate went to his widow. His surviving brothers and sisters, nephews and nieces in Lille did not inherit anything. Nor does he seem to have made provision to leave his collection to the Louvre or any other museum (as Caillebotte had done in a will drawn up in 1876, when he was only twenty-seven).

Cézanne apparently was in Aix at the time of Chocquet's death and nothing

is known as to how it affected him, whether he attended the funeral (which seems unlikely), or whether he visited Chocquet's widow in the ensuing years. We know only that he delivered the two decorative panels, which seem indeed to have been painted after 1891 and of which Rivière has said specifically that neither was ready at the time of Chocquet's death.[84]

However, after fifteen years of unbroken friendship and an impressive array of purchases which by far surpassed those of any other collector of that time, the painter must have deeply felt the void created by Chocquet's death. He reacted in a strange, yet for him not untypical, way; he took up a project for which he had made a sketch in the late seventies, an *Apotheosis of Delacroix* (V. 891), showing the master being carried heavenward by two angels while on the ground are assembled Pissarro, Monet, Cézanne himself, and Chocquet, the only non-artist who, quite logically, was admitted to the circle of Delacroix's admirers. Whereas none of the painters can be clearly identified—there are actually four figures in the group, not three—the fifth, the man standing close to the tree at the left, can be easily recognized as Chocquet on account of a separate sketch *(88)* which unmistakably represents him. In a photograph taken in 1894 in his Paris studio *(90)*, Cézanne appears to be working on the small canvas (V. 245) *(89)* which was inspired by the earlier watercolor sketch. It has been suggested that Delacroix's *Journal*, first published in 1893, might have revived Cézanne's interest in his *Apotheosis*, yet it would seem more likely that it was the death of his friend that prompted the painter to take up this old project which was also, in some ways, a homage to Chocquet.[85]

Almost nothing is known about the life of Marie Chocquet after her husband's death. She settled in Yvetot and kept with her the young daughter of a local working-class couple who, in 1887, had agreed to let the Chocquets bring up their child, then two years old. She seldom went to Paris where the house on the rue Monsigny held little attraction for her, since she and her husband had not really lived in it and the only memories it evoked were tragic ones. (After her death, a cradle and toys were found in the attic, mementos of the Chocquet child who had died at four.) The doors of the house were locked, the shutters closed, and neighbors began to speak of a 'deserted mansion.' At least once a year, however, Madame Chocquet made a brief appearance to inspect the premises. For the rest of the time, Victor Chocquet's collection remained plunged in darkness. If his widow had ever considered bequeathing his pictures to the state, such a project might have been discouraged by the disgraceful incidents surrounding the bequest of the Caillebotte collection or the 'scandal' aroused by its exhibition in 1896, although only thirty-eight paintings were accepted and twenty-nine were refused by the national museums, among them three of Cézanne's five canvases. (Caillebotte had died in 1893 and de Bellio in 1894, followed in 1896

by Count Doria.) But it is highly unlikely that the agitation created by the Caillebotte legacy had any effect on Marie Chocquet. As a matter of fact, she was more concerned with accumulating wealth than with dispensing it, and obviously did not care enough about posterity to make a will, not even to provide for the girl, now in her teens, whom she called her daughter.

She sued her husband's relatives in Lille, and in 1897 succeeded in having the properties he had owned jointly with his brothers and sisters sold so that she could receive his share. What truly seems to have interested Madame Chocquet is the extension of her holdings in Hattenville, until a sizable part of the community was apparently hers. Her uncle had already added a shed and pastures to the farms he had inherited; in 1886 her husband had acquired more fields, and she continued to buy available land without considering what would happen to these properties after her death. In 1897 she sold a house in Fécamp, doubtless because it was too far away; the next year she bought one in Yvetot in the street on which she lived. With all the farms and acres she owned, she was kept busy with the signing of leases to the various tenant-peasants who worked them. Between 1892 and 1897 she signed no fewer than eight such leases for nine of her properties, as well as three hunting permits.

Then she began to distrust her bank, and withdrew all her money. A letter from the director of the Crédit Foncier de France informed her that as of December 31, 1898, her account showed a balance of exactly one franc and one centime. She now kept her cash in a drawer and thus, on February 18,

88 Paul Cézanne *Victor Chocquet, Study for the 'Apotheosis of Delacroix'* 1878–80, watercolor (sketchbook page)

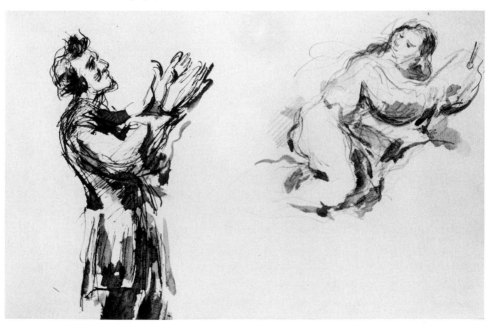

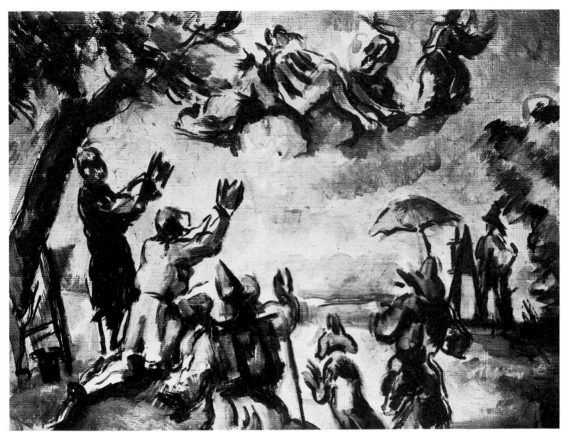

89 Paul Cézanne *Study for the 'Apotheosis of Delacroix'* 1891–94

90 Photograph of Cézanne in
his studio in Paris, 1894

1899, was able to pay 10,000 francs for one more small farm in Hattenville. There also was another farm, of which she was to take possession after March 29, 1899. But this time she had overreached herself. On March 24 she died after a short illness, at the age of sixty-six.

The estate was considerable; there was no will and there were no direct descendants. Rumors quickly began to spread, as is often the case when a fortune goes to unknown inheritors. According to these rumors, Victor Chocquet had married his cook and had made her his residuary legatee; since her death, half a dozen of her relatives had been discovered, nephews and grandnephews, among whom were a stevedore in Rouen, a porter at the Paris Central Market, a docker in Le Havre, a nursemaid, and an insecticide salesman. Strangely enough, it was through a member of the Chocquet family who stood to inherit absolutely nothing that these tales were corrected and the basic data about the 'respectability' of Chocquet, his wife, and their fortune were provided.[86]

Eventually eleven heirs were traced. Nine of these were cousins six times removed on the side of Madame Chocquet's father; their professions were only slightly less picturesque than those quoted in the papers, among them being journeymen, a gardener, a valet, a weaver, a lady whose third husband was a cook, and two nuns. Each was to receive two thirty-sixths of the total. The two others, cousins five times removed on Madame Chocquet's mother's side, were obviously members of the middle class and were to share eighteen thirty-sixths, or one half, of the estate. All seem to have been eager to receive their portion of the windfall, which is understandable in view of the fact that most of them were not only poor, but also advanced in age, the oldest being seventy-six.

The inventory of the contents of the house at Yvetot where Madame Chocquet had died was extremely thorough. It was made in June 1899 and took five days. It revealed no less than 38,560 francs in bank notes and gold pieces, found in a commode, as well as bonds and shares for several thousand francs. Madame Chocquet's jewelry does not seem to have been of great value, but there was a distinguished library of law books doubtless left by her uncle. There were a few paintings, mostly unsigned and not even framed, listed merely as 'landscape,' 'interior,' and so on, generally estimated at five francs; among them was one described as 'unsigned oil painting without frame, representing rocks, estimated two francs.'

The inventory of the mansion at Hattenville took only a day and did not yield anything of consequence. It was obviously the house in Paris that contained all the valuables, but the list of its contents, made in April by some law clerk who could not distinguish between Manet and Monet[87] does not help much in determining the extent of Victor Chocquet's collection, especially since no dimensions are given. One of the surprising features of this inventory is the frequent mention of pictures being without frames, since

those who knew him agreed that Chocquet was rather fastidious about fine carved frames. It is of course possible that many of the paintings had not been hung because of the limited space of his former apartment.

The law clerk, obviously unfamiliar with art, usually listed the names of the painters only where works were signed (or possibly inscribed on the back); in most other cases he merely indicated the subject of the work or ventured a guess as to its author, in which case he put 'attributed to.' His estimates were incredibly low; this could have been a device to keep taxes down, were it not that in 1899 inheritance taxes, as well as fiscal control, were practically nonexistent, and most property was assessed on a contractual basis. Moreover, the pictures were to be dispersed at auction, which meant that their true value was shortly bound to become a matter of public record. Indeed, Cézanne's *Mardi-Gras*, considered by the clerk to be worth less than 100 francs, was auctioned off for 4,400; Manet's *Pavers, rue de Berne*, listed without the artist's name and estimated at 150 francs, was to bring 13,500; Monet's *Haystack*, bought in 1888 for 1,520 francs and valued eleven years later at 800, was subsequently knocked down at 9,000; Renoir's small version of *Le Moulin de la Galette*, appraised at 500 francs, reached 10,500; and the *Seine at Billancourt* by Sisley, also priced at 500, went up to 6,000.[88]

Madame Chocquet's cousins and heirs had probably never heard of these painters but they doubtless began to scan their papers for news of the art world, and what they found must have pleased them. Although France was going through a period of tremendous tension and agitation as the Dreyfus affair reached its climax, this did not seem to affect the picture market. In close succession, three public auctions in Paris—of the Desfossés collection, of the Sisley studio, and of the estate of Count Doria—attracted great attention and yielded more or less sensational results.

The Vente Desfossés took place on April 26, 1899. It was a fairly 'conventional' collection including such by-then established masters as Corot, Courbet, Daumier, and Delacroix. A famous painting by Corot had to be bought in, as was Courbet's *The Artist's Studio* (now in the Louvre) which was knocked down at 60,000 francs. The average price for the Corots actually sold was 27,000 francs; two other Courbets brought around 5,000 francs each; the average price for the Daumiers was somewhat higher, and an *Entombment of Christ* by Delacroix went to Degas for 16,800 francs. Three Pissarros and one Sisley obtained more modest bids, but four landscapes by Monet reached an average of 9,000 francs.

The prices at the sale of Sisley's studio contents a few days later, on May 1 (the artist had died on January 29), were less spectacular but not unsubstantial. Many of his paintings sold for about 3,000 francs but some went up to 5,000, to 7,600, and one even to 9,000. In comparison, a view of L'Estaque by Cézanne in this same auction went for only 2,300 francs, and a Renoir oil for 4,000.

More important was the sale of the collection of Count Armand Doria, who had died three years before. It was held May 4–9 and was accompanied by a lavish catalogue (as had been the sale of the Desfossés collection). Doria had owned over sixty Corots, his interest in this artist matching Chocquet's in Delacroix. Among these were a dozen noteworthy canvases that reached from 10,000 to 35,000 francs while the rest ranged between 900 and 2,500 francs. One Delacroix sold for 19,500, three paintings by Manet averaged 6,000 francs each, whereas a single Monet went for 7,000 francs. Berthe Morisot and Pissarro remained in the 2,500 francs category. The great surprise of this sale was Cézanne's *Melting Snow (81)*, which was catalogued correctly as having previously been owned by Chocquet, and which brought the unexpected price of 6,750 francs, the highest paid thus far for a work by the artist. The bid actually caused so much excitement that the public, suspecting a maneuver, loudly clamored for the buyer's name, whereupon the purchaser rose and declared, 'It's me, Claude Monet!'

This widely reported event must have raised great hopes in the group of poor people who now jointly owned more than thirty paintings by Cézanne, as well as numerous works by Delacroix, Renoir, Monet, Manet, not to speak of a few assorted Corots and Daumiers among others. But anxious though they must have been to auction off everything, it took time to prepare the sale.

It was decided to sell the precious furniture, silver, porcelain, objets d'art, as well as the paintings, watercolors, pastels, and drawings in Paris, and the contents of the house at Yvetot in that locality. Apparently very few items were sent from Yvetot to be included in the more prestigious Paris auction; in any case, the bill for packing and freight amounted to only 39.60 francs. Despite the fact that the sale would come on the heels of three other auctions and could not be scheduled before the first days of July—generally considered too late in the season for such an important event—this unusual date was finally adopted.

On June 1, 1899, Camille Pissarro wrote to his son Lucien in London: 'A great artistic event is in view: *père* Chocquet having died, as well as his widow, his collection is going to be dispersed at auction. There are thirty-two first-class Cézannes, some Monets, some Renoirs, and only one thing by me. The Cézannes will go very high; they have already been appraised at 4,000 to 5,000 francs.'[89]

The reporter for the Paris *New York Herald*, however, soon showed his disappointment. In his opinion, the group of pictures could not measure up to the collections of Desfossés and Count Doria. Thus, on June 29 he wrote:

'The Chocquet collection of furniture and works of art, respecting which such remarkable stories have been set afoot, will be on view in the Petit Gallery, rue de Sèze, this afternoon.

'As has already been stated in the *Herald*, there has been great exaggeration respecting the value of this collection, which has been so long shut up in the

mysterious house in the rue Monsigny. What is to be divided among the heirs is a most interesting collection of modern paintings, and some eighteenth-century pieces of furniture. . . . Among the 188 pictures, drawings and watercolors that figure in the fine illustrated catalogue . . . I only noticed about twenty that are worthy of separate mention as being of value. Like many such collections, the works are of most unequal merit, and though each artist admired by the collector is represented by numerous specimens, they are mostly studies and sketches.

'Among the twenty-three pictures by Eugène Delacroix, which I have just seen, the best are No. 45, *L'Annonciation*, No. 47, *Le Naufrage*, and No. 50, portrait of a woman and interior. The remainder are mere sketches. . . .

'The three works by Manet [there were actually five], *La Marée Montante*, *Les Paveurs de la Rue de Berne*, and a portrait of Claude Monet, do not please me. They are really too unfinished to give a true impression of the value of the artist's pictures.

'Among the works of Claude Monet, on the contrary, I consider extremely remarkable especially No. 77, *Vue d'Argenteuil*, *Pommes et raisins*, *Méditation*, and the *Falaise de Varengeville*.

'*La Question au Miroir*, by Berthe Morisot, representing a young woman in white dressing gown, consulting her mirror, is a most successful effect in white, a most agreeable composition.

'Of the works by Renoir, No. 94, a portrait of a woman, presumably Mme. Chocquet [69], particularly pleased me. Others that have appeared to me among the best are: *Moulin de la Galette*, *La Grenouillère*, six heads of young children on one canvas, and *La Liseuse* [70]. *La Seine à Asnières*, on the other hand, I do not like at all, the combination of a yellow boat with most fantastic coloring is most unpleasant. . . .

'*La Marée Basse*, by Courbet, appeared to me a charming picture, with delicate coloring, recalling to mind in many respects some works by the best artists of the English school. *Les Gros Chênes*, by the same artist, is slightly brutal, and too hard for my liking. The next number in the catalogue, *Intimité*, is admirably painted, but the subject, a common-looking woman, half naked, is unpleasant beyond expression.

'To conclude, I should speak of the thirty-one pictures by Cézanne, all of which are distinguished by the hardness and coldness which appear to me to be characteristic of this artist's work. The best is a landscape not in the catalogue, called *Maison du Pendu* [87]. The most important, which is called *Mardi Gras*, represents a harlequin and clown. I must confess that I can see no beauty in it.

'I have omitted to speak of the portrait of M. Chocquet, by Renoir. To those who knew him as I did, the likeness is striking, but there are green reflections in the hair, which give the picture a strange and questionable aspect. . . .

'I consider that the pictures, drawings and watercolors will not realize more than 300,000 Fr.

'Among the furniture and works of art there are some good specimens of Sèvres porcelain and some fair specimens of eighteenth century furniture, but nothing of great value. If I put the total value of this collection at 80,000 Fr, I think I shall be near the truth.'[90]

On the whole, the French press was less antagonistic, less critical, and also less inclined to venture guesses on the expected sums. A few days before the sale, the English critic Dewhurst went to see Monet—whom he greatly

admired—at Giverny and had a long conversation with him. 'Discussing the coming event, which was already exciting much press comment,' Dewhurst later wrote, 'Monet told me how the late *père* Chocquet . . . had been a tower of strength to the early Impressionists. He encouraged them, foretold ultimate triumph, invested every franc of his savings in the purchase of their works, at prices ranging from £2 to £10.'[91] But Monet did more than reminisce on the occasion of this sale. After having set an example at the Doria auction by paying 6,750 francs for a Cézanne landscape, he apparently now strongly urged his dealer, Paul Durand-Ruel, who had not shown much interest in the artist,[92] to avail himself of this opportunity and at last add paintings by Cézanne to the enormous stock of other Impressionists he had accumulated over the years. Monet also persuaded Count Camondo that *The House of the Hanged Man* was a masterpiece worthy of the Louvre.

Cézanne himself seems to have paid little attention to the agitation surrounding the coming sale, and this despite the fact that here, for the first time, a large group of his works was to come on the auction block. The artist was then painting a portrait of Vollard, who subsequently remembered that Cézanne told him: '"You must go to see the Delacroixs in the Chocquet collection, which are going to be sold." He especially pointed out a very important watercolor depicting flowers [*92*], purchased by M. Chocquet at the Piron sale. The latter had bought it at the sale following Delacroix's death.'[93]

The exhibition of the collection took place on June 29 and 30, 1899, barely three months after Madame Chocquet's death; the sale itself, at the Galerie Georges Petit, was scheduled for Saturday, July 1 (paintings), as well as the following Monday (watercolors, pastels, drawings) and Tuesday (furniture, objects). The catalogue was sumptuous, with numerous illustrations, although only one of a painting by Cézanne (*Mardi-Gras*), as compared with Monet, for instance, who had six of his ten canvases reproduced. A portrait of Chocquet by Renoir served as frontispiece *(68)*, yet the catalogue itself does not list a single portrait of the collector, not even the frontispiece work. Nor is the portrait of Madame Chocquet *(67)* listed, while the two paintings of her that are listed—in one, standing in a black dress, in the other, sitting in a white one against the window in the rue de Rivoli apartment *(69, 70)*—are catalogued as *Portrait of a Woman* and *Woman Reading*, the former designated in the accompanying description as 'presumed portrait of Madame Chocquet.' Among the thirty-one entries concerning Cézanne, there are no likenesses of his friend, nor *The House of the Hanged Man*! The key to this enigma is No. 106 of the catalogue which reads, 'About twenty pictures not catalogued will be sold under this number.'

Although the catalogue was done more carefully than the inventory, it still leaves much to be desired. Some pictures are fully described while others are not, which makes identification difficult, especially in the absence of

reproductions. The dimensions are not very accurate, probably taken without accounting for the portions covered by frames; they appear to be more accurate for some of the paintings listed in the inventory as unframed, such as V. 250 and 266. Moreover, indications of the place of the signature are not always correct, and titles are totally unreliable (most of Cézanne's landscapes of the North and even one from the South are called 'Auvers').[94]

Following is the list of Cézanne's works in the Chocquet collection according to the sequence of the catalogue, with prices and names of buyers as provided by the official record of the auctioneer or other sources.

1 *Mardi-Gras.* Fr 4,400. Durand-Ruel. (V. 552).

2 *La Méditerranée.* Fr 1,500. Bernheim-Jeune. (V. 168). *(72)*.

3 *Eté.* Fr 1,400. George Viau. (V. 447). This picture, now called *Ferme en Normandie, le Verger*, was painted in Hattenville circa 1882.

4 *Au fond du ravin.* Fr 1,500. Durand-Ruel. (V. 400). This picture was doubtless painted in L'Estaque, circa 1879.

5 *Auvers, vu des environs.* Fr 950. Durand-Ruel. (V. 171).

6 *Auvers.* Fr 2,620. Thadée Natanson. (V. 323). In designating this work as *Vue générale d'Auvers* and dating it 1872, Rivière has caused it to be confused with V.150, which never belonged to Chocquet. This landscape, painted around 1881, probably does not represent Auvers-sur-Oise but some other village in the North.

7 *En sortant d'Auvers.* Fr 1,000. Vollard. (V. 464). This painting has nothing to do with Auvers. Its size, the place of its signature, and, above all, the description point to V. 404, a picture of the Jas de Bouffan: 'At left, a meadow with a few large trees. At right, enclosed by walls, some constructions capped with tiles and in the background a hill whose top appears in the distance. Signed in the lower left. Canvas, H. 48.5 cm, L. 64.5 cm.' The dimensions for V. 464, which were not given by Venturi, are 51x65 cm.

8 *Le Petit Pont.* Fr 2,200. Durand-Ruel. (V. 396). *(80)*. This picture was painted in Melun, 1879–80, and represents the bridge of Maincy. It has been said that Chocquet acquired it at the Tanguy sale of June 1, 1894, which did feature as No. 10 an oil by Cézanne, catalogued as *Le Pont*, whose dimensions, 60x73 cm, were identical with those of the Chocquet bridge. The latter may have been the painting now in the Kunsthalle, Hamburg (V. 242), whose size is the same. According to Bodelsen,[95] the Tanguy picture was bought for 170 francs by Vollard; Chocquet, having died in 1891, could not possibly have been the buyer at the Tanguy sale of 1894.

9 *Un Coin de bois.* Fr 1,450. Durand-Ruel. (V. 173). The catalogue locates the signature in the lower right corner, whereas it is actually in the lower left one.

10 *Un Pré.* Fr 800. Durand-Ruel. (V. 442). The picture shows an orchard rather than a meadow; it was painted at Hattenville circa 1882.

11 *L'Eté.* Fr 900. Rosenberg. (V. 443). Also painted at Hattenville circa 1882, this work is now called *Ferme normande, le Clos*.

12 *Une Ferme, à Auvers.* Fr 750. Auguste Pellerin. (V. 445). *(83)*. The catalogue description of this painting fits V. 445 perfectly: 'A green meadow; trees with thick foliage and in the background, half hidden, the buildings of a farm.' The dimensions, 49 x 65 cm, also correspond, but Venturi lists Vollard as first owner. This landscape, of course, belongs to the Hattenville series of circa 1882.

13 *Fleurs et Fruits.* Fr 1,300. Durand-Ruel. (V. 617). 'On a table a pot containing some flowers and haphazardly distributed, three fruits.' The identification of this still life, which would have been impossible from this description, was made thanks to the Durand-Ruel Archives.

14 *La Route.* Fr 1,900. Durand-Ruel. (V. 158).

15 *Les Petites Maisons d'Auvers.* Fr 1,500. Durand-Ruel. (V. 156).

16 *La Barrière.* Fr 880. Bernheim-Jeune. (V. 149). Although not stated in the catalogue, this is, for once, a landscape from Auvers-sur-Oise.

17 *Un Dessert.* Fr 3,500. Durand-Ruel. (V. 197). *(79)*.

18 *La Fontaine* (with Peacock). See following entry.

19 *Nymphes au bord de la mer.* Fr 2,800. Bernheim-Jeune. (V. 584, 583). Two over-door panels (see note 84).

20 *Fleurs dans un vase.* Fr 2,000. Durand-Ruel. (V. 181).

21 *Fleurs épanouies.* Fr 950. Vollard. (V. 216).

22 *Les Pêcheurs.* Fr 2,350. Hessel. (V. 243). *(73)*. The *procès-verbal* names Hessel as purchaser who, though a dealer, bought nothing else at the sale; this painting was first shown *hors catalogue* at the 1877 Impressionist exhibition.

23 *Le Ruisseau.* Fr 145. Vollard. This small painting, 16 x 22 cm, was not known to Venturi.

24 *Naïades.* Fr 275. Vollard. (V. 266). The catalogue merely indicates: 'Signed in lower left. Canvas. H. 19 cm, L. 22 cm.' Ratcliffe has identified this as V. 266 and has pointed out that this must be the little *Study of Nudes* which Chocquet purchased in 1875 when Renoir took him to *père* Tanguy's (see note 19). This picture is doubtless identical with the small painting *Trois baigneuses* listed in the Chocquet inventory.

25 *Petite Ville sur la falaise.* A marginal note in the copy of the Chocquet catalogue at the Bibliothèque d'Art et d'Archéologie, Paris, reads: *Not put on the auction block.* No indication can be found anywhere as to why this picture was withdrawn, and even the fact that it was withdrawn is mentioned nowhere. The *procès-verbal* of the sale and the itemized 'Revue des Ventes' in *Le Journal des Arts* simply skip No. 25. The catalogue entry offers no clues; it says, 'Carved wood frame. Canvas H. 17 cm, L. 24 cm.' Since the work is not listed as being signed, the only plausible explanation would be that it was *not* by Cézanne and that Vollard, on behalf of the artist, had requested its deletion. Having been provided by Chocquet with a carved wood frame, it may have been a painting of some consequence, yet there is no way of finding out whether it was sold under another artist's name.

26 *Tigre.* Fr 480. Behrendt. (V. 250).

27 *La Baigneuse.* Fr 505. Bernheim-Jeune. (V. 273). The identification of this picture is not easy. Since the small canvas *Three Female Bathers* mentioned in the inventory is accounted for (No. 24 above), one does not have to speculate how three female bathers could have turned into a single one; yet it is even more difficult to envision a single female bather as representing actually four male bathers, as seems to be the case here. The catalogue entry merely indicates: 'Signed in lower left. Canvas. H. 33.5 cm, L. 42 cm.' According to the records of the Bernheim-Jeune Gallery in Paris, the painting purchased at the sale was the small, first version of Cézanne's *Bathers* (V. 273) *(74)*. The dimensions of this work, 35 x 45.8 cm, and the place of the signature fit the catalogue entry. Venturi gave Leclanché as first owner of the picture—overlooking Chocquet altogether—but the *procès-verbal* does not mention him at all, even though Dewhurst listed him among those who attended the sale.[96] Since Maurice Leclanché was a client of Bernheim-Jeune, the painting may have been purchased on his behalf.

28 *Chemin à l'entrée de la forêt.* Fr 1,200. Durand-Ruel. (V. 320).

29 *Fleurs.* Fr 1,400. Durand-Ruel. (V. 182). This still life shows almost the same bouquet in the same vase as No. 20 of the Chocquet catalogue (V. 181). It would seem strange that Chocquet should have owned two paintings so closely related (in one version the blue vase stands on a plain, dark cloth; in the other, on a purplish one decorated with flowers), but then he also had several paintings of Hattenville that were not greatly different from each other.

30 *Pommes et gateaux.* Fr 2,000. Durand-Ruel. (V. 196).

31 *Fruit.* Fr 2,000. Durand-Ruel. (V. 207). *(78)*.

According to a marginal note in the copy of the catalogue at the Bibliothèque d'Art et d'Archéologie in Paris, there was also one painting by Cézanne, *hors catalogue*, which brought 200 francs, but nothing more can be ascertained; no reference to it can be found in the *procès-verbal* of the sale.

Renoir's portrait of Chocquet, No. 106 (94) *(68)*, was obviously sold during the first session. On his way home from the auction, carrying his purchases of works by Delacroix, Degas regretted having missed this picture which he called 'the portrait of a madman by a madman,' and which he greatly admired. Bought by Durand-Ruel for 'only 3,500 francs,' it would, Degas feared, be grabbed by Camondo.[97] However, Camondo did not acquire it. Vollard must have obtained another likeness of the collector by Cézanne *(77)* at the following session; he subsequently sold it to Degas.

The second session of the Chocquet auction, devoted to 'Aquarelles & Pastels' as well as drawings, took place on Monday, July 3, and began with three watercolors by Cézanne (which may have been the three that were exhibited at the 1877 Impressionist show).

107 *Roches parmi les bruyères, en forêt.* Fr 155. Sainsère. [Rewald No. 10].[98]
　　The catalogue states only: 'Signed in lower left, 1867. H. 22 cm. L. 35 cm.'

108 *Chemin dans la montagne.* Fr 180. Eugène Blot. [Rewald No. 17].
Although the catalogue does not say so, this watercolor, as the preceding one, is signed and dated 1867.

109 *Fleurs et fruits.* Fr 390. [Rewald No. 8].

However, before the auction of watercolors and pastels, there was the last item among the paintings, No. 106, under which twenty assorted pictures not listed elsewhere were to be sold. The only clue to their identity—for what it is worth—is provided by the *procès-verbal* which has its own numbering, so that every work actually has two numbers, the catalogue number and the *procès-verbal* one. Moreover, the *procès-verbal* adopts its own sequence, absolutely unrelated to that of the catalogue, which lists the artists in alphabetical order.⁹⁹ What system, if any, the *procès-verbal* follows, appears unfathomable; maybe it is merely the order in which the works arrived or were stacked in the office of the *commissaire-priseur*. The *procès-verbal* almost never gives any names of artists, nor all the titles, its main function apparently being to record the names of buyers and the prices paid by them. In the case of the Chocquet sale, this scanty information is fortunately supplemented by notes from the Durand-Ruel Archives, as well as the *bordereaux d'adjudication*, or invoices, delivered to Durand-Ruel for his purchases, which also carry both the catalogue and *procès-verbal* numbers. The list that follows, which pertains exclusively to No. 106 of the Chocquet auction, indicates the *procès-verbal* numbers in parentheses and simply quotes all entries, providing in brackets any further information derived from the *Gazette de l'Hôtel Drouot*, July 4–5, 1899, or from the annotated catalogue of Paul Durand-Ruel.

106 (2) *La Femme en noir*, tableau [by Corot]. Fr 95. Durand-Ruel, rue Laffitte.

106 (3) Un tableau *Pêches*. Fr 300. Rosenberg, Faubourg Saint-Honoré 77. Probably a picture listed by Durand-Ruel as 'nature-morte, oranges,' without artist's name.

106 (4) Un tableau *Bord de Rivière*. Fr 145. Vollard. This could have been a painting by Cézanne since, with few exceptions, Vollard seems to have bought nothing but Cézannes at the sale.

106 (6) Un tableau *Une plage*. Fr 250. d'Hauterive, 51 Poissonnière.

106 (7) Un paysage. Fr 20. Follin-héritier. The buyer, specifically designated as an heir, must have been Charles E. Follin, former judge of the Tribunal de Commerce in Rouen, one of the two more affluent cousins, five times removed, on Marie Chocquet's mother's side. Then seventy-one years old, he certainly did not invest much in art.¹⁰⁰

106 (9) Un tableau *Le faucheur*. Fr 105. Moline, rue Laffitte.

106 (10) Un tableau *Tulipes et raisins*. Fr 52. Ducret, 10 Grange Batelière.

106 (11) Une plage *Falaise au bord de la Mer*. Fr 42. d'Hauterive.

106 (12) Un tableau *Fleurs*. Fr 55. Fouanard, rue Volney.

Mᵉ PAUL AULARD, Commissaire-Priseur à Paris, Rue St. Marc, Nº 6.

Sucʳ de Mᵉ Béchard des Sablons.

BORDEREAU D'ADJUDICATION

Vente

Doit Mᵣ Durand Ruel

Rue

Stock

77997 IMP. MAULDE, DOUMENC & Cⁱᵉ

Numéro du Catalogue	Articles du Procès Verbal		Fr.	c.	
		Du 1ᵉ Juillet 1899			
		Timbre de Quittance	"	10	
5.365	106	2	La femme en noir (Corot)	95	4.185
5.364	106	18	Tête de femme (Corot)	520	4.184
5.351	78	23	Étude de cheval (Delacroix)	240	6.151
5.363	105	26	Tête de vieillard, Éc. Espagnole	430	4.123
5.349	37	29	Portrait d'homme (Courbet)	480	1.371
5.361	95	46	Naïade (Renoir)	1600	3.482
5.350	47	57	Le naufrage (Delacroix)	8100	1.381
5.357	86	63	La Jetée (Morizot)	4650	1.632
5.359	84	69	Les petits (Renoir)	3100	Rac
5.355	106	70	Dans bois (Monet)	2900	1.379
5.341	16	71	Les ... maisons d'Auvers (Cézanne)	1700	1.369
5.360	91	72	Liseuse (Renoir)	4600	1.373
5.352	69	75	Marée montante (Monet)	1450	1.302
5.346	20	76	Pommes et gâteaux (Cézanne)	2000	1.365
	88	79	Au moulin de la galette	10500	B.J.
5.354	81	87	Matinée (Monet)	3200	
5.353	79	91	Pommes et raisins (Monet)	6000	Rac
5.362	106	94	Port. de Mʳ Chocquet (Renoir)	3800	1.372
5.356	85	96	Le quai (Morizot)	2600	1.377
5.333	1	98	Mardi gras (Cézanne)	4400	1.362
5.336	8	99	Le petit pont (Cézanne)	2200	1.380
5.342	17	102	La bataille d'amour, Un dessert (Cézanne)	8300	1.363
5.340	14	105	Laronde (Cézanne)	1900	1.364
			à Reporter	77170	10

One of the invoices of the Chocquet sale from the Durand-Ruel Archives. (The marginal annotations were made subsequently to identify individual works)

Mᵉ PAUL AULARD, Commissaire-Priseur à Paris, Rue St. Marc, Nᵒ 6.

Sucᵗ de Mᵉ Béchard des Sablons.

BORDEREAU D'ADJUDICATION

Vente

Doit M. *Durand Ruel*

Rue

Stock

77997 IMP. MAULDE, DOUMENC & Cⁱᵉ

Photo

Numéro du Catalogue	Articles du Procès Verbal		Fr.	c.
		Du 5 Juillet 189 9		
		Timbre de Quittance		10
5.389	H.C 490	Portrait de Mᵉ Chocquet assis Cézanne	460	3.558
5.388	H.C 492	Portrait de Mᵉ Chocquet par Cézanne	360	1.983
5.387	H.C 493	Portrait de Mᵐᵉ Chocquet par Renoir	1400	1373
			2210	10
		10 %	110	50
			2320	60
		le 5 Juillet 1899		

à Reporter

Invoice for Nos. 490, 492, 493 sold *hors catalogue*; from the Durand-Ruel Archives. (The marginal annotations were made subsequently to identify individual works)

106 (13) Un tableau *Entrée de bois.* Fr 42. Rayre, rue de Châteaudun.

106 (14) *Rocher*, tableau [by Delacroix]. Fr 110. Bernheim-Jeune.

106 (15) Un portrait Homme. Fr 720. Rosenberg.

106 (16) Un tableau *Tête de Femme.* Fr 105. Baron de Neufville, rue Ampère 11.

106 (17) *Bord de Mer*, tableau. Fr 185. d'Hauterive. According to Durand-Ruel, this was a 'paysage avec rivière.'

106 (18) *Tête de femme, tableau.* Fr 320. Durand-Ruel. According to the Durand-Ruel records, this was a 'Tête de jeune fille' by Prud'hon copied after Correggio.

106 (19) *Tête de fillette* (Tableau). Fr 120. Fouanard.

106 (53) Un tableau [*Fleurs* by Delacroix]. Fr 3,250. Haro, rue Visconti. This could have been the painting that Chocquet had acquired at the Delacroix sale for 880 francs.

106 (70) Un tableau par Claude Monet [*Sous bois*]. Fr 2,900. Durand-Ruel. Possibly the painting of an *allée* in autumn bought by Chocquet in 1878 at the Hoschedé sale for 95 francs.

106 (74) *La Maison du pendu* par Cézanne. Fr 6,200. I. de Camondo, rue Glück 4.

106 (94) Un portrait d'homme [*Portrait de Chocquet* by Renoir] [*68*]. Fr 3,500. Durand-Ruel.[101]

This list contains exactly the twenty paintings announced as comprising No. 106. Why they were not catalogued individually must remain a secret forever. Yet even this list does not account for all the portraits of Victor and Marie Chocquet known to have belonged to them. There were at least one more of each of them by Renoir *(67, 76)* and no fewer than five of him by Cézanne, *66, 75, 77, 85* among them. One of these portraits could have been No. 106 (15), but there is no way of finding out, since the records of the Rosenberg gallery in Paris were destroyed during World War II. While one of the two portraits of Chocquet by Renoir was No. 106 (94) *(68)*, what about the other *(76)?*

There exists a separate invoice made out to Durand-Ruel, dated July 5, 1899, which lists three more paintings from the Chocquet collection, but this time without *procès-verbal* numbers. Instead, the three pictures, each designated simply as 'Portrait,' are numbered 490, 492, and 493. This indicates that in addition to the all-embracing No. 106 there was still a supplement *hors catalogue*, the extent of which only heaven knows. According to the Durand-Ruel records, No. 490 was Cézanne's *Portrait of Victor Chocquet Seated (75)*, which sold for only 450 francs; No. 492 was the *Portrait of Chocquet at Hattenville* by Cézanne *(85)*, which sold for even less, 360 francs; and No. 493 was Renoir's likeness of Victor Chocquet *(76)* which, in contrast, brought 1,400 francs. But what was the missing No. 491 that was not acquired by Durand-Ruel? It could have been Cézanne's first portrait of the collector (V. 283) *(66)*, which apparently went to Bernheim-Jeune. Vollard became the owner of the small head of Chocquet *(77)*. Although no record of

this exists, he may have purchased it at the Chocquet sale. Degas bought several paintings, watercolors, and drawings by Delacroix, among them the watercolor *Mars-el-Kebir* which Chocquet had obtained at the Vente Delacroix in 1864.[102] Since the *procès-verbal* shows no record of Nos. 490–493, it would be futile to look for further details.

Try as one may, unsolved questions still remain which prevent the establishing of a definite list of Cézanne's works owned by Chocquet. And since it is not known how much the collector paid for his friend's paintings, it is not possible, either, to determine their increase in value, except possibly for the small study of nudes purchased from Tanguy in 1875 for 50 francs, which brought 275 at the sale. The rise in value for the other painters in the collection is certainly more spectacular, at least in the few cases where it can be checked. Yet the prices paid at the auction appear occasionally rather whimsical, such as the bids for Renoir's two portraits of Chocquet which are the same size, but one of which *(68)* fetched 3,500 francs and the other *(76)* only 1,400.

Monet's *Women and Flowers*, bought in 1878 for 62 francs, brought 3,400 in 1899; Berthe Morisot's *Young Woman with Mirror*, also bought in 1878, for 260 francs, sold for 10,100. Manet's picture of Monet in his boat, acquired in 1884 for 1,150 francs, reached 10,000, while Monet's *Haystack*, for which Chocquet paid 1,520 francs in 1888, went for 9,000 eleven years later. Yet Delacroix's watercolor *Mars-el-Kebir*, which Chocquet had obtained for 125 francs in 1864, cost Degas only four times that much thirty-five years later. On the other hand, the house in the rue Monsigny, acquired in 1890 for 150,000 francs, was sold in 1899 for 140,000.

The total of the first session was 297,860 francs (fairly close to the estimate of 300,000 francs for the *two* sessions ventured by the critic of the Paris *New York Herald*). The total of the second session was almost 30,000 francs; the third session, comprising the porcelain, furniture, and other antiques, brought—according to the *Journal des Arts* of July 8, 1899—another 118,205 francs. The grand total was practically 450,000 francs, or about 70,000 more than the ungenerous estimate of the *New York Herald*.

Whether the beneficiaries of these considerable amounts were pleased with the results of the auctions is not known. But Berthe Morisot's daughter noted in her diary: 'Nothing was more comical than to watch the heirs at the Chocquet sale, simple people from *les Halles* who did not seem to know how to walk on a carpet. They were seated on a bench and wrote down the price of each object as though they feared being taken advantage of.'[103]

Although the bids for Cézanne's work could not rival those reached by the paintings of Monet, Renoir, or Manet (his *House of the Hanged Man* brought somewhat less than his *Melting Snow* had sold for at the Doria sale), Duret was to write six years later that with the Chocquet sale Cézanne's prices 'until then very low, began their climb to reach the height that one sees today.'[104]

172

91 Auguste Renoir *Portrait of Paul Cézanne* 1880, pastel

It is interesting to note that Paul Durand-Ruel actually bought half of the works by Cézanne at the sale[105] and that, in general, almost all of Cézanne's paintings were purchased by dealers, with the exception of five or six that went to collectors (catalogue Nos. 3, 6, 12, 26, and 106 *(74)*, the case of No. 22 not being quite clear). Vollard showed himself much less acquisitive than Durand-Ruel, but he had of course constant access to the artist, whose sole 'agent' he had become. One is tempted to assume that he seldom paid Cézanne more than 1,000 francs per canvas, since this would explain why Vollard did not buy a single work for more than that amount and let Durand-Ruel 'grab' the most important and expensive pictures. Incidentally, Durand-Ruel also gave 1,500 francs for a pastel by Renoir, catalogued as:

'No. 152. *Portrait d'homme*. Frontal view, half-length; bald dome surrounded by frizzy hair, brown beard. Black garment. Signed at upper left: 1880. H. 54 cm., L. 44 cm.'

173

92 Eugène Delacroix *Bouquet of Flowers* 1848–50, watercolor

This is Renoir's *Portrait of Cézanne (91)*. At one point Cézanne must have borrowed it from either Renoir or Chocquet since he painted a copy of it (V. 372) which originally belonged to Pissarro. Surprisingly enough, Chocquet does not seem to have owned any of Cézanne's self-portraits.

The only object for which Vollard spent more than 1,000 francs was a large square watercolor on gray paper by Delacroix, No. 111, *Bouquet of Flowers (92)*, which cost him 1,325 francs. This was the watercolor so fervently admired by Cézanne, and the dealer apparently intended to present it to him. However, it took Vollard some time to carry out this project, since it is only in a letter of January 1902 that the artist thanks him 'for the magnificent present you made me of the work of the great Master.'[106] Cézanne now painted an oil copy of the watercolor (V. 754) *(93)*. In 1904, Emile Bernard saw the watercolor standing in his bedroom in Aix, face carefully turned to the wall to

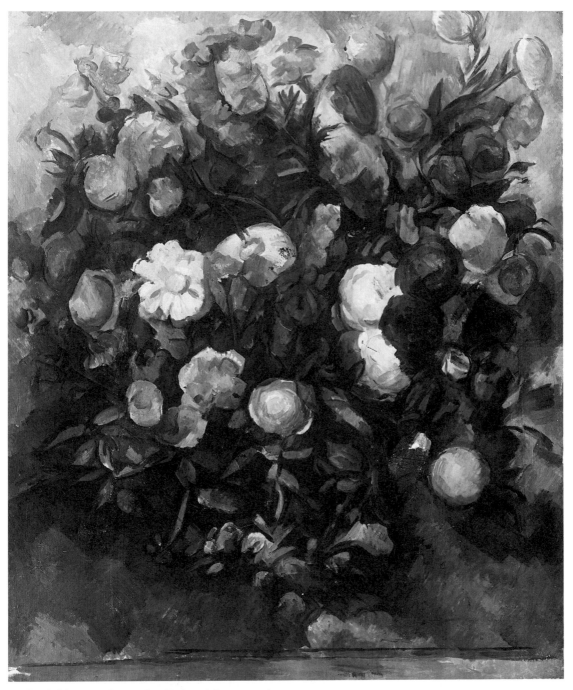

93 Paul Cézanne *Copy after Delacroix's watercolor* 1902–4

CATALOGUE
DES
Tableaux Modernes
PAR
CÉZANNE, COURBET, DELACROIX
MANET, MONET, RENOIR, SISLEY, TASSAERT

AQUARELLES & DESSINS
OBJETS D'ART ET D'AMEUBLEMENT
ANCIENNES PORCELAINES TENDRES DE SÈVRES
Porcelaines et Faïences diverses — Orfèvrerie
PENDULES ET BRONZES DU XVIIIᵉ SIECLE
SIÈGES ET MEUBLES
DES ÉPOQUES LOUIS XV ET LOUIS XVI

DONT LA VENTE, PAR SUITE DU DÉCÈS DE Mᴹᴱ Vᵛᴱ CHOCQUET, AURA LIEU
GALERIE GEORGES PETIT, 8, rue de Sèze, à Paris
Les Samedi 1ᵉʳ, Lundi 3 et Mardi 4 Juillet 1899
A DEUX HEURES

EXPOSITIONS
PARTICULIÈRE : *Le Jeudi 29 Juin 1899, de 1 heure à 6 heures.*
PUBLIQUE : *Le Vendredi 30 Juin 1899, de 1 heure à 6 heures.*

Le présent Catalogue se trouve :
CHEZ LES COMMISSAIRES-PRISEURS
Mᵉ PAUL AULARD | Mᵉ P. CHEVALLIER | Mᵉ L. BRIÈRE
6, rue Saint-Marc, 6 | 10, rue Grange-Batelière, 10 | 4, rue Richer, 4
ET CHEZ LES EXPERTS
M. GEORGES PETIT | MM. MANNHEIM
12, rue Godot-de-Mauroi, 12 | 7, rue Saint-Georges, 7

The title page and another page (right) from the catalogue of the sale of the Chocquet collection, 1899

prevent it from fading.[107] In view of the fact that the Chocquet sale must have revived Cézanne's recollections of his friend and his treasures, and that he himself now owned and was absorbed in one of Chocquet's prized possessions, it appears particularly difficult to accept Bernard's account, according to which he was to replace Chocquet in the *Apotheosis of Delacroix.* It would seem more likely that Bernard was to be *added* to the group of the master's admirers.

There were still other Chocquet auctions, held in Yvetot, one comprising real estate, the other mostly furnishings of the house in the rue de Caudebec. The buildings, farms, and plots in Hattenville, Bermonville, Fauville, Saint-Aubin-sur-Scie, Rouxmesnil, Criquetot-le-Mauconduit, and Fécamp, sold in October 1899, totaled 255,975 francs. Together with 25,600 francs for the properties in Yvetot, these holdings brought almost as much as the paintings.[108]

The catalogue of the contents of Madame Chocquet's house does not mention any works by Cézanne or any other artist. The auction was expected to last seven days and was announced as follows:

'Important antique and modern furniture, Flatware, Jewelry, Books, Paintings, Engravings, Lace, Clocks, Mirrors, Ivories, Art Objects and Carriages.—Sale at

20 TABLEAUX

CÉZANNE

2 — *La Méditerranée.*

A droite, les maisons à toiture de tuiles rouges sont étagées sur la falaise, parmi la verdure des frondaisons d'été.
A gauche, la mer bleue, sous un ciel d'azur : au fond, la côte que dominent les falaises.
Signé à droite, en bas.

Toile. Haut., 42 cent.; larg., 58 cent. 1/2.

CÉZANNE

3 — *Été.*

A travers les branches, on aperçoit les constructions, dont le soleil caresse la muraille.
Au-devant de la maison coiffée de tuiles rouges, le sol est tout paré d'herbe verte.

Toile. Haut., 65 cent.; larg., 81 cent.

CÉZANNE

4 — *Au fond du ravin.*

Dans l'escarpement des roches, les arbustes ont poussé quand même et la vie s'exprime dans ce coin de nature, au milieu des déchirements.
Ciel gris ennuagé.

Toile. Haut., 73 cent.; larg., 53 cent. 1/2.

Yvetot, rue de Caudebec, at the residence where Madame Chocquet died, a person of independent means. 10, 11, 12, 17, 18, 19, and 20 July 1899 and following days if necessary.'

According to the catalogue, the flatware must have been quite important, and there were also 600 bottles of 'bon vin d'Algérie,' as well as two carriages with harnesses among the other items. Indeed, Madame Chocquet's had been a rather large household with at least three domestics who earned between 30 and 75 francs a month. The pictures included in this auction seem to have been of the more popular kind, such as four engravings representing respectively Joan of Arc, Anne de Boleyn, Charlotte Corday, and a slave merchant. No trace is to be found of the 'oil painting without a signature, unframed, depicting some rocks, estimated at two francs,' which had been mentioned in the original inventory of the house in the rue de Caudebec, established by Maître Lefrançois, notary at Yvetot.

Almost forty years later, the collection of Eugène Blot, who had attended the Chocquet sale and had bought one of Cézanne's watercolors (as well as works by Delacroix and Renoir), was auctioned off at the Hôtel Drouot in Paris. The catalogue of the Blot collection listed a painting, No. 51, not reproduced but described:

'Cézanne. *Les Roches*. 1867. Foreground, against the light a mass of barren rocks in a state of titanic chaos. In an opening appears a section of clear blue sky against which the foliage of a number of trees is silhouetted. In the background, rises the rounded top of Mont Sainte-Victoire with its sun-drenched slopes. Panel. H. 0.27 m; L. 0.43 m.

'On the back of the panel, one reads: "Study by Cézanne, acquired by me at the sale of Chocquet's widow at Yvetot, and of which this lady assured me that it came from Cézanne, who had been an intimate friend of Monsieur Chocquet." Signed: Lefrançois, former notary at Yvetot.'[109]

The strange fact is that the date of this painting corresponds to that of two of Cézanne's watercolors in the Chocquet sale, one of which had been acquired by Blot himself. As far as can be ascertained, the picture was bought in at the Blot sale. Since both Eugène Blot and his son are now dead, there seems to be no way in which it can be traced at present. This is merely one of the enigmas that have still to be solved before the entire list of Chocquet's Cézannes can be established.

The heart of the problem lies of course with the woefully inadequate inventories of the Chocquet estate and the no less woefully incomplete catalogue of the sale. Yet despite its exasperating shortcomings, this catalogue has been quoted as a source of vital information. In a memorable and impassioned controversy concerning the chronology of Cézanne's works, Douglas Cooper asserted: 'Both Venturi and Gowing have chosen to ignore, for no stated reasons, the dates given for certain pictures in the catalogue of the Chocquet Sale (1899). Yet Chocquet must be regarded as one of the only first-hand sources for reliable dating, and in fact on examination nearly all his dates prove to be acceptable.'[110] Cooper specifically mentions two paintings, Nos. 3, *Eté*, and 4, *Au fond du ravin*, as having been listed with the date 1880, a date he considered 'acceptable,' whereas he found 'unacceptable on technical grounds' the date of 1882 that Gowing had suggested for Chocquet's *Eté* (V. 447). Yet it is Gowing's, not Cooper's, date that is borne out by the purely external evidence presented here. Much more serious than such a discrepancy of two years, however, is the fact that the dates Venturi and Gowing allegedly had 'chosen to ignore' and which Cooper held up to them by using Chocquet as his authority, *do not exist*. The catalogue of the Chocquet sale does not contain a single date except where the artist had included it on the painting alongside his signature, and not always even in these cases.[111] This is not at all surprising, since Chocquet apparently failed to keep any records and since the task of cataloguing the collection had obviously to be completed in great haste to prevent the auction from being delayed until the fall.

Thus the catalogue of the Chocquet collection is far from being 'one of the only first-hand sources for reliable dating' (see the illustrations on pp. 176 and 177). It is not even the monument to the collector's taste and discernment that it could and should have been. Actually, nothing is left to commemorate this

extraordinary man who contributed so much to the final triumph of Impressionism, except the few portraits of him by Renoir and Cézanne now scattered over the globe. In the graveyard of Yvetot there is no tombstone bearing his name. When no descendants tend or claim them, even perpetual concessions of cemetery plots are reassigned after half a century or so; this fate befell Victor Chocquet's grave not many years ago.

NOTES

In the course of preparing a new catalogue raisonné of Cézanne's oeuvre, I was struck by the paucity of material concerning Victor Chocquet, the first consistent collector and champion of the painter's work, as well as his best friend outside the small circle of comrades of his youth and of his Impressionist colleagues. Moreover, what information was available often appeared to be contradictory. This led to research, the result of which is presented here. Although the new data on Chocquet are reported fully, the focus is on his relations with Cézanne, to the exclusion of his interest in other artists, on which there is still very little known.

This study would not have been possible without the generous help I received from Mademoiselle Suzanne Lemonnier of the staff of Maître Pierre Tesnière, *notaire* at Yvetot, who untiringly assembled the most minute information; from Madame Palliez-Chocquet of Lille, who kindly communicated family letters as well as precious newspaper clippings; Maître Bernard Jozon in Paris, successor of the *commissaire-priseur* who presided over the historic Vente Chocquet, for the records of that sale; M. Charles Durand-Ruel who, with his customary patience and affability, provided invaluable details from the files of his century-old firm; M. Bizot of the Etude B. Andriveau in Paris, who was extremely helpful with the genealogy of the Chocquet family; Madame Felkay of the Archives de Paris, who guided me through the maze of documents under her care; M. Jacques Dupont, Inspecteur Général des Monuments Historiques, who occupied Chocquet's apartment on the rue de Rivoli, or one similar to it; the late Philippe Huisman in Paris and the late Helmut Ripperger in New York; M. François Daulte in Lausanne; Professor Lee Johnson, now at the University of Toronto, M. Pierre Cabanne in Paris, and others.

1. Quoted in F. Fels, *Claude Monet* (Paris, 1925).

2. Quoted in J. Renoir, *Renoir, mon père* (Paris, 1962), p. 186.

3. T. Duret, *Histoire des peintres impressionnistes* (Paris, 1906), p. 140.

4. G. Rivière, *Renoir et ses amis* (Paris, 1921), pp. 36–42.

5. Rivière, *Renoir*, pp. 186–88.

6. P. Cabanne, *The Great Collectors* (London, 1963), pp. 45–62.

7. Archives Nationales, Paris; document dated June 19, 1857. The text originally read 'mariage sous régime de communauté,' but the words 'de communauté' are crossed out and replaced by 'dotal.' This means that the bride's dowry remained her personal property and would have to be restored in case of a separation.

8. Rivière, *Renoir*, p. 187.

9. Marie Sophie Chocquet was born in Paris on May 7 or 8, 1861, and died probably also in Paris, on Oct. 14, 1865.

10. An apocryphal anecdote, published after the death of both Chocquet and his wife, seems typical of the stories that circulated in their lifetime. According to this tale, the collector one day discovered a painting by Delacroix which he was able to buy for 5,000 francs only after having scraped together his savings and brrowed money left and right. But how was he going to admit this to his wife? He told her that his purchase had cost him 700 francs, yet even at this price there were tears, reproaches, lamentations, a quarrel. One evening, however, Mme Chocquet triumphantly arrived in her husband's office, exclaiming: 'I got 1,500 francs! We made a profit of 800!'—'How is that?'—'I sold the Delacroix!' (*Le Gaulois*, July 2, 1899.)

11. See Delacroix's letter to Chocquet of Mar. 14, 1862, in J. Joëts, 'Les Impressionnistes et Chocquet,' *L'Amour de l'Art*, Apr. 1935, p. 125. Only a few months earlier, in July 1861, Philippe Burty, another fervent admirer of Delacroix, had met the artist for the first time and was thenceforth to devote himself to the task of making his work better known. He prepared the catalogue for the posthumous sale; see H. Bessis, 'Philippe Burty et Eugène Delacroix,' *Gazette des Beaux-Arts*, Oct. 1968. United in their passion for Delacroix, Chocquet and Burty were to become good friends.

12. The *procès-verbal* of the sale lists Chocquet as purchaser. He bought the painting for 880 francs and the watercolor for 125, but these were far from the cheapest items in the sale.

13. See P. Burty in *Chronique des Arts*, no. 73, 1864. Among the other names cited by Burty were those of Arosa, Robaut, Th. Silvestre, Thoré, Diaz, Th. Rousseau, P. Huet, Riesener, Daumier, Carpeaux, and Bracquemond.

14. See R. Niculesco, 'Georges de Bellio, l'ami des impressionnistes,' *Revue Roumaine d'Histoire de l'Art* 1, no. 2 (1964): 212.

15. Unpublished letter of Oct. 1865, courtesy Mme Palliez-Chocquet, Lille.

16. It is impossible to ascertain when the Chocquets moved into this building. The marriage contract of 1857 gives his residence as 204, rue de Rivoli. The files of the Paris *cadastre* for 1857–62 are missing; after 1862, Chocquet is listed under No. 198, rue de Rivoli, where his yearly rent was 1,200 francs.

17. Quoted in Fels, *Monet*; see also note 24.

18. M. Bodelsen, in 'Early Impressionist Sales 1874–94,' *Burlington Magazine*, June 1968, p. 334, has established that Chocquet was *not* among the buyers.

19. This picture cannot be identified with certitude. It is unlikely that it was the small *Bathers* (V. 273), which apparently belonged to Chocquet, because in 1875 Cézanne would hardly have left with Tanguy a study for the large *Bathers* (V. 276) which was not to be completed before 1877. In his unpublished Ph.D. dissertation ('Cézanne's Working Methods and Their Theoretical Background,' University of London, 1960), R. W. Ratcliffe has suggested that Chocquet's first purchase is identical with V. 266. The latter is doubtless the small picture of three bathers listed in the Chocquet inventory and catalogued under No. 24 in the Chocquet sale (the dimensions are the same).

The letter V. followed by a number refers to the catalogue by L. Venturi, *Cézanne: Son art, son oeuvre* (Paris, 1936).

20. Quoted in A. Vollard, *Renoir* (Paris, 1918), chap. 8.

21. M. Denis, *Journal*, vol. 2, *1905–1920* (Paris, 1957), pp. 34–35 (entry of early 1906).

22. See the page from Tanguy's ledger, first mentioned by Ratcliffe, 'Cézanne's Methods,' and subsequently published by W. V. Andersen, 'Cézanne, Tanguy, Choquet' [*sic*], *Art Bulletin*, June 1967, pp. 137 39, fig. 1. Bodelsen ('Early Sales,' pp. 334–35) has given a somewhat different interpretation of this document.

23. See Cézanne's letter to Chocquet, Gardanne, May 11, 1886 in *Paul Cézanne: Correspondance* (Paris, 1978), p. 226.

24. See Joëts, 'Les Impressionnistes,' p. 122. It is quite possible that Chocquet's ex-

pression of regret at not having known Monet a year sooner, which the artist had connected with the auction of 1875 (see note 17), was actually uttered at this first meeting, in Argenteuil in 1876.

25. For a condensed catalogue of the exhibition see L. Venturi, *Les Archives de l'Impressionnisme* (Paris, 1939), 2: 257–58.

26. Chocquet appears under the name of Hue; see Emile Zola, *L'Oeuvre*, édition des oeuvres complètes (Paris, 1928), p. 229.

27. See Vollard, *Renoir*, chap. 8. Vollard quotes Renoir as having received 1,000 francs for the painting (now in the Sterling and Francine Clark Art Institute, Williamstown, Mass.), but this seems much too high a price for the period, the painting being of circa 1875.

28. See T. Duret, Introduction to the catalogue of the *Vente Chocquet*, Paris, July 1–4, 1899, p. 6.

29. See Cézanne's letter to Camille Pissarro, [Aix] Apr. 1876, in *Cézanne: Correspondance*, p. 150.

30. See Niculesco ('Georges de Bellio,' p. 247, note 105) for a comparative list of the Caillebotte, Chocquet, and de Bellio collections, which shows that each put the emphasis on different artists. Caillebotte bought no Morisots and few Manets, possibly because they were better off than their colleagues, yet this would apply also to Degas, to whom, however, he was partial but who was completely neglected by Chocquet and not much appreciated by de Bellio. Caillebotte favored Pissarro, de Bellio favored Monet, and Chocquet owned many more Cézannes and more Renoirs than both of them, especially if one adds works not listed by Niculesco.

Monet is supposed to have said, 'I have known only Chocquet and Georges de Bellio who were real art lovers and not speculators.' Quoted in L. Vauxcelles, 'Un Après-midi chez Claude Monet,' *L'Art et les Artistes*, Dec. 1905, p. 87. The same applies of course to Caillebotte, except that his friends considered him a painter rather than a collector.

31. Chocquet to Burty, Nov. 15, 1874, in Joëts, 'Les Impressionnistes,' p. 124.

32. Ratcliffe, 'Cézanne's Methods.'

33. Not all of Cézanne's letters to Chocquet are preserved. There is no letter, for instance, thanking Chocquet for the press clippings concerning the Impressionist exhibition; in that same letter the artist may conceivably have described the magnificent bay of L'Estaque, unless he had mentioned it to Chocquet in Paris. The first known letter to Chocquet is dated Jan. 28, 1879, and was written more than four years after the two met.

34. Cézanne to Camille Pissarro, L'Estaque, July 2, 1876, in *Cézanne: Correspondance*, p. 152.

35. Almost twenty-five years later, Camille Pissarro was to occupy an apartment at 204, rue de Rivoli, where Chocquet had lived before moving practically next door to No. 198. In a letter to his son, Pissarro described the view from his window, to which he planned to devote an entire 'series' of paintings: '. . . a superb view of the park, the Louvre to the left, in the background the houses on the quays behind the trees, to the right the Dôme des Invalides, the steeples of Ste Clotilde behind the solid mass of chestnut trees. It is very beautiful.' Camille

	Chocquet	Caillebotte	de Bellio
Cézanne	31 (+5 or 6)	5	5
Degas	—	7	2
Manet	5	4	8
Monet	11 (+1)	16	35
Morisot	3	—	4
Pissarro	1	18	10
Renoir	11 (+3)	8	8
Sisley	1	9	6

Pissarro, *Letters to His Son Lucien* (New York, 1943), p. 333, letter of Dec. 4, 1898.

T. Reff, in 'Cézanne's Drawings, 1875–85,' *Burlington Magazine*, May 1959, p. 175, reproduces a drawing by Cézanne and suggests that it may represent a view from Chocquet's apartment. This is not quite possible, however, since the 'anonymous roofs and chimneys' in the foreground of this drawing cannot be associated with that section of the rue de Rivoli which faces directly the Tuileries Gardens. Moreover, from Chocquet's windows the two Gothic spires appear at the right of the dome and not at the left as in Cézanne's drawing.

36. Monet to de Bellio, June 7, 1876; see C. Richebé, 'Claude Monet au Musée Marmottan,' *Académie des Beaux-Arts* (1959–60), pp. 117–18.

Two of the four Tuileries paintings are dated: one, 1876; the other, 1875. But since Monet first met Chocquet in Feb. 1876, the 1875 date is obviously wrong. This is not a rare occurrence with Monet, who frequently signed and dated pictures only when he sold them and was prone to err concerning their date of execution. For similar instances of mistakes in Monet's dating, see J. Isaacson, 'Monet's Views of Paris,' *Allen Memorial Art Museum Bulletin*, Fall 1966, pp. 4–22 (about landscapes of 1867); and J. Rewald, 'Notes sur deux tableaux de Claude Monet,' *Gazette des Beaux-Arts*, Oct. 1967, pp. 245–48. The Tuileries view dated 1875 was the one acquired by Caillebotte.

37. For that reason no inventory seems to have been taken. The notifications of death for both Augustin-François Buisson, of Nov. 19, 1876, and his sister, *veuve* Buisson, née Julienne-Armande Buisson, five years later, give rue de Caudebec in Yvetot as their domicile.

38. Unpublished letter of Marie Chocquet to Eléonore Chocquet, Paris, June 20, 1877; courtesy Mme Palliez-Chocquet, Lille.

39. For a condensed catalogue of the exhibition, see Venturi, *Archives* 2: 259–61.

40. It was therefore impossible for Cézanne to indicate any lenders. But, so far as is known, at that time nobody besides Chocquet owned Cézanne's recent works.

41. 'L'Exposition des Impressionnistes,' *L'Impressionniste: Journal d'Art*, Apr. 14, 1877; article reprinted in Venturi, *Archives* 2: 316.

42. Although the catalogue entry, *Les Baigneurs—Etude*, *Projet de tableau*, would point to the study (V. 273) rather than to the final version (V. 276), now in the Barnes Foundation, Merion, Pa., it is possible that Cézanne did substitute the latter, which may have been ready just in time for the opening. A mention by Rivière and a sketch by Degas, made at the exhibition, relate more closely to the large composition than to the small study.

43. See T. Reff, 'New Sources for Cézanne's Copies,' *Art Bulletin*, June 1960, p. 49.

44. R. Fry, *Cézanne: A Study of His Development* (London, 1927), p. 55. Meyer Schapiro has observed that the portrait 'is all built up without obvious trace of plan or guiding structural lines, as if from the spontaneous play of the brush in direct response to the man. Most remarkable of all—what we return to again and again—is the largeness of effect, the powerful possession of the space.' (*Cézanne* [New York, 1952], p. 46.)

45. T. Reff, 'Cézanne's Constructive Stroke,' *Art Quarterly*, Autumn 1962, p. 255, n. 17.

46. This supposition would seem to be supported by Ratcliffe's findings ('Cézanne's Methods') according to which 'apart from the small group of paintings executed during Cézanne's first stay in the Auvers region, between mid-1872 and early 1874, most of the signatures on the paintings datable to the 1870s were added at varying times after the execution of the inscribed work.'

47. One might even wonder—although this is admittedly somewhat farfetched—whether Chocquet, who could no longer

make any purchases, did not insist on anonymity so that the other Impressionists would not know to what extent he continued to buy from Cézanne.

48. Exhibition review, quoted in J. Rewald, *Cézanne: Sa vie, son oeuvre, son amitié pour Zola* (Paris, 1939), p. 224.

49. Translated almost literally from Rivière, *Renoir*, p. 40.

50. Translated almost literally from Duret, 'Introduction,' *Histoire des peintres*, p. 7.

51. *L'Impressionniste: Journal d'Art*, Apr. 14, 1877; reprinted in Venturi, *Archives* 2: 317.

52. For this recently discovered article, see *Nouvelles Littéraires*, Feb. 2, 1967, p. 9. Zola's mention of 'paysages de Provence' is not necessarily in conflict with the theory concerning Cézanne's red signatures, since of four landscapes signed in red—V. 464, 158, 168, and 171—two (V. 464 and 168) represent landscapes of the South.

53. See Bodelsen, 'Early Sales,' pp. 336–37.

54. Duret, 'Introduction,' *Histoire des peintres*, p. 6.

55. L. Gowing, Catalogue, *An Exhibition of Paintings by Cézanne* (Edinburgh and London, 1954), comments to No. 18.

56. A. Vollard, *Cézanne* (Paris, 1914), chap. 8.

57. Cézanne to Chocquet, Gardanne, May 11, 1886, in *Cézanne: Correspondance*, p. 226.

58. See Cézanne's letters to Zola of Mar. 23 and 28, as well as Apr. 4, 1878, ibid., pp. 160–61 and 164.

59. Ratcliffe, 'Cézanne's Methods.'

60. Rivière, *Renoir*, pp. 39–40.

61. On this copy see J. Rewald, *Paul Cézanne —The Watercolours* (London, 1984), pp. 119–20, No. 145.

62. According to Vollard's account book (entry No. 3343), at the Chocquet sale he purchased a painting by Delacroix, *Hagar and Ismael in the Desert*, 24 x 27.5 cm, for 55 francs. A little later he records (entry No. 3362) the purchase from Cézanne himself or from his son for 100 francs of a 'painting by Cézanne, *Hagar and Ismael in the Desert*, copy of the picture by Delacroix from the Chocquet sale, 52 x 58 cm.'

Cézanne is also supposed to have copied a river landscape after Delacroix (V. 644). This painting was owned by Eugène Blot who, in his memoirs (*Histoire d'une collection de tableaux modernes* [Paris, 1934], p. 36), speaks of a 'copy of a small Delacroix which I later rediscovered and bought at the Count Doria sale.' Cézanne knew Doria, but since it is also known that at least in one instance Chocquet and Doria traded paintings, this small Delacroix landscape could conceivably have belonged to Chocquet before entering the Doria collection (sold in May 1899, shortly before the Chocquet sale).

63. Vollard, *Cézanne*, chap. 8. On this subject, see note 93.

64. T. Duret, *Les Peintres impressionnistes* (Paris, May 1878); pamphlet reprinted in T. Duret, *Critique d'avant-garde* (Paris, 1885), in which, however, no collectors are named.

65. Information courtesy M. Charles Durand-Ruel, based on de Bellio's own annotated catalogue of the sale.

66. On the Hoschedé sale, see Bodelsen, 'Early Sales.' pp. 339–40.

67. E. Duranty to Zola, summer 1878; see M. Auriant, 'Duranty et Zola,' *La Nef*, July 1946, p. 50. (The letter is erroneously ascribed to 1879 although it was obviously written shortly after the Hoschedé sale of June 1878.)

68. The French livre had been replaced in 1803 by the franc, yet the expression was still used throughout the nineteenth century. The equivalent of 50,000 francs in 1878 is hard to establish, but twenty years later the best-paid of Mme Chocquet's three domestics earned 70 francs a month.

69. This exchange, to which an unpublished letter by Ephrussy relates (courtesy Mme Palliez-Chocquet, Lille), seems to have been consummated; there was only one medium-sized Sisley and not a single small canvas by him when the Chocquet collection was sold in 1899.

70. For Renoir's letter to Chocquet, see Joëts, 'Les Impressionnistes,' pp. 121–22. Apparently Chocquet did not commission Renoir to paint any pictures there that might renew his link with Delacroix.

71. Quoted by W. Dewhurst, *Impressionist Painting* (London, 1904), p. 110. According to this interview, which took place a few days before the sale in 1899, Monet also told Dewhurst that 'late in life M. Chocquet inherited, quite unexpectedly [!] a large fortune.'

72. Gowing, Edinburgh-London catalogue, *Cézanne Exhibition*, comments to Nos. 29 and 30.

73. See G. Rivière's tentative oeuvre catalogue in his *Paul Cézanne* (Paris, 1923), p. 214, under 'vers 1886.' Despite many errors, Rivière often provides reliable information that can be traced directly to Cézanne's son, who had married one of Rivière's daughters. Since he would have been in Hattenville with his parents, the painter's son evidently remembered the site.
 In his catalogue of the Courtauld Collection (London, 1954), D. Cooper ignored Rivière's geographical identification for V. 443 and dated it circa 1880 (see his comments for No. 7, p. 85).

74. Another related landscape (V. 444) seems to have been painted at a later date, during a subsequent visit to Hattenville. After the Barbizon painters, who had favored Honfleur, not only Normandy, but also the rest of the French Atlantic coast were highly popular with the Impressionists and their friends in the 1880s. Around 1879, Renoir had become acquainted with the Bérard family and frequently visited them at their château in Wargemont near Dieppe where he painted many landscapes and portraits. Between 1880 and 1886, Monet spent almost every summer in Normandy, particularly at Fécamp, Petites Dalles, Pourville, Varengeville, Le Havre, Etretat, and Dieppe. Pissarro, in 1883, worked at Petites Dalles and subsequently in Rouen, where Gauguin also went, before painting in Brittany in and after 1886 (in 1885 both Gauguin and Degas had been in Dieppe). Signac went to Port-en-Bessin in 1884, to Saint-Briac in 1885, and to Fécamp the following year; Seurat, who had done his military service at Brest in 1879–80, painted in Grandcamp in 1885 and in Honfleur in 1886. Boudin roamed all over the coast, working in Normandy and Brittany in 1880, at Le Havre and Dieppe in 1882, in Caudebec in 1884, and even built a house in Trouville that same year.

75. Rivière, *Cézanne*, pp. 212–13, also ascribes an unidentified landscape and Chocquet's portrait (V. 562) to a sojourn at Hattenville of 1885, which is not otherwise documented and is even fairly unlikely in view of Cézanne's known schedule for that year. Rivière may have relied on Duret (*Histoire des peintres*, p. 140), who speaks of Chocquet's portrait as being 'painted outdoors, in the country, in Normandy, in 1885.' However, during that summer Cézanne worked at La Roche-Guyon and went shortly to Villennes, Vernon, and Médan; he may even have paid a quick visit to Monet at Giverny. If he did see Chocquet at Hattenville, he would not have had the time necessary to paint his portrait there.

76. Joëts ('Les Impressionnistes,' p. 124) had read, 'Since I am struck by this *necessity*' (italics added) and this has been repeated frequently. A check with the original document, courtesy Mme Palliez-Chocquet, Lille, has revealed that Cézanne had written 'sérénité' rather than 'nécessité.'

77. Cézanne to Chocquet, in *Cézanne: Correspondance*, p. 226.

78. Renoir to R. Marx, July 10, 1888; see C. Roger-Marx, *Renoir* (Paris, 1937), p. 68.

79. It has always been said that Chocquet refused to lend a requested piece of furniture to the fair unless a canvas by Cézanne be included in the exhibition. However, a check

of the official catalogue shows no loans by Chocquet to the seventeenth- and eighteenth-century sections, neither of furniture, nor of bronzes, ceramics, silver, or clocks which he was collecting.

80. See Cézanne's letter to Count Doria, Paris, June 20, 1889, in J. Rewald, *Cézanne, Geffroy et Gasquet* (Paris, 1950), p. 10.

81. See Cézanne's letters to O. Maus, Nov. 27, 1889, in *Cézanne: Correspondance*, pp. 229–30; to Chocquet, Dec. 18, 1889, p. 230; and to O. Maus, Dec. 21, 1889, pp. 236–37.

82. According to the Calepins du Cadastre de la Ville de Paris, Archives de Paris.

83. Hortense Cézanne to Mme Chocquet, Emagny, Aug. 1 [1890], in *Cézanne: Correspondance*, p. 233.

84. Rivière, *Cézanne*, p. 217. Not remembering when Chocquet had died, Rivière dated both panels 1888, while specifying that they were 'intended for the decoration of M. Chocquet's private house, rue Monsigny; neither one nor the other was completed at the time of the latter's death.' Only one of the two decorations, painted around 1892–94, still exists in its original condition (V. 584); the other, which had been divided into three sections, is now in the Louvre, where they have been reassembled.

85. A description of the composition is given by Emile Bernard, *Souvenirs sur Paul Cézanne et Lettres* (Paris, n.d. [written in 1920]). On May 12, 1904, Cézanne wrote to Bernard concerning Delacroix, 'I do not know whether my fragile health will allow me ever to carry out my dream of painting his apotheosis.' (*Cézanne: Correspondance*, p. 301.)

86. Rectifications by Dr Chocquet of Armentières published in *Le Matin* (Paris), June 14, 1899, as well as an article of the same date in *Le Reveil d'Yvetot*; courtesy Mme Palliez-Chocquet, Lille.

87. The inventory apparently was dictated, which would explain such phonetic errors as putting singulars for plurals (*Gros arbre*

instead of *Gros arbres* or *Tête d'enfant* instead of *Têtes d'enfants*). It seems that a distinction between Manet and Monet was attempted insofar as the latter is always designated as *Claude* Monet; where the list says Monet without first name, the reference is to Manet.

88. The room by room inventory of the Paris residence at 7, rue Monsigny is reproduced on pp. 74–77 of the *Gazette des Beaux-Arts* (July–Aug. 1969) where this article originally appeared.

89. Camille Pissarro, *Lettres à son fils Lucien* (Paris, 1950), p. 468.

90. Unsigned article, *New York Herald* (Paris), June 29, 1899. According to Blot, *Histoire d'une collection*, the art critic for that paper in 1900 was George Bal.

91. Dewhurst, *Impressionist Painting*, p. 110.

92. In 1894, at the sale of the Duret collection, Durand-Ruel had passed up the three Cézannes owned by the critic. One of these (V. 650) was purchased by Emmanuel Chabrier for 650 francs. Two years later, after the death of the composer, Durand-Ruel acquired the painting at the Vente Chabrier. This may have been one of his earliest purchases of a work by Cézanne.

93. Vollard, *Cézanne*, chap. 8. This work, Robaut No. 1042, had brought 2,000 francs at the Vente Delacroix, 1864, but was acquired by Chocquet at the Piron sale, announced as 'Collection de Feu M***,' on Apr. 21, 1865, for 300 francs. At the Chocquet sale it reached 1,325 francs. On this subject, see Lee Johnson's catalogue of the Delacroix exhibition (British Arts Council, 1964), No. 165.

94. Georges Petit, in whose spacious galleries many auction sales were held, also officiated as 'expert' for the paintings in the Chocquet collection. He obviously did not consult Vollard on the subject of Cézanne's works, nor Durand-Ruel, whose position as champion of the Barbizon painters and the Impressionists he wished to rival. It is true, however, that on June 1, 1899, an employee of Georges Petit wrote to Camille Pissarro,

asking him whether he could come to the gallery where the Chocquet pictures were deposited and be kind enough to provide information on the collection (see the catalogue *Archives de Camille Pissarro*, Paris, Hôtel Drouot, Nov. 21, 1975, No. 85(5) [with wrong date and wrong name]). But Pissarro had hardly known Chocquet and doubtless could not be of great help. Be this as it may, there are numerous errors in the Chocquet catalogue, most of them probably due to carelessness.

The Sisley landscape, which the inventory had listed with the date 1877 and which indeed bears this date (Daulte No. 252), was catalogued without it. The Delacroix No. 46, catalogued as measuring 57×68 cm, was later given in the Vente Degas as measuring 48.5×69 cm, which seems to be the correct size. It was catalogued as *Le Roi Jean à la bataille de Poitiers*, even though Robaut had titled it *Bataille de Nancy* (No. 261). There are no references at all to Moreau's or Robaut's catalogues of Delacroix's work, despite the fact that Robaut (*L'Oeuvre complet de Eugène Delacroix* [Paris, 1885]) had listed a number of oils as belonging to Chocquet, such as Nos. 324 (Chocquet sale No. 53), 543 (51), 651 (48), 1375 (52), 1444 (47), 1707 (45). As to the watercolor of flowers (note 93), it was sold without any mention of the Piron Collection or the special clause in the artist's will.

The billing after the sale was similarly fraught with errors; Durand-Ruel was billed for Renoir's *Moulin de la Galette*, which had been purchased by Bernheim-Jeune; Cézanne's *Un Dessert*, which Durand-Ruel had bought, was listed on his invoice under the title *La Bataille d'Agincourt*, see p. 169.

95. Bodelsen, 'Early Sales,' p. 346.

96. Dewhurst, *Impressionist Painting*, p. 111.

97. See Julie Manet, *Journal: 1893–1899* (Paris, 1979), p. 237 (diary entry of July 1, 1899), quoted p. 167 above.

98. The citation 'Rewald' followed by a number refers to Rewald, *Paul Cézanne— The Watercolours*, London, 1984.

99. Bodelsen ('Early Sales,' p. 332) states that the consecutive *procès-verbal* numbers 'indicate the order in which the pictures were put up for sale.'

100. Some members of Victor Chocquet's family, though they were not heirs, also attended the sale and acquired minor souvenirs among the objets d'art auctioned off on July 4.

101. See note 97.

102. Degas's purchases were considerable. According to the *procès-verbal* he bought No. 46, *Le Roi Jean à la bataille de Poitiers* for 6,700 francs (in the sale of Degas's collection in 1919 this was called correctly *La Bataille de Nancy*); No. 55, *Hercule délivre Hésione* (500 francs); the watercolors: No. 116, *Les Forts et un palais du gouverneur en Algérie* (350 francs); No. 119, *Hortensias jaunes et roses* (300 francs); No. 133, *Le Prisonnier* [de Chillon?] (125 francs); No. 142, *Cavalier arabe dans une fantasia* (650 francs); and the following drawings: No. 169, *Etude pour une décoration* (70 francs); No. 172, *Le Roi* (200 francs); No. 175, *Ovide chez les Scythes* (220 francs); No. 179, *Etude de pendentif pour un plafond de la Chambre des Députés* (300 francs), as well as another such study, No. 182 (160 francs).

It seems worth mentioning that Degas, who had no personal connection with Chocquet, thus indulged heavily in his passion for Delacroix, whereas Cézanne did not, although by then he could well afford to have done so. But Degas was a collector at heart, while Cézanne was not attached to possessions.

103. Julie Manet, *Journal*, p. 239.

104. Duret, *Histoire des peintres*, p. 141.

105. Durand-Ruel decided to keep some of the Cézannes for his private collection but immediately began to avail himself of various opportunities to exhibit his new acquisitions (even those that were not for sale). On Oct. 18, 1900, he sent twelve Cézanne paintings to the Cassirers in Berlin who returned them on Jan. 9, 1901, not a single one having been sold. In 1904,

Durand-Ruel lent five Cézannes to the artist's retrospective at the Salon d'Automne, Paris, and in 1905 he included several Cézannes in the large exhibition he organized at the Grafton Galleries in London (see 'Depressionist Days of the Impressionists,' p. 203).

106. Cézanne to Vollard, Aix, Jan. 23, 1902, in *Cézanne: Correspondance*, pp. 278–79. In 1935 Vollard told the author that this was not a gift, but an exchange to which the painter 'generously consented.'

107. See Bernard, *Souvenirs sur Cézanne*, pp. 50–51. Bernard states specifically that Cézanne had *purchased* the watercolor from Vollard, and his account was published in Vollard's lifetime.

108. It is difficult to establish the total of the Chocquet estate, but it is known to have reached almost a million and a half francs, of which a good deal consisted in securities.

109. *Collection Eugène Blot*, Hôtel Drouot, Paris, Apr. 23, 1937. In his book of memoirs, *Histoire d'une collection* (see note 62), Blot speaks at length of various Cézannes he owned, but does not mention the Chocquet sale or any works by Cézanne connected with Chocquet, such as this panel.

110. D. Cooper, 'Two Cézanne Exhibitions, II,' *Burlington Magazine*, Dec. 1954, p. 378.

111. I have checked the catalogues of the Chocquet sale in the Metropolitan Museum of Art, Frick Art Reference Library, Wildenstein Galleries, and Knoedler & Co., in New York, as well as in the Bibliothèque d'Art et d'Archéologie, the Wildenstein and Durand-Ruel galleries in Paris, and have inquired about the copy in the Courtauld Institute in London.

The Impressionist Brush

To Jean and Hélène Adhémar

'When an artist undertakes his work,' Heinrich Wölfflin observed, 'certain optical conditions present themselves to him by which he is bound. Not everything is possible at all times. Vision has its own history and the revelation of those optical categories should be considered as the primordial task of art history.'

Throughout the nineteenth century there were two 'traditions': one, the generally accepted one, a high-priced and widely acclaimed commodity; and another, a more adventurous one, generally contested at birth and forced underground. Among the many things the adventurous—i.e., the true—tradition stands for is a brush stroke that speaks a language of its own, that expresses a concept, that frequently has a spontaneous quality, a sweeping assurance that transcribes the most volatile perceptions onto canvas. As used by such masters as Rubens and Rembrandt, this brush stroke never 'sticks' to the support but manages—even though it applies opaque pigment to solid ground—to capture the vibrations of light, the pulse of life. What characterized the nineteenth-century accepted tradition, on the other hand, was torpid brushwork bent on erasing itself, so to speak, in a strenuous effort to hide the intervention of the painter's tool for the sake of a smoothness and finish which, according to Cézanne, 'fait l'admiration des imbéciles' (earns the admiration of imbeciles).

Almost anyone can be taught to paint. But knowing how to apply pigment to canvas does not automatically carry with it an ability to produce art, any more than a knack for winning at Scrabble guarantees the capacity to write poetry. Though the painter's technology is fairly easily acquired, the same brush that can create a masterpiece can produce a daub. Great achievements occur only when an artist has something original to say and uses his technical knowledge to fashion a personal expression. His brush stroke is not an end in itself, but part and parcel of the creative process.

It is undeniable that Meissonier was devilishly clever at depicting horses (small), as was Rosa Bonheur (large), that Bouguereau was unequaled at

First published in *The Metropolitan Museum of Art Bulletin*, no. 3, 1973–74. Reprinted with permission from the Metropolitan Museum of Art, New York, New York

assembling rosy children (cute) and chaste or wanton maidens (titillating), and that Gérome excelled in Egyptian scenes (historical) with a profusion of archaeological details and sundry stuffed animals. These skillful compositions, painted by wielders of uninspired brushes, were expensive objects of fashion, far removed from the true tradition, the one celebrated by Baudelaire when he chanted the beacons of mankind: Rubens, Leonardo, Rembrandt, Michelangelo, Puget, Watteau, Goya, and Delacroix.

The optical conditions by which the Impressionists were bound were not those practiced by the darlings of the official Salon—the Meissoniers, Cabanels, Géromes, Bouguereaus—but those which had been established by a few selected predecessors, in whose footsteps they decided to follow. It seems permissible then to elaborate on Wölfflin's statement by saying that during the middle of the last century certain optical conditions presented themselves to the artist *between which he had to choose.*

By that time, the age-old struggle between color and line had reached a dead end. Under the banner of Ingres's dictatorial leadership, line reigned supreme. All official art instruction was dominated by men infused with the ideas of Ingres, who opposed color as if it were a vice. At best, color was considered a complement to line, an inferior though unavoidable adjunct to it.

Perhaps no one has better formulated these concepts, steeped in what was considered the classical heritage, than William Blake when he wrote, 'The great and golden rule of art, as well as of life, is this: that the more distinct, sharp and wiry the bounding line, the more perfect the work of art, and the less keen and sharp, the greater is the evidence of weak imitation, plagiarism, and bungling.'

It is against the background of such narrow doctrines that the originators of a modern approach emerged and slowly formulated the ideas that inevitably led to Impressionism.

Even though he was decried as a 'colorist,' Delacroix had not been able to reach an expression where color would be completely independent of line. Yet, within the confines of prevailing pictorial customs, he achieved wonders by infusing historical, mythological, or Oriental subjects with a splendor behind which quivered the sensibility and sensuousness of a visionary enamored of all the hues of the rainbow. However, the adored 'Orientalists' of those days were Fromentin and, especially, Gérome, authors of countless compositions in African settings, artists interested in the narrative and picturesque, not the pictorial potentials of their subjects. If Delacroix, by contrast, discovered the luminous complexion of the African continent, it was because he arrived in the East with an eye not only attuned to but eager for its multicolored radiance. Yet even Delacroix had to look for color under foreign skies or in history; he avoided contemporary subjects unless he could turn

189

them into allegories. Indeed, the aspects of ordinary life were still considered too banal to be worthy of the artist's brush.

Courbet, on the other hand, involved with the social significance of his work, could not jeopardize the ideological message of his paintings by indulging in vibrant tonalities. And he had to sacrifice color for yet another reason: the garb worn by his preferred subjects—workers or peasants of Ornans—was a far cry from the lustrous garments of odalisques, the exotic raiment of black slaves, or the blood that spills from a warrior's sword, sights that excited the imagination of Delacroix. Millet and Corot, who turned to nature as an escape from the literary connotations of subject matter, also used color sparingly and did not manage, either, to shake off completely the current precepts of composition, of the relationship between figure and background, of scale, perspective, and so on. Nor did they use brushwork that showed radical departures from the norm.

And yet, from Delacroix to Corot there appeared—sometimes surreptitiously—all kinds of pictorial innovations that unnerved a public unwilling to change its visual habits.

Indications of unrest, and even of mutinous initiatives, were not lacking. In 1867, both Courbet and Manet, tired of fighting a hostile and self-perpetuating jury, had defiantly organized their own one-man shows, something still unknown then. There had also been various Salons des Refusés, where rejected works had been exhibited, with the covert intent of demonstrating how justified the jury had been in excluding them. Thus, the exhibition assembled in 1874 by the group who would become known as the Impressionists was no real novelty. Nor should it have been so surprising that a new generation of painters had arrived on the scene who preferred Delacroix to Bouguereau, Courbet to Gérome, who loved nature, admired Corot, and considered color a divine gift. But the critics tried to dispose of them with their cheapest weapon: ridicule. What the jury's inequities had been unable to achieve, a mocking press hoped to accomplish: to dispose once and for all of this irreverent bunch. Though their work did not carry any serious threat and at worst merely showed a brazen disrespect for society's concepts of artistic law and order, these people had to be eliminated so that the established traditions could continue unchallenged.

The fact that the Impressionists were able to break this stranglehold testified to their strength and their will to persevere. The miracle is not only that this goal was finally achieved, but that it was done by the most unlikely band of iconoclasts: a haughty dandy like Manet; an easygoing street urchin like Renoir; a soft-hearted revolutionary like Pissarro; a self-doubting dreamer like Cézanne; an exquisite young woman of highly proper background like Berthe Morisot; and a rich bourgeois of impeccable breeding but occasionally arrogant and nasty disposition like Degas. Among them was only one rude, outspoken, defiant, and domineering egotist, Claude Monet.

Yet, despite different ideas and different approaches, different attitudes and different contributions, together they ran a self-promoting and apparently inexhaustible academicism to the ground.

Had fate limited the life spans of the individual Impressionists as it had rationed those of Alexander the Great or Raphael, Mozart or Byron, Watteau or Géricault, Impressionism as a movement might not have come into being. But even if such a circumstance had come to pass and these painters had not lived to organize their historic exhibition of 1874, the unorthodox tendencies that appeared very early in their works—not least their brush strokes, applied as vehicles both of perceptions and emotions—would have inspired others to explore similar avenues of color and light. One of the surest signs of the 'inevitability' of Impressionism is that this movement was not the feat of a single person, nor was it buttressed by the performance of a central figure, as was Romanticism by Delacroix or Realism by Courbet, but that it embodied the aspirations of a group. That group, gathered more or less by accident and lacking real homogeneity, comprised artists of the same generation inspired by vaguely parallel tendencies, though what most clearly bound together a Degas and a Pissarro was their mutual contempt for officialdom rather than a common artistic outlook or attitude.[1]

Except for Bazille, who was killed during the war of 1870, none of the Impressionists died young. But it is tempting, nevertheless, to speculate on what they would have left behind had they disappeared before the 1874 exhibition. Some of their star-crossed contemporaries, such as van Gogh, Seurat, and Lautrec, conceived masterpieces and imposed their indelible mark on the evolution of art during the very few years that they were given. Most of the Impressionists would have bequeathed to us paintings of considerable stature—not just of 'promise'—though, for many of them, the early works offer few clues to their mature style. Had they died at the age of about thirty-five, their names, while significant, would not carry anything like the weight they carry today.[2] In some cases the brush stroke alone changed so much that, to the uninitiated, an early and a late canvas by Degas, or Renoir, or Pissarro, for example, may seem to have been painted by different artists.

Be this as it may, there can be no doubt that even in Manet's early works we would have recognized the inheritor of a superb, painterly tradition, a man with a fluidity of the brush and an innate sense for color equal to those of the Spanish and Dutch masters he so admired. Only toward the end of his life did Manet apply a brush that was truly liberated from museum souvenirs, and for that he was indebted to the Impressionists, to Monet above all. If Monet would not have been hailed as the forerunner of Abstract Expressionism, an accolade he has been granted on the strength of his final canvases, he would nevertheless have gained admiration as a highly individual, unusually challenging, and powerful young artist, one, incidentally, whose daring and

forcefulness were matched in the middle 1860s by Cézanne and the somewhat older Pissarro. We would have been deprived of Cézanne's subsequent work, from the patient accumulation of layers of pigment to the deliberate later style that became so meaningful to the next generations. The young Degas, on the other hand, while still far from the amazing freedom of his last oils and pastels, would have deserved special notice for the masterful draftsmanship and the very personal color accents with which he transformed Ingres's meticulous technique into a modern vernacular. At the same time his sense for composition shows how adventurous and unconventional he could be. André Chénier (another genius whose life was cut brutally short) had proclaimed, 'Sur des pensers nouveaux faisons des vers antiques!' (On new thoughts let us write antique verse!) Degas with an uncanny gift for observation, managed to rely on time-honored modes of execution while informing them with the most modern thoughts.

Only the young Renoir and Sisley may not have announced any particular gifts, except that of sensitivity. They might have survived merely as pleasant enough talents, somewhat on the level of that shown by their unfortunate comrade, Bazille. During his early years, Renoir was torn between the heritage of Delacroix and Courbet; Sisley only slowly disengaged himself from the Barbizon school. Renoir, possibly because of his belated start, evolved a truly astonishing dexterity of brush that provided his delicate vision with a beautifully orchestrated proficiency. But Sisley did not keep in step with the others. Despite the marvelous perceptivity and the authentic lyricism of which he gave many proofs in the 1870s when his handling of the brush showed the same assurance and deftness as that of Monet, his later work slackened and lost its exquisite freshness, its delectable sense of color. Not being as robust as Monet, not as constantly delighted with what he saw as Renoir, Sisley may have been worn out by the ravaging struggle for survival of which—unlike the others—he never saw the end.

But Sisley's fate illustrates another, singular fact. There was something like an 'Impressionist moment,' when young eyes and fresh minds undertook together an assault of false traditions, like revolutionaries who, shoulder to shoulder, storm the barricades. They helped each other, learned from each other, shared their experiences in a truly unique and admirable fashion. Would we be able to distinguish who gave and who received more if some of the painters had not emerged, during later years, as definitely stronger or weaker personalities? We know only that their selfless communion was necessary to shape their individualities. Once that Impressionist moment, which lasted less than ten years, had passed and the painters began to separate, their potential for renewal may have been strengthened in some instances, but in others it was diminished. The latter seems to have been the case for Sisley.

Cézanne, though deeply affected by his isolation, stubbornly overcame its

paralyzing effect and built with brush and color a new universe no longer subject to the whims of ephemeral sensations. Even a man of such sturdy poise and wisdom as Pissarro, who in contact with nature had achieved a rustic simplicity of the highest order, went through a period of groping. It was then that he turned to Seurat's optical and technical innovations in the hope of finding there new structural elements. But his Impressionist eye could not submit to cold calculations and—once freed from narrow theories—Pissarro found again the vigorous spontaneity of which his later works bear witness. Renoir likewise suffered for a while from lack of self-confidence and thought that insistence on line might help him establish a link with tradition, until he discovered that tradition did not exclusively mean Raphael and Ingres, but also Watteau and Fragonard.

Only Monet does not seem ever to have looked back. This does not mean that he was spared doubts, was never dissatisfied with his work, or did not, on occasion, destroy paintings that would not measure up to his standards; what it means, rather, is that there was not much room for introspection in the life of this positive force of nature. A constant forward thrust runs through his entire work, preventing him from pausing after any achievement (or arguing its merits or faults), and steadily driving him on to new conquests. If any painter ever was inspired by the longing of the dying Faust, after he had seen visions of a new humanity, it was Monet:

> *Zum Augenblicke dürft' ich sagen:*
> *Verweile doch, du bist so schön!*

> And to the instant I could say:
> Please linger on, you are so fair!

Artists have always been preoccupied with the instant. Michelangelo depicted it as God extending a finger to the awakening Adam; Rembrandt caught it as the knife fell from the grasp of Abraham about to sacrifice his son; so did Delacroix when he painted Sardanapalus on his deathbed, surrounded by expiring concubines and a rearing horse being slaughtered. Others did not see the instant, despite its action-charged significance, as a phase among phases but chose to freeze it into a kind of sublime, motionless eternity: as did Poussin when he represented the rape of the Sabines, or Velázquez the surrender of Breda, or Greco the burial of Count Orgaz, or David the oath of the Horatii. Still others preferred a moment of timeless permanence, pregnant with what had been and would always be; Vermeer selected this all-encompassing stillness for his view of Delft, Corot for his panorama of the Roman Forum, and so, in a way, did Turner in his vaporous landscapes.

Only the Impressionists pursued the instant for the instant's sake, not as the climax of biblical or historical or mythological events, not as a symbol, not as distillation of intimate visions, but as the immediate response of their retinas and brushes to their observations of nature.

They were no revolutionaries nor did they intend to be. They looked with admiration to their elders, ambitious to be worthy of them. But they were adamant about one thing: they wished to find the expression of their perceptions outside of ready-made formulas. Rather than philosophers or historians, they were the visual conscience of their time!

In their quest for ways of rendering what they saw, they not only fashioned new techniques, but introduced a new element into painting: since their enchantment with nature's spectacle released their creative urge, some of that enchantment had to be transfixed upon their canvases. Thus not only poetry, but optimism and joy became ingredients of their work.

Was it really so difficult to understand that an artist could rise in the morning and find in the play of early light an incentive to paint? Was it really unheard-of that an artist, enamored of nature, should put up his easel in the middle of a meadow to retain on his canvas his immediate impressions? Was it inconceivable that an artist's eye should find beauty everywhere?

In those days it was. And Pissarro expressed something new when he said: 'Happy are those who see beauty in modest spots where others see nothing! Everything is beautiful, the whole question lies in knowing how to interpret.'

Interpretation was the crucial factor. Since nobody had ever done what the Impressionists set out to do, they had to invent a new 'language,' a new brushwork adapted to their unorthodox concepts. But each of them had to elaborate and test for himself the technique best suited to his intentions. Despite the many things that bound them together, the Impressionists were individualists. It is not surprising, therefore, that their brushwork should reflect both their personalities and their incessant search for improved means of expression. Like handwriting, the brush stroke is a mirror of the individual and of his mood.

But merely to study and reproduce the colored vibrations of nature does not result in a work of art. What could not be done by the photographic lens (which appeared on the scene simultaneously with Impressionism) was achieved by the painters: a projection of their inner sensibility, the selection of what was pictorially 'needed' and what was not, the clear concept of what would constitute a balanced composition, the acute observation that was allowed to dominate the creative conscience, and finally the experience that guided the hand. Rapidity had never been such an essential part of the artistic process as it became with the Impressionists while they observed nature's evanescent wonders. Their technical proficiency thus gained importance, since it had to be adapted both to the painter's instant perception and to his lasting intentions.

'I want to reach that state of condensation of sensations which produces the picture,' Matisse wrote in 1908. It is remarkable that although he wished to achieve something totally alien to the Impressionists, this basic idea was also theirs. What they observed had to become a picture. But then what any artist

194

sees, remembers, imagines, or thinks must produce a picture. The miracle that confronts every painter is how to transform a surface into an illusionistic representation. The Impressionists covered the surface with countless hatchings, loose scrawls, or tightly knit strokes until from them emerged the image that transmits their experience and emotion. Yet when they sent it out into a hostile world in order to communicate their discoveries of nature's neglected aspects, it turned out that nobody could 'read' their transcriptions. For it is the eye of the beholder that establishes the cohesion of the countless signs scattered over the canvas; it is his eye that endows the painter's image with its ultimate gloss.

Non-artists are without visual initiative. Our perception is based on tradition and schooling; it is without originality. That is why artists who mark out new paths meet with such resistance (or, at best, apathy). The Impressionists paid a heavy price for daring to follow fresh concepts. The historic importance of their first exhibition held more than one hundred years ago—an importance of which they themselves may not have been fully aware—is that it eventually changed our perception of nature. Nature herself does not change, but artists can teach us to see her differently, can bring her closer to us, can unveil her hidden beauties. Thus, a small group of determined innovators transformed the world for us. It liberated us from stagnant habits and literally opened new vistas that in turn have been and will be replaced by those of succeeding artists. But that is as it should be, since art is not a question of progress; it is one of vitality, of flux and reflux. Among the experiences that are now an indelible part of our culture is the Impressionist vision of nature.

'The great use of a life,' William James said, 'is to spend it for something that outlasts it.'

NOTES

1. In the legacy of the Impressionists—aside from their work and influence—is the fact that since their simultaneous appearance in 1874 many new endeavors have been presented by groups. Though there were such outsiders as van Gogh and Lautrec and major figures clearly dominating their following, such as Gauguin and Seurat, the history of art from Neo-Impressionism and Symbolism to the Nabis, from the Fauves to the Expressionists and Cubists, from Dada and Surrealism to today is a history not only of individuals but also of collective efforts. And many of these efforts were received with the same hostility that greeted the Impressionists.

2. By the same token it is of course impossible to guess whether Seurat's *Grande Jatte*, executed when he was twenty-five, would not have borne the same relationship to what he might have done later on, as does Cézanne's *House of the Hanged Man* of 1874 to his *Château Noir* painted thirty years later.

If van Gogh had reached the age of Monet, as Malraux has pointed out, he would have lived until 1939.

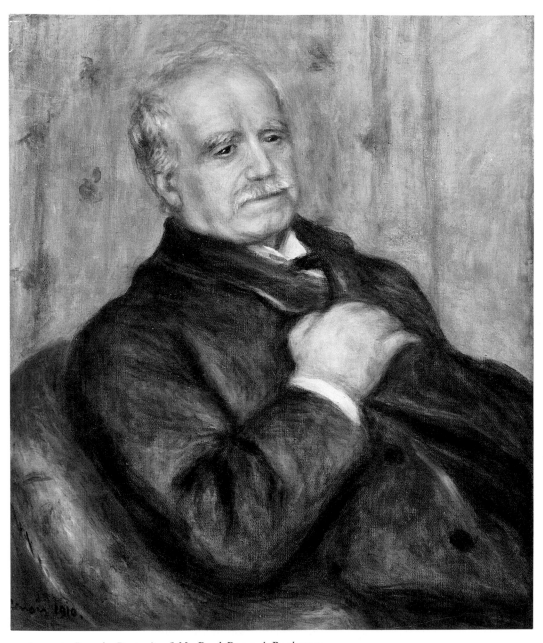

94 Auguste Renoir *Portrait of M. Paul Durand-Ruel* 1910

Durand-Ruel: 140 Years,
One Man's Faith

To Charles Durand-Ruel

No name of a non-artist is more closely bound up with the history of Impressionism than that of Paul Durand-Ruel. This man was more than the dealer of the Impressionists—he was their defender and friend, among the first to understand their revolutionary art, and for many years the only one with courage enough to invest up to his last cent in their paintings, a gesture which often brought him near bankruptcy.

Although not the founder of the establishment which in 1943 proudly commemorated its one-hundred-fortieth anniversary in an exhibition of works by all the masters introduced to France and America through his gallery, it was Paul Durand-Ruel who built up the world-famous firm. Originally a stationery shop, the enterprise had been extended by his parents to carry artists' materials and, through dealings with painters, had established the custom of accepting its clients' work in exchange for colors and brushes. Thus, an important stock of canvases had been assembled, a stock consisting mostly of run-of-the-mill merchandise on which profits were realized not so much through sales as through lending pictures to artists and academies who used them as models to copy from. This inadventurous trade could have been continued for decades if in 1865 Paul Durand-Ruel, then thirty-four, had not taken over his parents' firm.

Having developed a definite taste of his own, the new director immediately began to contact those among the contemporary artists whom he most admired: Corot, Millet, Courbet, Daumier, and the major and minor masters of the Barbizon school. Buying directly from them large quantities of paintings, Durand-Ruel soon established himself almost as their exclusive dealer.

It was while he stayed in London, where he had taken refuge from the Franco-Prussian War and the Commune, that one of the Barbizon painters, Charles Daubigny, introduced his two young friends Pissarro and Monet, who had also fled to England, to Durand-Ruel. From the start the dealer was enthusiastic about the works they showed him; he bought some and asked for

First published in *Art News*, December 1, 1943

more. Pissarro's *Crystal Palace (95)* was actually his opening Impressionist purchase. He realized that these young painters, who at that time had only refusals and laughter to their credit, were the logical successors to the school of 1830. It was to take him more than twenty years to persuade his clients of this truth.

Later, when the war exiles had returned to Paris, Monet and Pissarro arranged that their friends Degas, Renoir, and Sisley meet the man who had encouraged them so generously. Soon Durand-Ruel began buying their works too. At the same time he went to see Manet in his studio and acquired no less than thirty important canvases from him, among them *Horses in a Meadow* and *The Jetty of Boulogne*, to say nothing of such celebrated masterpieces as *The Dead Toreador (96)* and the *Guitarist (97)*. Within a few years he found himself with an enormous and steadily growing stock of Impressionist paintings, since Monet, Pissarro, Renoir, and Sisley depended almost exclusively on him. But Durand-Ruel was not only unable to sell their works, he even experienced serious difficulties with his pictures by the Barbizon masters, most of whom died in the decade after the war, occasioning public auctions of their studios and thus bringing large numbers of their works onto the market. Further adding to his difficulties was the obligation under which he found himself to put in the highest bid in order to sustain prices whenever an Impressionist canvas turned up at a public sale. Thus,

95 Camille Pissarro *The Crystal Palace* 1871

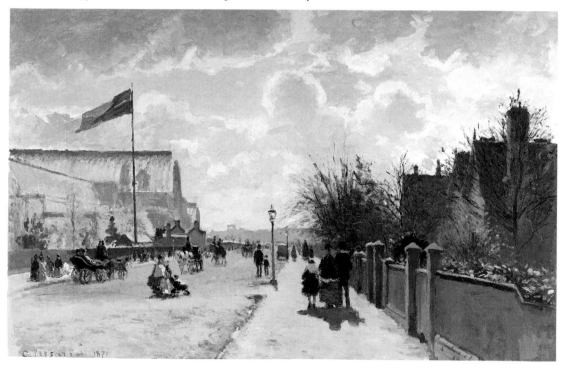

96 Edouard Manet *The Dead Toreador* 1864

ironically, he was compelled to repurchase the paintings he had so far, with so much difficulty, been able to sell, further augmenting his continually growing stock.

To buy steadily without selling can hardly be considered a sound business basis and it was only natural that Durand-Ruel often found himself faced with almost insoluble problems. Certain of his letters to Camille Pissarro show that if the painter was sometimes left without a centime, it was certainly not because his dealer had 'forgotten' to mail his check.

'You cannot conceive what difficulties I have had for about a month now; I waste my time running after people who make promises and never keep them,' writes Durand-Ruel in June 1883; and five months later he says: 'I am terribly sorry to leave you without a penny, but I have nothing at all at the present moment. I must even greet misfortune with a smile and I have to give the appearance of being almost rich.' In June 1884 he complains again: 'I am still very annoyed with the way business is going. All those whom I ask for help tell me to wait. That's easy to say.' In spite of this disastrous situation, he does not give up hope and writes in October 1884, 'If we fight just a little more, we shall finally dominate our enemies'; a year later, however, completely discouraged, he exclaims: 'All I earn is trouble. I wish I were free to go live in the desert!'

Durand-Ruel could hardly expect his painters to subsist on these complaints, and as a matter of fact they often threatened to abandon him, only to return to the realization that no other dealer or collector was willing to offer them even the few francs Durand-Ruel still managed to send. Though it cannot be concealed that there were sometimes ill feelings between the dealer

and his protégés, who were dissatisfied with his low prices, his unkept promises, and the way he handled their work (frequently showing it together with academic paintings), there can be no doubt that Durand-Ruel did everything he could in order to help them live and to promote their art. His faith in their genius was unshaken by his inability to market it. Taking little interest in other newcomers, he concentrated on Monet, Renoir, Degas, Sisley, and Pissarro with whose fate his own seemed inextricably linked.

As he confesses in his personal notes, Durand-Ruel might well have been ruined had not America come to his aid. This happened at the end of 1885 when his affairs had taken so disastrous a turn that he longed 'to live in the desert.' Unexpectedly he received an invitation from the American Art Association and resolved to assemble a great number of paintings for an important exhibition in New York, the first of its kind. In March 1886 he sailed with three hundred canvases, among them not only works by the Impressionists, but also some by academicians (designed to 'soften the shock'), as well as Seurat's *Bathers* (now in the Tate Gallery), the latter at Pissarro's request.

Ready to 'revolutionize the new world simultaneously with the old,' as he said, Durand-Ruel naturally expected the same violent hostility from public and press which he had experienced in France. But quite the contrary, his exhibition achieved a real *succès d'estime* which he later explained thus: 'Since I was almost as well known in America as in France for having been one of the first defenders of the great painters of 1830, the public came to examine carefully and without prejudice the works of my new friends. It was presumed that these works had some value since I had continued to support them.'

Encouraged by the moral and financial success of this venture, Durand-Ruel decided to return to America the next year with a new collection of paintings. But this time he was to encounter the opposition of certain American dealers who had become alarmed by the unexpected success of his first show. They managed to put through a new customs ruling which not only delayed the opening of the second exhibition, but obliged Durand-Ruel to send back to France every painting sold in New York and then to import it a second time into America. It was such complications that made him finally decide to open a branch in New York, enabling him ultimately to assist in the formation of some of the finest American private collections, such as the Havemeyer, the Martin Ryerson, the Potter Palmer, the Robert Treat Paine, as well as many others, both private and public.

Any consideration of Paul Durand-Ruel's historic role would be incomplete if it were confined to his relations with the Impressionists alone. His gallery also dealt in works by Rembrandt, Goya, Velázquez, and others, and, long before Meier-Graefe's 'discovery' in Spain, it was one of the first to handle the paintings of El Greco. Around the year 1907 anyone with 30,000

francs—then about $6,000—could have bought at Durand-Ruel's the El Greco *Landscape of Toledo* which today is one of the jewels of the Metropolitan Museum.

When fame came to his painters, competition also came to Durand-Ruel, although the sheer number of canvases assembled during the long 'pre-recognition' years gave him a unique position among all art dealers, as it had given him the solid friendship of those artists who lived to see fame and wealth.

Of all these painters, Renoir was perhaps the most attached to Durand-Ruel; it was he who painted the portraits of his daughter, of his sons who later took over his galleries, and of the dealer himself. The beautiful portrait of Paul Durand-Ruel done in 1910 *(94)* is more than a perfect likeness, it is a homage rendered to a far-seeing and faithful friend who transformed the business of art dealing into a personal mission.

97 Edouard Manet *The Guitarist* 1860

98 A prized treasure of the Art Institute of Chicago is Renoir's *On the Terrace* (left wall), which Londoners failed to notice eighty years ago. Next to it are two important paintings by Monet. Glimpsed through the door is Manet's *Monsieur Pertuiset*, now in the São Paulo Museum of Art

Illustrations 98 to 102 show works in the Paul Durand-Ruel Collection which were exhibited at the Grafton Galleries, London, in 1905

Depressionist Days of the Impressionists

In memory of Pierre Durand-Ruel

In 1873 the Parisian art dealer Paul Durand-Ruel published a luxurious catalogue in three volumes in which he introduced among the works of already recognized masters some paintings by younger men in whom he was just beginning to take an interest. Cleverly interspersed between the pages devoted to Delacroix, Millet, Corot, Rousseau, Dupré, and Troyon, the products of these newcomers—Manet, Monet, Pissarro, Sisley, and Degas—did not appear too conspicuous; yet, M. Durand-Ruel's customers preferred not to follow him in his enthusiasm for these unknowns. As years went by he was left with an ever-mounting stock of unsalable works, until the dealer came close to bankruptcy. Had an exhibition held in New York in 1886 not helped to turn the tide, he would have been ruined. Fortunately his success in America was followed by a slowly rising interest for his painters in France; England, however, remained refractory. M. Durand-Ruel therefore decided to take some of his best things, 315 pictures altogether, to London, and on January 16, 1905, he opened a huge exhibition at the Grafton Galleries. The show was composed of 59 works by Renoir, 55 by Monet, 49 by Pissarro, 38 by Boudin, 37 by Sisley, 35 by Degas, 19 by Manet, 13 by Berthe Morisot, and 10 by Cézanne. Of the painters represented, Renoir, Monet, Degas, and Cézanne were still living; Pissarro had died only recently. An album of photographs which shows the different rooms and close-ups of the walls reveals that in those days the Grafton Galleries harbored treasures such as have seldom, if ever, been assembled since and were richer in works by Impressionists than any single museum is today *(98–102)*.

The London press, although recognizing that the exhibition was 'exceptionally rich in representative works of the most prominent artists of the school and unique of its kind in England,' was not particularly enthusiastic. The *Connoisseur* termed it 'certainly so far the most important event of the present art season in London,' but explained in an apologizing note, 'The Whistler Memorial Exhibition was not opened to the public when these pages went to press.' And the London *Times* stated with caution, 'As to

First published in *Art News*, February 1, 1945

99 Two masterpieces stand out here, both distinguished by single hanging: left, Renoir's *The Loge*, now in the Courtauld Institute Galleries, University of London; right, his *Dancer*, once in the Widener Collection, now in the Washington National Gallery. Monet's *Pheasants* (bottom, third from left) and his *Vases of Chrysanthemums* (bottom, second from right) are now in American private collections. The *Woman Sewing* by Renoir (far right, bottom row) now hangs in the Sterling and Francine Clark Art Institute in Williamstown, Mass.

the greatness and goodness of the art there will be various opinions,' adding: 'It is natural that after the conquest of Paris and New York Mr Durand-Ruel should wish to conquer London. He may not succeed, but at least he has come formidably armed.'

Each critic had his own likes and dislikes, but no single one approached this exhibition without the intention of picking some flaw, of showing his knowledge through severe criticism or mild remonstrances. How different was the case of the Whistler Memorial! There the *Burlington Magazine* announced weeks in advance that His Majesty the King was lending his collection of prints and that the French government was sending the portrait of Whistler's mother. No sovereign or government would lend the Impressionists their prestige. The Luxembourg only reluctantly had accepted part of the Caillebotte bequest and Monet had had almost to force upon it the gift of Manet's *Olympia*. The battle was still far from being won. Nothing proves this better than the British comments.

Renoir, according to the expert of the *Connoisseur*, 'the most unequal of the great Impressionists, excels in painting living, palpitating flesh, but his most enthusiastic admirers cannot defend certain phases of his art in which he sinks far below the level even of mediocrity.' The critic of the *Times*, however,

100 Renoir's large and magnificent *Luncheon of the Boating Party* is now one of the most important and possibly the most famous painting in the Phillips Collection in Washington, D.C. It is surrounded here by landscapes and a still life by Monet

stated of his works that even 'the least of them are beautiful. . . . Nearly all are delightful, none are ugly.' But he could not say the same in connection with Manet. 'To the older critics,' he wrote, 'Manet's method . . . was wrong, because the result, whatever the technical merits, was ugly. A composition like that of *Spanish Dancers* [The Phillips Collection, Washington, D.C.] gave no pleasure to the eye; a portrait like that of *Eva Gonzales* [National Gallery, London]—a young girl with the figure of middle age, with a staring expression and an ill-drawn face—was in no sense beautiful, and therefore did not justify its existence. . . . For us it is a masterpiece *manqué*. The painting of the dress is fine; the figure is full of life; but Manet meant to paint a beautiful woman, and he has not done so.'

It cannot come as a surprise that Cézanne found no admirers in London. To the *Connoisseur* he appeared hardly as a compeer of the other Impressionists, 'His work in their company strikes one as that of a gifted amateur, whose tastes and intentions are far ahead of his technical skill.' The *Times* critic had nothing at all to say about him, but it is easy to imagine what his reaction was, since he found even Monet without any 'power of drawing' and 'monotonous in his worship of the sun.'

Unexpectedly, however, even Degas was severely judged, although as the

101 The centerpiece of this wall is Manet's *Portrait of Eva Gonzales at her Easel*, now in the London National Gallery. It is flanked at left by a flower still life by Cézanne (top), still in the Durand-Ruel collection, and by Manet's *Group of Spanish Dancers* (bottom), which is in the Phillips Collection, Washington, D.C. At its right are another flower still life by Cézanne (top), now in the Art Institute of Chicago, and (bottom) Manet's *The Artist's Garden in Versailles*, which is in a New York private collection. There are more works by Manet and Cézanne at left and right

'draftsman' of the group it was he who was usually more readily approved of than any of his comrades. But the reviewer for the *Times* certainly pulled no punches. 'It is fashion in "advanced" circles,' he wrote

'to place Degas on a level with Manet. . . . We for our part, and to our regret, fail to find even the elements of that greatness which his admirers say is his and his almost alone of the painters today. Never was there a painter who took the road to immortality with so little baggage. What has he done, except paint (in his young days) a few charming little pictures, perfectly drawn and highly finished, and, in mature life, a number of pastel studies of dancing girls in momentary attitudes? Even were we to admit that he is as good a draughtsman—and it is hard to admit—as Jan Steen—and that he is a master of all the subtleties of artificial light, does that prove him to be more than a *virtuoso*? . . . No. The American collector [without any doubt an allusion to Mr Havemeyer] who has been paying his thousands for the little *Danseuses* of Degas will one day wake up to the fact that an artist, to count permanently, must have something to say.'

It must have been a satisfaction, indeed, to the critic of the London *Times*, that no British collector prepared himself such an unpleasant awakening. The exhibition did not attract any buyers. The paintings had still to wait many

206

102 One of Renoir's favorite models, *Angèle*, is seen here as she dozes while posing with a cat in her lap; this picture is now in the Sterling and Francine Clark Art Institute, Williamstown, Mass. At the extreme left above the chair are two more paintings by Renoir; all the other works are by Monet, including one of the many versions of a *Haystack*, a snow scene from Norway (third from the right, top), one of Monet's numerous façades of the *Rouen Cathedral* (bottom, extreme right), and *Rocks at Belle Isle* (top, extreme right)

years before they could take their place in the greatest museums and private collections of the entire world. But eventually, of the pictures shown in 1905 in London, to mention but a few, Manet's *Wandering Musician* went as a Chester Dale bequest to the National Gallery of Art in Washington; his portrait of Astruc was acquired by the Bremen Museum; Pissarro's *Girl Holding a Twig* and Renoir's *View of the Seine* are now in the Louvre; Renoir's *Portrait of Miss J. D.-R.* [M. Durand-Ruel's daughter] now belongs to the Barnes Foundation; Degas's pastel the *Green Singer* went first to Moscow and then, via the Stephen C. Clark Collection, to the Metropolitan Museum in New York; Renoir's *Grenouillère* is still in Moscow; his *Portrait of Chocquet* and Cézanne's *Landscape near Pontoise* are among the treasures of the Fogg Art Museum; Cézanne's *Portrait of Chocquet*, once in the collection of the Museum of Modern Art, New York, now belongs to the Columbus Musuem of Art; his *Vase of Tulips* is in the Art Institute of Chicago; Manet's *Music in the Tuileries Gardens* is now in the National Gallery and Degas's *Miss Lala at the Cirque Fernando* is in the Tate Gallery, both London. However, it was to take some time until they reached their final destinations.

In the meanwhile, M. Durand-Ruel, after having first extended the exhibition for a few days, had to take his entire stock back to France. The

Whistler Memorial show had opened and there was no longer hope of attracting people with the pictures of artists who made enemies even without cultivating the 'gentle art' of doing so. All he had earned was gratitude. 'The thanks of all London art lovers,' wrote its British correspondent to the *American Art News*, 'are due M. Durand-Ruel for the magnificent opportunity he has given us to study the French Impressionist painters, a school in which he has taken the deepest interest for thirty years. . . . Fine examples of the work of Monet, Manet, Degas, Pissarro, Renoir, Boudin, and Cézanne have been shown, and the advantage of studying these leaders in their own field cannot be overestimated.'

Although not a single painting had been sold during the exhibition, fate somehow managed to soften its harshness. Mr Frank Rutter, having given a lecture on Impressionism 'for the purpose of raising a fund to acquire one or more representative pictures of this school for the nation,' approached M. Durand-Ruel after the closing of the show and bought a painting by Boudin which was given to the National Gallery. This is the only 'souvenir' that London kept of the greatest Impressionist exhibition ever to have been organized.

Pissarro, Nietzsche, and Kitsch

To Joanna Drew

'I recall at the Académie Suisse there were students
who were remarkably skillful and could draw with
surprising sureness. Later on, I saw these same
artists at work; they were still skillful, but no more
than that. Just think of Bastien-Lepage! and Carolus
Duran!!! No, no, no, that is not art!'

Camille Pissarro to his son Lucien, 1884

The chronicling of events is a matter of selection and evaluation. Volumes of
newspapers do not constitute a history book, though they contain much of the
data for one. Only time provides the perspective that endows past happenings
with their true meaning, disclosing their importance or triviality. It is from a
distance that minor occurrences may reveal themselves pregnant with the
most decisive elements; it is from a distance also that many who were major
figures in their day shrink to nothingness. But unless we perceive this clearly
and let those who fall by the wayside sink into oblivion, we are abusing the
advantages of hindsight.

This is exactly the danger we are facing at present when some historians,
with the admirable aim of presenting a total picture of the artistic
achievements offered by nineteenth-century France, engage in the
resurrection of the ghosts of Academism. By doing so, they bestow upon the
very men who were merciless enemies of every new tendency an equality of
rank which places them among the significant forces of the past. This is
neither 'justice' nor 'clarification'; it is instead a dangerous manipulation that
diverts the powerful flow of the mainstream of history.

Shortly before the outbreak of the First World War, Louis Dimier, a
French critic whose reactionary attitude entitles him to a special niche in the
literature of art, published a learned volume, *Histoire de la peinture française
au XIXe siècle (1793–1903)*. He chose 1903 as his cutoff date because that was
the year in which Léon Gérome had died and with that artist there

First published as the Introduction, catalogue of the Pissarro exhibition, Hayward
Gallery, London, 1980–81

'disappeared the successor of David and Ingres, heir to the authority established by them.' As the impartial historian he pretended to be, Dimier dutifully recorded that Gérome had been the only one who 'brilliantly resisted' Impressionism, 'designating Manet's paintings as *cochonneries*.'

The year 1903 also saw the death of Camille Pissarro, whose name appears exactly once in Dimier's 319 pages, when the author explains that divisionism and the application of scientific data to art were tendencies prompted, above all, by the need 'to justify the technique of Monet, born of the hallucinations of an exasperated eye. . . . The system was called *pointillé*. Pissaro [*sic*], friend of Monet and disciple of Impressionism, followed it.'

One may consider 1903 as a significant date because of Gérome or Pissarro, but to select it because *both* men died that year simply won't do. Such are the pitfalls of a supposedly equitable perception of history, that the perfectly correct statement, 'In 1903 Pissarro and Gérome died,' implicitly puts the two men on the same level. One of the great Impressionists and an essential figure in the evolution of modern art is equated with the benighted Academician who considered Impressionism to be 'le déshonneur de la France.' Even more, it establishes a parallel between a man whose perceptions and creative powers remained fresh and vivid until the last and a dried-out practitioner whose main concerns were with Oriental picture postcards and slick nudes, some of them in marble with bronze adjuncts.

Those who think that Dimier honestly believed in the historic role played by Gérome should perhaps consider that what is at stake here is not Dimier's sincerity, but the stand he took. At the time Dimier deemed it relevant to slander Impressionism (with Monet, Renoir, and Degas still alive), completely to overlook Pissarro, and to glorify Gérome, the cause of the latter was already irremediably lost; new generations had appeared, on whom Gérome's 'authority' did not have the slightest hold. And well before Dimier attempted his peculiar classification of the vital currents of the nineteenth century, there had been men who had spoken up for Manet and Cézanne, Monet and Pissarro, recognizing them as the true masters of the period. Among them were Emile Zola and Mallarmé, Théodore Duret, Gustave Geffroy, Octave Mirbeau, and Georges Clemenceau. To go back today and absolve Dimier is to race through history in reverse gear.

Gérome, admittedly, does not even deserve to be attacked and could remain a footnote were it not for recent endeavors to re-establish him and his brethren—the Lhermittes, Besnards, Chabas, Le Sidaners, Henri Martins, and Bérauds—in the overview of French nineteenth-century art. This is done under the illusion that they represent the other side of the coin. But this concept is based on a fallacy. When two real forces confront each other, such as Ingres and Delacroix, their opposition yields positive results and adds vitality to the period. It is possible, and indeed necessary, to appreciate both Delacroix and Ingres as, incidentally, Camille Pissarro did. Yet the struggle

between Academic art and Impressionism which dominated the second half of the last century—that is, Pissarro's entire life span—was not a competition between equal forces. Those who, in the wake of Gérome, endeavored to stem the tide of Impressionism had nothing to offer but stillborn concepts, antiquated ideals, empty skills, and a contemptible willingness to accommodate the conquests of plein-air painting to the debased taste of the Salon jury.

How are we to evaluate the contribution of a man like Besnard, who has recently been credited with 'making the richness of the Impressionists' atmospheric color acceptable' in the context of Salon painting? Was that a purpose of historic import? Was the watering-down of the Impressionist approach to nature an achievement that deserves recognition? 'They shoot us but they go through our pockets,' Degas quipped.

Souvenir hunters who are presently 'rediscovering,' or even 'rehabilitating,' various producers of anemic Salon wares seem completely unconcerned with the fact that what those people manufactured were *unnecessary* pictures. Nor do they appear to recognize that the authors of those commercial artifacts were by no means modest and inoffensive wielders of outmoded and syrupy brushes, but active reactionaries in positions of power.

Though this is sad, it is not new. By a strange coincidence, Friedrich Nietzsche wrote his study *The Use and Abuse of History* in 1873, at the very time when Pissarro and his friends were beginning to plan their first group exhibition, the historic show that was to gain them unprecedented abuse and the derisive designation of 'Impressionists.' Nietzsche noted, in discussing the necessity of history in relation to man's struggle, that 'the great moments in the battle of individuals form a chain of crests that links humanity through the ages, and the highest points of those vanished moments are yet great, luminous, and alive.' Concerning himself with the artist's perennial struggle for acceptance, Nietzsche wrote:

'Consider the simplest and commonest example, the inartistic or half-artistic natures whom a monumental history provides with sword and buckler. They will use these weapons against their hereditary enemies, the strong artistic spirits, who alone can learn from that history the one true lesson how to live, and embody what they have learned in noble action. Their way is obstructed, their air darkened by the idolatrous and eager dance round the half-understood monument of a great past. . . . Apparently the dancing crowd even has the monopoly of "good taste," for the creator is always at a disadvantage compared to mere onlookers. . . . But if the custom of democratic suffrage and numerical majorities be transferred to the realm of art, and the artist put on his defense before the court of aesthetic dilettanti, you may take your oath on his condemnation, although—or rather because—his judges had proclaimed solemnly the canon of "monumental art," the art that has "had an effect on all ages," according to the official definition. In the eyes of these judges no need nor inclination nor historical authority exists for the art which, being contemporary,

103 Carolus Duran in academic regalia

is not yet "monumental." Their instinct tells them that art can be slain by art: the monumental must never reappear, and to that end its authority is invoked from the past. They are connoisseurs of art, primarily because they wish to kill art. . . . They develop their tastes to a point of perversion that they may be able to show a reason for continually rejecting all the nourishing artistic fare that is offered them. For they do not want greatness to arise; their method is to say, "See, greatness is already here!" In reality, they care as little about the greatness that is already here as that which is about to be born. . . . Monumental history is the cloak under which their hatred of present might and greatness masquerades as an extreme admiration for the mighty and great of the past. . . . Whether they really know it or not, they are actually behaving as though their motto were: "Let the dead bury the living."[1]

212

104 Camille Pissarro, circa 1895

And in truth, these barren Academicians who are now being rescued from well-deserved neglect did try to bury the living. Yet Nietzsche overlooked that their historian-servants would also pervert our vocabulary. For if perpetrators of moist nudities à la Chabas, of adorable peasant girls à la Bastien-Lepage, of draped silks on lifeless dummies à la Besnard, of sentimental calendar landscapes painted in dots à la Le Sidaner, if these are given credit for 'bold and sparkling representation,' for their 'richness of color and texture,' for their 'luminous and blond tonalities,' or the virtuosity of their brushwork, then no words are left to describe the accomplishments of Manet, Monet, Renoir, Pissarro, and their friends. Shall we have to forge a

213

new language for doing justice to the men who added so many fresh perceptions to our vision? Or would it not be simpler to sweep away once and for all the anecdotal productions of anti-monumental practitioners and turn our attention to those who contributed to the chain of crests whose peaks are still great, luminous, and alive?

Not all of them have yet received their full due. In spite of his stoic and brave, stubborn and even cheerful struggle, Camille Pissarro's name is seldom mentioned among those who played a pivotal role in the evolution of nineteenth-century painting. Yet it was he who, more than any other, built the bridge that led from Barbizon to Louveciennes and eventually to Asnières and La Grande Jatte. He did so quietly, guided by a generous nature and by deep convictions that often conflicted with his own material interests. He never sought the limelight and yet managed somehow to *cultiver son jardin* at Eragny and simultaneously keep in touch with all that was new and original. His hand, which early on had reverently clasped that of Corot and later offered guidance to Cézanne, Gauguin, Signac, and van Gogh, was eventually extended to Matisse and even the young Picabia.

While Manet, the purebred traditionalist, carried the torch of anti-Academism and hoisted the banner of an artistic revolution, Pissarro, the anarchist sympathizer, remained in the background, continuing a painterly tradition transmitted not only by Corot, but also by Courbet and Millet. Equally important, however, was his incredible gift for discerning promise in others and helping them develop their potential. His constant function as teacher, collaborator, and friend added an extra dimension to his stature as an artist, since he became involved in all the movements of the second half of the last century which have shaped the art of our own. In addition, surrounded by often antagonistic colleagues, he was the only one to whom the others listened, because his conciliatory attitude was always above suspicion. Thus, as an artist *and* as a human being, Pissarro fulfilled a mission matched by no other of his associates or contemporaries.

It is almost a miracle that he managed to achieve a complete balance among the different roles life thrust upon him: he was a painter undaunted by the difficulties of an existence strewn with constant hurdles; he was a father devoted to his children, whose artistic inclinations he tirelessly fostered, as though good advice could turn them into masters; he intensely observed the political scene—a very lively one at that—and carried the burden that the Dreyfus affair imposed on all French Jews; he was always ready to be counted when positions had to be taken on social issues; and he was always willing to dispense benevolent and wise counsel. While these qualities endeared Pissarro to all who came in touch with him, it is of course his work that ensures his place and constitutes his great legacy.

There have not been many exhibitions of Pissarro's diverse and multifaceted production. The present show, celebrating the artist's one-

hundred-and-fiftieth birthday (a startling number of years in view of the fact that he still appears so near, his action so close to us), demonstrates the breadth and originality, the warmth and modesty and purity of his artistic nature: in one word, his genius. It illustrates his lifelong quest for expression, a quest in the course of which his style underwent several changes, for he would always reach for new goals rather than sink into facile routine. And—if such a demonstration were needed—this retrospective shows once more that obstacles can hamper but never silence the creative forces opposed by anti-artistic natures. For, to quote again from Nietzsche:

'One thing will live . . . a work, a deed, a rare illumination, a creation; it will live because no posterity can do without it.'

NOTE

1. Friedrich Nietzsche, *The Use and Abuse of History*, 2d ed., rev. trans. Adrian Collins (New York, 1957), pp. 16–17 (with author's emendations).

Book Reviews

Adolphe Tabarant. *Manet et ses oeuvres*. Paris: Gallimard, 1947.
Pp. 600; 21 pls.

It is not easy for a reviewer to pass judgment on a book which literally
represents the lifetime work of an author over eighty years old, offering on six
hundred closely printed pages the result of a tremendous and patient effort.
That effort in itself commands such respect that it almost silences any
criticism; and yet, it is the achievement that we have to study, not the author's
touching devotion to his task.

There can be no doubt that Adolphe Tabarant knows more about Manet
than anybody else, that he has studied more documents, assembled more
evidence, paid careful attention to more details than has ever been done
before. He has indeed so completely identified himself with his subject that he
more than once loses the necessary detachment, so that some of his chapters
read more like the story of the author's research throughout the years than a
treatment of the painter's work. Unable to keep his own person out of the
narrative, he never passes up an opportunity for polemic and seems to
consider any opinion differing from his own, every slightest error, as personal
insults both to himself and to Manet. He quotes such errors with apparent
relish, chastising their unfortunate authors with frequently facile quips, and
often does not even deign to discuss them, merely advancing his own views
with a defying tone of finality. It is not without irritation that the reader finds,
for instance, Moreau-Nélaton, author of the first scholarly book on Manet,
referred to as 'this good man, timid and pusillanimous' by a writer among
whose chief characteristics is pusillanimity. Though it is doubtlessly true that
in most of his polemics Tabarant's point of view is correct, he insists with
such vindictiveness on ridiculing anybody who dares disagree with him, that
his text often descends from the level of a learned discussion into the arena of
public quarrel.

First published in *The Art Bulletin* (Yale University, New Haven, Conn.), September
1948

Tabarant has so stubbornly concentrated upon his subject that he seems to ignore everything else, and through the consistent focus upon his hero he has unwittingly distorted the entire picture. The reader, overwhelmed by the mass of information offered, perceives Manet as if through a magnifying glass, with minute detail blown up tremendously, yet the whole blurred, as well as detached from its natural surroundings. A tireless investigator, the author seems at first to have neglected nothing, refusing to separate the important from the trivial, but at the same time he has reduced all of Manet's friends and contemporaries to mere shadows and has thus set his larger than life-size portrait of the painter against a completely dead background. In the process of dumping the burden of his tremendous knowledge into the lap of his readers, he appears to have crushed Manet himself under the weight of documentation. And yet his book is admirable in the single-mindedness of its concentration, a true mine of information, with practically each page offering new facts, dates, precisions.

To say, however, that the profusion of Tabarant's material makes for a readable book, or even a volume that may be easily used for reference, would be departing from the truth. In fact, the very concept of his work, which might be called a 'catalographical biography,' could be cited as an example of what a book of that type should not be. The rambling way in which the stupendous amount of information is assembled and presented is well-nigh certain to exasperate the majority of those—and there will be many—who have to consult it.

The account of Manet's career is intricately connected with a catalogue raisonné of his works, the discussion of each phase of his life being followed by an enumeration of the paintings, watercolors, or drawings done in that period. The method throughout the book is to give, first, a precise description of the picture's subject, but of the subject only, with few indications of colors and hardly any mention of technique (in other words a description that offers an idea much vaguer than a photograph, while not providing the elements which a photograph cannot supply); to this are added measurements and other data, and, if warranted, a few words about the model or other particular circumstances, followed by the picture's history from the time it was painted to the present day. References to exhibitions and publications (though neither complete nor assembled with any consistency) are included, but the history concentrates upon the successive owners, the prices they paid, the auctions in which the work appeared (with the room number at the Hôtel Drouot, names of *commissaires-priseurs* and experts, and mention of who replaced them while they were on active duty). If any prominent collector or personality was among the successive owners, a short notice is included about him, his collection, the works it contained other than those of Manet, when and where it was sold and for how much. Then any other versions, sketches, or drawings for the painting under discussion are described in turn (preparatory studies

always being listed *after* the work with which they are connected, instead of before), with their pedigrees from the time of their execution until today. Immediately, without any transition, the text reverts to Manet's life or examines with the same system his next work. Accounts of Manet's exhibitions at the Salon or elsewhere are generally relegated to special chapters, accompanied by lengthy quotations of favorable or unfavorable comments with which his works were received on such occasions. These quotations are thus separated from the description of the painting or pastel itself.

It seems obvious that pedigrees of works of art are interesting only in specific instances in connection with the history of a particular canvas, but it is most unlikely that many readers will want to know the detailed background of some 450 paintings, 80 pastels, and 140 drawings and watercolors. The purpose of a catalogue raisonné is precisely to offer such information in a condensed and easily accessible form to serve for reference rather than to be read. By incorporating the catalogue material into the text, Tabarant forces his reader to consume much arid and often useless information while pursuing the narrative of Manet's career. The reader thus continually loses the thread of the painter's biography and in the end fails to derive a clear picture of either the man or the artist.

Strangely enough, Tabarant has neglected to provide some of the most essential references along with all the numbers, dates, and prices he quotes so profusely. Nowhere does he refer in his text to the number under which a work is reproduced in the appendix, an omission which is particularly disturbing because the illustrations do not strictly follow the text. Nor are all works reproduced, though most of them are. In the text they are discussed in chronological order, while in the plate section they are arranged by mediums: first paintings, then pastels, and finally watercolors and drawings. Therefore, to locate illustrations requires reference to a special list, an inconvenience which further distracts from the reading. Even more serious, however, is the fact that Tabarant has in most cases completely ignored, or has chosen not to refer to, the existence of previously published catalogues of Manet's work.

Several attempts have already been made to catalogue Manet's paintings and pastels (but not his watercolors and drawings). The first list was published by Duret in 1902 and again, extended, in 1906. It was followed in 1926 by Moreau-Nélaton's publication. But the first real catalogue raisonné was published in 1931 by Tabarant himself, *Manet: Histoire catalographique*, of which only 225 copies were issued. This book, which listed also some watercolors, rendered the previous publications obsolete, but its usefulness was considerably limited by the lack of any illustrations. In the absence of reproductions, here Tabarant's detailed descriptions of each work were an essential feature. The next catalogue, by Jamot, Wildenstein, and Bataille, appeared in 1932 in two volumes, one of which was devoted to plates. It was

by no means a perfect publication, but its consultation was facilitated through tables, indexes, cross-references, etc., and it gave, for instance, for every painting the corresponding numbers of the Duret, Moreau-Nélaton, and Tabarant catalogues. Among its strangest innovations was a rather unpleasant one, the inclusion of a number of doubtful works and even fakes, not always designated as such and listed like the originals except that their titles were set in a different type, a subtlety that has sometimes escaped attention. A major asset of this publication was its large plates, though these are unfortunately not arranged chronologically.

In his present catalogue Tabarant had to content himself with illustrations somewhat smaller than postage stamps, their average size being $\frac{3}{4} \times \frac{5}{8}$ inches. About thirty are grouped on every plate. They are of course inadequate, but this reviewer does not want to take issue with this aspect of Tabarant's book. Under present conditions in France and in order to keep the price of the volume down, there was probably no other solution. For cursory reference the reproductions will do, but it cannot be denied that fewer or shorter descriptions of paintings and larger illustrations would have served a better purpose. In any case, readers of Tabarant's new catalogue will often want to refer to the plates of the Jamot-Wildenstein-Bataille volume and a table correlating the numbers is indispensable. Yet no such concordance has been provided by Tabarant, whose new catalogue follows with few exceptions his first publication; thus, both often disagree considerably with the Jamot-Wildenstein-Bataille chronology. It is certain that more than a few of the Jamot-Wildenstein-Bataille dates are subject to revision, yet the dates which Tabarant proposes do not always withstand a thorough examination either. He has a strange tendency to group together works of similar subjects, as if, so to speak, Manet had painted only apple still lifes at one given moment, or vases with roses at another. It seems more likely to assume, as Jamot-Wildenstein-Bataille had done, that Manet treated such subjects throughout his life (at least Tabarant does not furnish any proof to the contrary).

A concordance would also have permitted identification at first glance of those works not previously included in catalogues of Manet's output. Tabarant lists a number of them, and though they do not seem to be major works, there are several of some interest. For such hitherto unpublished works, the small reproductions of his book are of course absolutely inadequate. It is impossible to judge their importance, their quality, and—to the extent that one can discern from a photograph—their authenticity from these minuscule vignettes. In his first, unillustrated catalogue, Tabarant had admitted works whose authenticity has been contested by Jamot-Wildenstein-Bataille, and the present volume includes not only these same works, but also some new ones on which not every reader may wish to share the author's convictions. Tabarant's new discoveries, at least, should have received special treatment and should have been reproduced on a scale that

would make closer study possible. In fact, some of the newly discovered works are not reproduced at all. Furthermore, it would have been helpful to have reproductions of the original versions of such works as Manet's *Study for the 'Bar at the Folies-Bergère.'* Though Tabarant comments at length about the outrageous way in which this has been retouched, he reproduces it not in its original condition (though a photograph exists), but as it appears today, repainted.

Had Tabarant confined all information pertinent to specific works to a catalogue section where it could have been consulted easily (as he had done in his first book), his biographical text would doubtlessly have afforded a much clearer image of Manet and he could have avoided at the same time considerable repetition. In his own words his book presents 'an uninterrupted account in which catalography is joined to individual episodes, to the current of life. Its documentary aggregate, the most considerable ever to have been put at the service of an art monograph, covers everything that relates to Manet' (p. 516). But this statement is not merely lacking in modesty, it is not even correct. There are many facts connected with Manet, some of them quite important, which remain unrecorded here. Since there is no bibliography, it is difficult to distinguish what escaped the author's attention from what he chose not to relate, but it is even more difficult to understand *why* he did not incorporate numerous facts and documents which must have been known to him.

Whenever he tackles a problem, Tabarant is careful to investigate all its aspects and, confronted with conflicting evidence, takes pains to leave the issue open instead of drawing conclusions. He thus considers at length, and without committing himself, such questions as whether Léon Koëlla was Manet's son, or whether the painter knew on his deathbed that his left foot had been amputated. But other questions either remain unexplored or are briefly answered with no indication whatever of the authority for the solution. It is quite puzzling, for instance, to read apropos of Manet's *Soap Bubbles* that this composition 'was obviously nothing but a pleasant pastime' (p. 114). Why 'obviously'? And how does one distinguish in the Manet oeuvre the works that were a 'pleasant pastime' from those that were not?

Manet's friendship with Baudelaire, certainly no negligible question, especially for the author of the book *La Vie artistique au temps de Baudelaire*, is treated with truly surprising briefness. Tabarant affirms that the painter and the poet met in 1858–59 (p. 49) without supporting this contention by any proof, yet he does not hesitate, on the other hand, to devote an entire chapter to the problem of whether Manet really did make a disparaging remark about Renoir, as reported by Monet (pp. 252–57). Nor does he even mention the fact that there had been a disagreement between Moreau-Nélaton and Jamot, and a very conclusive article by the latter, on the question of whether Manet painted his *Battle of the 'Kearsarge' and the 'Alabama'* after having actually

seen the battle. Indeed, the few lines Tabarant devotes to the subject (pp. 88–89) are likely to leave the reader in doubt, whereas Jamot's study, to which there is no reference, offered sound arguments for his contention that Manet had been in Cherbourg for the event. (It is difficult not to mention here that there *are* ample references to Jamot's writings whenever Tabarant disagrees with his findings.)

A complete list of Tabarant's omissions would be too long, but the enumeration of a few will give an idea of his strange method, which accumulates minor details on some questions while completely passing up comparatively major ones. There is no mention of the fact that at the Salon of 1865 Manet found himself complimented for a canvas by Monet and thereupon at first refused to meet the younger man; nor is there any indication of how Manet and Cézanne first met in April 1866, though this is known through documents published by Alfred H. Barr, Jr., not only in English, but also in French (*Gazette des Beaux-Arts*, n.s. 6, no. 17 [1937], pp. 51–52). Tabarant does not once allude to Degas's painting of Manet and his wife, a canvas from which Manet cut off his wife's likeness and which he later returned, thus mutilated, to Degas after one of their not infrequent quarrels. (It is reproduced in the catalogue of the first Degas sale in May 1918.) On the whole, Manet's friendship with Degas receives insufficient consideration. Just as incomprehensible is the fact that Tabarant does not quote Berthe Morisot's letters on Manet's *Balcony* for which she posed, and on Manet's attitude when the painting was exhibited at the Salon of 1869. These important documents were published in Paris in 1933 by M. Angoulvent.

In addition to such omissions, which cannot be explained since they deal with facts known for many years, there are others doubtlessly due to the fact that certain publications have escaped Tabarant's attention, such as Denise Le Blond-Zola's article on Paul Alexis (*Mercure de France*, March 1, 1939) with information about Manet's duel with Duranty; Ima N. Ebin's study, 'Manet and Zola' (*Gazette des Beaux-Arts*, n.s. 6, no. 27 [1945], pp. 357–58) with further details on Zola's controversial article devoted to Manet, which appeared only in Russian; or the interesting note on an episode of Manet's 1853 sojourn in Venice to be found in the *Burlington Magazine* (August 1945), but originally published by Marie Thérèse Ollivier, *Emile Ollivier, sa jeunesse* (Paris, 1918), pp. 228–29.

Such details certainly have their place in a volume which not only claims completeness, but also indulges in detailed information on many questions which do not actually add to our knowledge of Manet. On the whole it must be admitted that much of Tabarant's new material merely consists of dotting the *i*'s and crossing the *t*'s without actually offering new insights, important revelations, decisive corrections. This does not mean that such dots on the *i*'s are not useful, yet when this kind of footnote material is found prominently incorporated in a narrative, the effect is somewhat disturbing. One cannot

help thinking that a new and revised edition of Tabarant's first catalogue with a separate biographical study would have made a much more desirable publication. Better organized and assembled with more discrimination, Tabarant's documentation would thus have provided an interesting and helpful book instead of being an accumulation from which only a patient student will be able to derive useful information.

Two new studies of Monet's life and art

Monet. Text by William C. Seitz. 132 reproductions with 48 in color. 160 pp. New York: Harry N. Abrams

The Invincible Monet. By C. P. Weekes. 244 pp. New York: Appleton-Century-Crofts

William C. Seitz is no stranger to the recently revitalized interest in Claude Monet. He contributed an introduction to the large Monet retrospective held in 1957 at the City Art Museum of St. Louis and the Minneapolis Institute of Arts. Earlier this year he organized the splendid Monet show at the Museum of Modern Art in New York which subsequently went to Los Angeles. But except for their catalogues—well done in both these cases—exhibitions are ephemeral affairs despite the impact they may have. It is lucky, therefore, that Mr Seitz was able to put his vast knowledge of the artist between the covers of a large and sumptuously illustrated volume. The author has done a tremendous amount of research and has made pilgrimages to practically all the places where Monet worked, taking some superb photographs of the sites he painted, thus providing an extremely interesting insight into the master's concept and vision. Just as illuminating as these photographs and other documents are the text and comments on individual paintings, reproduced in excellent black-and-white illustrations in addition to well-selected and usually quite satisfactory color plates.

Seitz writes exceedingly well; many of his descriptions are graphic and poetic. Better still, one senses behind his prose a man who loves art, who gets excited over paintings. And his excitement is infectious. This in itself is a rare treat as art books go. Yet there is more than enthusiasm and deep affection for his subject in his book. Seitz is a scholar, willing to go to a great deal of trouble to check a minute detail, to do the kind of spade work of which the general reader remains unaware.

First published in *Herald Tribune Book Review* (New York), November 13, 1960

Of course, Seitz has carefully studied the Monet literature, which is quite extensive in French, while no monograph on the artist had as yet appeared in English. Compared with the vast quantity of frequently repetitive books on van Gogh, Cézanne, or Renoir, this is amazing in view of the fact that Monet, from his early to his last works, is rather well represented in American and British public and private collections. (It is strange also that this gap should now be filled by two publications, appearing simultaneously.)

Seitz has used his multiple sources with proper discrimination, particularly called for because the artist was fairly careless about dates and other details. Many of the interviews he gave in later years contain contradictory statements and Monet's 'official' biographer, Gustave Geffroy, whose rambling volume appeared during the artist's lifetime, is often incredibly unreliable or vague. In addition, Seitz has tapped new sources and has accumulated countless bits of information which round out the general picture and make it more lively. Thus he has interspersed his comments with well-chosen quotations from unpublished or little-known documents, supplying all kinds of relevant details. However, he has successfully avoided the danger of drowning his narrative in picturesque minutiae. His text flows unhampered, always logically connecting biographical facts with aesthetic considerations. His step-by-step analysis of Monet's evolution and his evaluation of the artist's place within the Impressionist movement are both fascinating and instructive.

The volume also features a very comprehensive biographical outline, better than anything published hitherto, a selected bibliography, and a special section on Monet's drawings, the first of its kind. The excellent editing, for which Irene Gordon is responsible, and handy cross-references add to the book's usefulness. To leaf through this handsome publication is a pleasure; to read it means learning to understand, to appreciate, and to love Monet better. One can't help but feel grateful to William Seitz for this rewarding experience.

After putting this book aside, it is difficult not to wince at C. P. Weekes's *Invincible Monet*, a biography in which, at the outset, the reader is warned not to expect any art criticism. This may explain the total absence of illustrations, but on such a premise an essay about a painter only justifies itself when it contains new material, proposes a novel approach, or offers as yet neglected psychological interpretations. Unfortunately, this is not the case here. Indeed, the purpose of the book seems somewhat mysterious: it devotes fifteen chapters, from pages 1 to 225, to Monet's life from birth up to 1883 and then lumps the remaining forty-three years (exactly the second half of the artist's life span) into two chapters, 16 pages in all. Does this mean Monet ceased to be 'invincible' shortly after the death of his first wife, Camille, or that the author grew tired of his subject? There is nowhere a clue to this unusual treatment of a biography.

Rather carelessly written, the book affects that regrettable 'vivid' style which would have the reader believe that the writer knows what his hero feels, thinks, remembers, and even murmurs on occasion. That the text remains flat in spite of such devices can be explained only through the obvious fact that here—unlike the case of Seitz—there is no emotional communication between author and subject. Lack of understanding, replaced by an accumulation of commonplaces, mars Weekes's entire book. Some of his statements are plainly inept, such as when he says that Camille 'was more than the perfect model, she provided Monet's eyes—those wonderful organs of minute perception—with a heart. All the warmth, the humanity, the sense of deep feeling in his pictures came from her, indirectly but none the less surely.' Actually, the true character of Monet's relationship to Camille has never been investigated, but there seems reason to assume that it was overcast by dark shadows; anybody who approaches it as superficially as does Weekes is bound to bypass the entire problem. Is the abrupt ending of the volume supposed to imply that the widower Monet deserves less attention because warmth and humanity had vanished from his work after Camille's death? This is admittedly a rhetorical question, since those qualities were by no means the true keys to his greatness anyhow.

The formidable power of Monet's creative urge, sometimes almost lyrically conveyed by Seitz, never comes alive in Weekes's prose. The people around Monet remain clichés. Some passages are so ambiguous as to leave the reader aghast. Speaking of Manet's *Luncheon on the Grass*, the author says, 'as one critic unkindly but not untruthfully wrote, "the nude, when painted by vulgar men, is inevitably indecent."' I have read this paragraph several times and still do not know whether Weekes simply agrees with the quotation or really wishes to insinuate that Manet's picture is 'truthfully' indecent; since he also calls Manet 'vulgar' on other pages, I am afraid that this is actually what he meant.

As to new material, there is very little trace of it, unless conclusions with no evidence to substantiate them should be considered as new data. In the absence of any solid frame of reference, one is left with the suspicion that many affirmations are merely part of the author's brisk style and his tendency to simplify matters. My confidence in his propensity for serious research was shattered when I discovered that two errors which I had committed in my writings (misspelling the name of Armand Silvestre and asserting that Sisley had been in England during the Franco-Prussian War) are faithfully repeated by Weekes. Nor are these the only mistakes. Inaccuracies are particularly frequent where peripheral figures are concerned, as if the author could not be bothered with them.

Misunderstanding Monet

Monet: A Biography. By Charles Merrill Mount. Simon & Schuster, New York. 444 pages; illustrated

This book is biased, Philistine, repetitious, inept, and smug. The author, an artist whose dealer hails him as the last of the international portrait painters, states in his preface that in 1956 the Guggenheim Foundation 'and its director, Henry Allen Moe, graciously waived their age requirement to make [him] the youngest scholar' honored with a grant. In the opinion of this reviewer, the foundation must also have waived a few other requirements to enable this young man to devote years of research to vilifying a painter whose significance grows with the passing years. Mount likes to speculate that Monet's 'seduction of Camille Doncieux [his first wife and mother of his two sons] was an expression of youthful lust,' and that 'the dowry of another woman Monet seduced, the wife of his patron Ernest Hoschedé, permitted him to achieve his final enormous position in French art.' That Monet was one of the great geniuses of his time is quite overlooked. Indeed, to Mount, Monet was only 'a simple young man from Le Havre, possessed of no more than a lyric gift for landscape painting.'

Thus, the young Monet is described as a 'swaggering, self-centered, emotional, and contentious young man' (p. 40), showing a self-assurance 'that one might reasonably have confused with smugness' (p. 34). In the recesses of his deep-set eyes 'lurked a look of purpose and a hint of slyness' (p. 35), which probably explains why 'he never could resist the temptation to play a sly game' (p. 49); nor did he have 'too much scruple' (p. 59), especially when it came to his ferocious tendency toward 'self-dramatizing and attitudinizing' (p. 59). That he was 'smooth as an eel' (p. 70) cannot surprise therefore, yet the author feigns dismay at finding him among 'the most abject followers' of Courbet (p. 72). His was an 'undisciplined mind' (p. 74) whose 'fiendishly calculated conduct' (p. 86) reveals him a 'compulsive competitor' (p. 87) endowed with 'overtones of megalomania' (p. 97). No wonder this 'charming, eager but slightly unlovable young man' (p. 122), who was not averse to 'low cunning' (p. 132), tried to 'gain sympathy . . . by unpleasant means' (p. 131), and actually treated 'family, self, mistress, and even unborn child with transparent dishonesty' (p. 146). He 'demonstrated no shortcomings as a groaner' (p. 152), was 'cynical' (p. 170), and appeared, to sum it up, 'superficially attractive, handsome, only modestly intelligent but with powers of articulation' (p. 171).

First published in *Art News*, January 1968

225

This treatment of the man is also accorded to his early works. Here emphasis is monotonously placed on the painter's infrequent attendance at academic classes, as a result of which he was unable to equal Winterhalter. The author deplores Monet's 'fearful lack of rudimentary training' (p. 58) and does so not just once or twice, but practically on every other page. We see the young artist arrive in Paris, 'his entire baggage the slapdash arrogance of a fledgling who refused to learn the basic disciplines of his craft' (p. 47). His efforts are therefore 'limited by the shallowness of his knowledge and powers of reasoning' (p. 63), even though he may succeed occasionally in producing 'a flashy showpiece full of daring artifice and visual horseplay' (p. 77). The real difficulty remained 'his lack of assiduous studio training' (p. 77), 'lack of the studio work he had found so irrepressibly tiresome' (p. 78), 'lack of rudimentary studio skills' (also p. 78), 'meager training' (p. 81), 'lack of substantial training' (p. 87), absence of 'regular academic training' (p. 91). Being 'technically unequipped' (p. 100), Monet was in a 'state of ignorance' (p. 110) and consequently was 'too easily content with effects cheaply bought. In every deeper requirement he failed' (p. 111). For many problems 'he had neither technical equipment nor understanding' and was 'unlearned in the restraints of studio techniques' (also p. 111). He suffered from 'incorrigible inaccuracies of draftsmanship' (again p. 111), 'deficient craftsmanship' (p. 124), and 'insecure technical equipment' (p. 130). Yet despite these shortcomings, he was 'never impatient to learn tidy solutions to technical problems' (p. 117). 'Lacking the experienced craftsmanship' (p. 164), he found himself subjected to the 'humiliating truth of his inexperience' (also p. 164), though it must be admitted that as 'a fanatic and a simpleton, his lack of education spared him the painful burden of inert ideas' (p. 159). And so it goes.

Even Monet's friends are not spared. Manet's and Courbet's brave gestures of building their own pavilions at the Paris World's Fair of 1867 are called 'peerless idiocy'; Manet is accused of 'inadequate draftsmanship,' Degas stands exposed because 'his Ingresque concept of a correct line ignored the grace of line itself' and because 'he had an unfortunate talent for falling flat.' Renoir is only 'at times capable of adequate drawing,' while Pissarro's 'figures were lamentable.'

Mr Mount is not only negative; he also has an inimitable breezy style, much given to such high-sounding phrases as, 'These callow voices of intellect rang out with fervor and throbbed with ineffable rapture.' Or, 'Monet found personalities who were a preview of the cultural landscape.' And that, under these circumstances, the painter got himself into a situation where 'artistically, in relation to his family, and personally with regard to Camille, all his eggs were in one basket,' was probably unavoidable.

It is poor Camille, Monet's mistress and wife (she died after the birth of their second child), who comes off best, even though, in the view of the

author, 'she had allowed herself to be made a young cynic's instrument of pleasure.' She was not too lucky when she posed for Monet, 'her tall, rambling and beautifully knit form, so sensuous and acutely supple, reached the canvas with its obvious eroticism faded and replaced by a more listless air.' The author studiously avoids using the word 'love' where Monet's feelings for Camille are concerned. The best he will do is admit that, 'as time passed, she pleased him more'; notwithstanding, the painter 'decided only to be undecided in his relationship' with her. Fortunately, despite the illegitimate birth of her first child (whom Monet recognized), she manages to retain Mr Mount's sympathy; 'If she were no longer innocent nor conventionally pure, Camille nevertheless surely displayed praiseworthy qualities that proceeded from an innocent and pure heart.' The reader will be reassured to know that everything changed radically after marriage and after the 'instrument of pleasure' had become respectable as Madame Monet. Indeed, 'as ingredients, Monet and the lovely twenty-three-year-old Camille fused deliciously.'

Mr Mount has, it is true, discovered some unknown documents relating to Camille's dowry and marriage contract, but since he published them several years ago in a periodical, they are no longer absolutely new. What is reprehensible is that he interprets them in such a way as to place Monet in the worst possible light. He completely overlooks the fact that Monet was not the only painter in those days to consider marriage a bourgeois institution: Pissarro had two children before he married their mother, and Cézanne's son was a teenager when his parents were legally united. Neither of them was prompted to accomplish this formality by the prospect of money; yet Mr Mount argues that Monet agreed to marry Camille only because she was coming into some money.

Apparently there was not even a copy editor available for this book who knew that Gambetta never was 'President of France'; that Courbet did not sport the Legion of Honor before it was awarded him, and that he noisily refused it when it was; or that *nom de dieu* cannot conceivably be translated as 'Name of God' (there are other, incredible, errors of translation). Yet facts and texts can—and should—be checked, unless we consider that a biographer has no obligation nor responsibility either to his subject, or to history, or to the reading public.

In all fairness to the author, I must admit that I managed to get through only the first 203 pages of his book.

List of Illustrations

Measurements are given in inches before centimeters within brackets

Color plates

Index

Figures in italics refer to illustration numbers